IMAGES OF WAR

ARMOURED WARFARE AND THE FALL OF FRANCE 1940

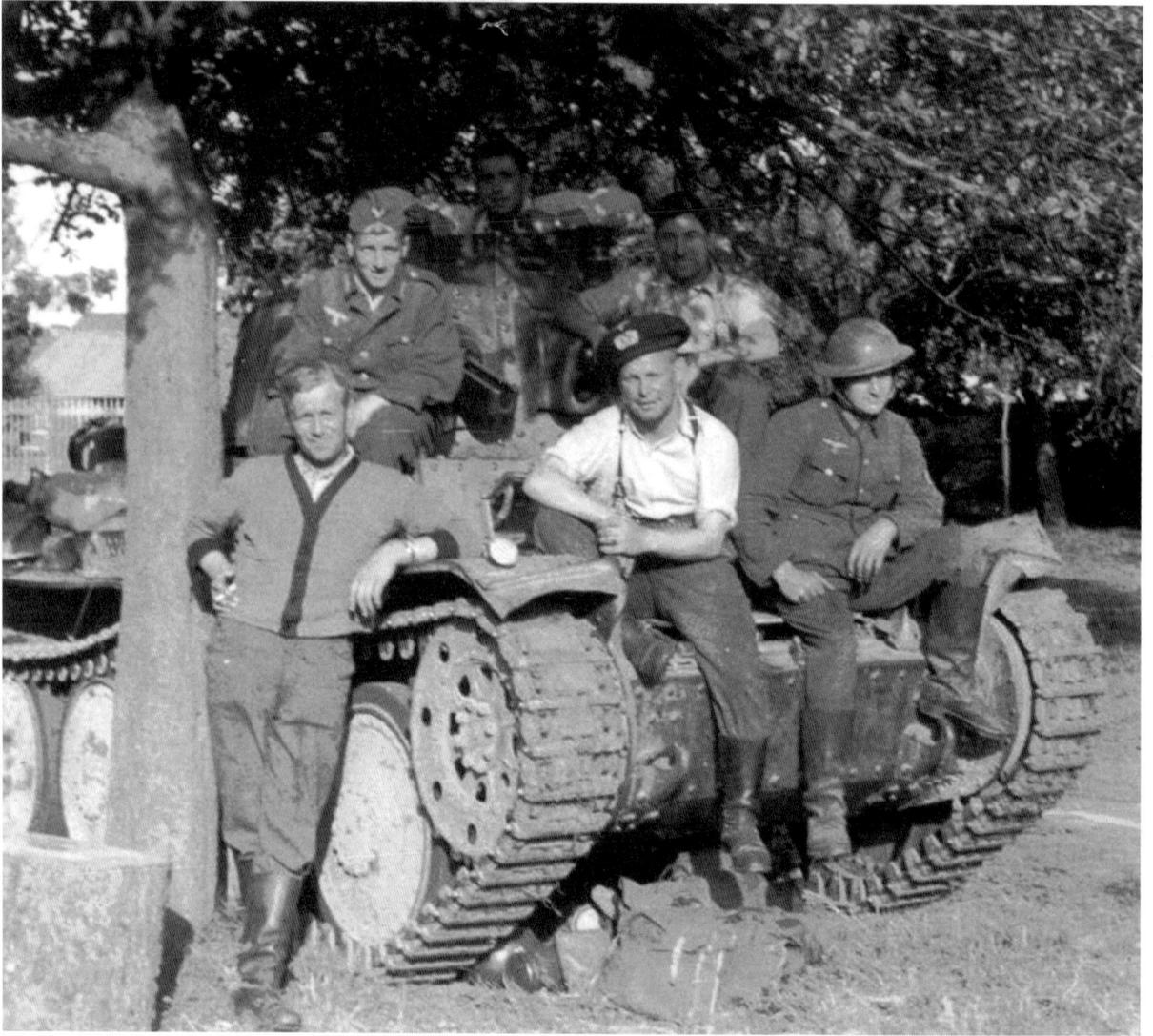

Triumphant panzertruppen seated on their Czech-built PzKpfw 38(t).

IMAGES OF WAR

ARMOURED WARFARE AND THE FALL OF FRANCE 1940

RARE PHOTOGRAPHS FROM
WARTIME ARCHIVES

Anthony Tucker-Jones

Pen & Sword
MILITARY

First published in Great Britain in 2013 by
PEN & SWORD MILITARY
an imprint of
Pen & Sword Books Ltd,
47 Church Street,
Barnsley,
South Yorkshire
S70 2AS

Text copyright © Anthony Tucker-Jones 2013
Photographs copyright © as credited 2013

ISBN 978 1 84884 639 5

Typeset by Chic Graphics

Printed and bound by CPI Group (UK) Ltd, Croydon, CR0 4YY

Pen & Sword Books Ltd incorporates the Imprints of
Pen & Sword Archaeology, Atlas, Aviation, Battleground, Discovery, Family
History, History, Maritime, Military, Naval, Politics, Railways, Select, Social
History, Transport, True Crime, and Claymore Press, Frontline Books, Leo
Cooper, Praetorian Press, Remember When, Seaforth Publishing and
Wharncliffe.

For a complete list of Pen & Sword titles please contact
Pen & Sword Books Limited
47 Church Street, Barnsley, South Yorkshire, S70 2AS, England
E-mail: enquiries@pen-and-sword.co.uk
Website: www.pen-and-sword.co.uk

Contents

Introduction

It was in the summer of 1940 that the myth of the invincibility of Adolf Hitler's Panzerwaffe and Luftwaffe was truly created. Nothing could withstand the combined power of the panzer and the Stuka dive-bomber – all fell before them in a state of sheer panic. In short succession Norway, Denmark, the Netherlands, Belgium and then France fell under the Nazi jackboot. Swallowing up Germany's smaller neighbours was one thing, but France should have been a much more indigestible meal for the Nazi war machine. Protected by the Maginot Line, with a large reasonably well-equipped conscript army and backed by sizeable overseas colonial forces, the average French citizen felt secure in his bed through the anxious months of the Phoney War of 1939.

At 2100hr on 9 May 1940 Codeword Danzig was issued alerting Hitler's airborne troops that they were about to spearhead an attack on Belgium and the Netherlands. The following day the Nazi Blitzkrieg rolled forward striking the British Expeditionary Force (BEF) and the French 1st, 7th and 9th Armies in Belgium and the French 2nd Army in northern France at Sedan. Belgian, British, Dutch and French attempts to stem the Nazi tide proved futile and while the Allies enjoyed a minor success at Arras, once their reserves had been exhausted and their remaining forces cut off, Paris lay open.

It was all over by early June when the trapped British, Belgian and French troops were forced to evacuate Dunkirk, Calais and Boulogne. The Germans then battled their way south and by 10 June were across the Somme. At this point Italian dictator Benito Mussolini attacked southern France, and twelve days later the humiliated French Army agreed to an armistice leaving the country divided in two.

What is so remarkable about the Fall of France is that only a year earlier the French Army was considered to be the strongest in the world. In reality, as subsequent events proved, it was fatally flawed; first, since the bloodletting of the First World War it was very short of manpower; and secondly, the French looked to the success of their earlier defensive actions against the Germans to formulate their defence policy. The heroic defence of Verdun loomed large in the French psyche.

In the aftermath of the First World War the French and German Armies became a product of the economic, political and social upheavals of the 1930s. While the dynamic German armed forces became an instrument of revenge with which to

punish those who had imposed the Treaty of Versailles, the moribund French armed forces remained a static defensive weapon. The Nazis arose from the ashes of the feeble Weimar Republic determined to restore national pride and Germany's military power.

Meddling in the Spanish Civil War allowed Germany, and Russia for that matter, to test out their new tanks. These were not the lumbering support tanks of the First World War but something entirely new – an overtly offensive weapon that could pierce an enemy's defensive line then turn his flank. French military experts lead by Charles de Gaulle knew that they must keep up with this new military theory or face the consequences. Warfare is not just about having the equipment to conduct war, it is knowing how to use it to its maximum effect. The Fall of France in 1940 proved a salutary lesson in this.

While France may have been reasonably ahead in the arms race it lost the concepts race. During the early 1930s, while Secretary General of the Council for National Defence, Charles de Gaulle developed his idea of an armoured division supported by a tactical air force. When he published his book *The Army of the Future* the French were not receptive but the Germans took a great interest in his theories. In 1935 the first panzer division was formed exactly along the lines de Gaulle envisaged.

It was not until late 1938 that the French War Council decided to equip two armoured divisions on the de Gaulle pattern. By then it was far too late, the Germans mustered twelve hard-hitting panzer divisions. Hitler had made his plans and so had his Italian accomplice Mussolini. General de Gaulle was commanding the tanks of the French 5th Army in Alsace when the panzers invaded Poland. He can only have despaired as his ideas came to pass in the hands of France's traditional enemy.

Britain was in a similar position. While the British military were keen enthusiasts of the tank following their experiences at Amiens in 1918, cost and the country's love affair with mounted cavalry greatly slowed progress. Like the French the British developed two kinds of armoured force: the fast-moving, all-arms groups that were the basis for future armoured divisions and tank battalions assigned an infantry support role.

In 1937 it was decided to equip a number of British cavalry regiments with tanks instead of expanding the existing Tank Corps. While tank enthusiasts such as Captain Liddell Hart and Generals Fuller and Hobart designed and trained tank units that were unique in concept and technical proficiency only a very few were experienced in mechanised warfare.

Hitler wanted to attack France as soon as possible to secure his western borders in the wake of defeating Poland in September 1939 before then turning east again

to tackle Russia. However, he was informed that it would take months to refit his panzers. Nearly every single vehicle needed an overhaul and depleted ammunition stocks were insufficient to ensure victory over the French Army.

After six months Hitler invaded Norway and Denmark on 9 April 1940. The outnumbered Danes offered virtually no resistance, but the Norwegians (with belated British and French military assistance) lasted until early June. France and the Low Countries (the Netherlands and Belgium) now braced themselves for the inevitable German attack.

Ironically from the very start on 10 May 1940 both the Germans and the Allies played out Hitler's envisaged campaign to perfection. The moment the German offensive commenced the Allies drove north to confront Army Group B, which in the event overran the Netherlands in the space of just five days. In Belgium other units of Army Group B shoved the Allies back after securing Belgium's much-vaunted strongpoint Fort Eben Emael. As all this played out Hitler and his generals rubbed their hands together. Now that the Allies were committed in the Low Countries and with the French Maginot garrison pinned down, Army Group A smashed through the Ardennes to reach the French coast in a mere ten days.

In the Low Countries there was a strong pro-German sentiment. In the Netherlands this extended well beyond the country's German-speaking minority. Likewise in Belgium the, dominant French-speaking Walloon population was constantly discriminated against by the Flemish population who had more sympathy for Germany than France. In 1936 King Leopold of Belgium cancelled his country's defence treaty with France to win favour with the Germans. On top of this the Dutch and Belgian Armies were weak and disorganised.

The Dutch, in as much as they had a defensive plan, intended to abandon the north-east of their country and form a bastion around the key cities of The Hague, Amsterdam and Rotterdam and wait for help. In the event this would consist of three French divisions; two of which were landed on the islands of Beveland and Walcheren at the mouth of the Scheldt from where they could do little to impede the Germans; another was sent to link up with the Dutch Army, but unable to get through turned back without firing a shot. The Dyle Line was never defended with the Allies barely reaching it before turning back to meet the threat of a panzer breakthrough in their rear. On 15 May the Dutch surrendered.

Defence talks between French and Belgian officers in late 1939 and early 1940 came to nothing. In fact in April 1940 the Belgians flatly refused to give the French permission to inspect the defensive line on the River Dyle just to the east of Brussels. When the Belgian King finally agreed to integrate the command of his Army with the British and the French on 12 May 1940 it was too late. The French were preoccupied with the threat to their own country and the Allies wanted Belgian

troops to withdraw to defend France. Belgian soldiers resisted until 27 May, when having been abandoned by their Allies they surrendered. Britain and France who had started the war together on 2 September 1939 found themselves once more alone, their reluctant allies having fallen by the way side.

The defeat of France at the hands of Nazi Germany was swift and humiliating. The very strong, but poorly led, French Army exhausted its reserves trying to stem Adolf Hitler's relentless armoured Blitzkrieg and was simply unable to defend Paris. In a desperate attempt to slice through Hitler's spearhead General Charles de Gaulle, with about three tank battalions, launched an unsuccessful counterattack at Montcornet. Despite this gallant effort it was only a matter of time before the inevitable French surrender.

Once it had turned north Army Group A was able to assist Army Group B drive the cornered Allies into a pocket around Lille on 24 May 1940. Three days later the left flank of the salient dissolved when the Belgian defenders surrendered and by 30 May the remaining Allied forces were hemmed in behind a 7-mile wide, last ditch perimeter around the port of Dunkirk. The British Army had little option but to escape back over the English Channel.

During late May and early June the British, French and Belgian defenders at Dunkirk held on while over ¼ million British and 112,000 French and Belgian troops were evacuated to Britain during Operation Dynamo. The success of the latter in part has to be attributed to the actions of 'Frankforce' at Arras, in the debacle that was the 1940 French Campaign this shines out as one of the few bright moments. Shortly after the Germans entered Paris without a fight and French morale collapsed completely. An armistice was signed on 22 June 1940 leaving a divided and humiliated France.

Photograph Sources

The purpose of this title is to present a visual account of the very swift and dramatic fall of France in May 1940, providing a graphic record of the destruction wrought by Hitler's successful Blitzkrieg through both the Low Countries and France.

To that end over 180 contemporary photographs have been carefully selected to illustrate how France fell in the space of just 6 weeks. While the main focus of the images is the tanks and other armoured fighting vehicles of both sides, the much wider aspects of the war are also covered, and this is reflected in the accompanying text.

The photos contained in this book have been drawn from the author's extensive military history picture library built up over the last three decades. He hopes the reader enjoys the following selection, which is designed to offer some insight into one of the highly decisive opening campaigns of the Second World War.

Chapter One

Finest Tanks in Europe

By 1940 France had mobilised one-third of its male population from the ages of 20 to 45, which gave the French armed forces a total manpower of 5 million men. Less than half this number served in northern France, but was boosted by well over 1½ million British troops by June 1940. The Dutch and Belgians were able to field 400,000 and 650,000 men respectively.

The French Army was organised into 117 divisions, the British Army contributed 13, the Belgians 22, Dutch 10 and exiled Poles 2 divisions. In total they were able to deploy about 14,000 artillery pieces, nearly double that of the Germans. The French Army was divided into three army groups in the north; the 2nd and 3rd Army Groups held the Maginot Line to the east, while the 1st Army Group in the west was to move forward to defend the Low Countries should the need arise.

France's key mobile forces were 1st Army's Cavalry Corps consisting of the 2nd and 3rd Light Mechanised Divisions plus four mechanised infantry divisions, 2nd Army's 2nd and 5th Light Cavalry Divisions, 7th Army's 1st Light Mechanised Division and two motorised infantry divisions plus the 9th Army's the 1st and 4th Light Cavalry Divisions.

Notably the French 7th Army, reinforced by one of the light mechanised divisions, was to move into the Netherlands via Antwerp. To the south was the BEF tasked with advancing to the Dyle Line to the right of the Belgian Army between Louvain to Wavre. The French 1st Army, with two light mechanised divisions and an armoured division in reserve, was to hold the Gembloux Gap between Wavre and Namur. The French 9th Army covering the entire Meuse sector between Namur and Sedan was also to support the move into Belgium.

The French High Command did not believe the panzers would attempt the dense Ardennes forest. Although both French and Belgian intelligence warned of a German build-up in this region, the weak French 2nd Army found itself acting as the hinge for the Allies' move-forward, defensive strategy. This army comprised just five divisions, two of which were over age reservist units and another was a West African division from Senegal. Disastrously, with is weak manpower and lack of anti-aircraft, anti-tank weapons and air support, the French 2nd Army was right in the path of the panzers attack at Sedan.

At the beginning of the Second World War despite popular perceptions France had some of the finest tanks in the world, and French armour was certainly equal in quality and quantity to that of the Germans. France's military collapse in May 1940 occurred not because of poor tank resources but the inability to use them effectively in containing the Wehrmacht's Blitzkrieg tactics. During the First World War France had almost been the very first country to produce the tank and was only just beaten by Britain. Its early assault artillery, little more than guns in steel boxes, was at best crude but led to the highly successful Renault FT-17 light tank. A new production programme during the rearmament of the 1930s ensured France had far more sophisticated tanks than Britain or Germany and with better armament.

While the Allies, particularly the Belgians and the Dutch, had very little armour, the French had 3,254 tanks. This force was not only larger than that of the Germans but also of a better quality. On paper French tanks were superior to Hitler's Panzer Mk I and Mk II, both the French B1-bis and the Somua had better armour and their guns packed a bigger punch. By June 1940 just over 400 B1 and B1-bis and 430 Somua S-35s had been built. General Gamelin, commander of the French armed forces, admitted after the Second World War that the French tank force was vastly better equipped to deal with German tanks than the Germans were to deal with French ones. At the time it did them no good whatsoever.

Most notably the Char de Bataille Renault B1-bis armed with a 47mm turret gun, a powerful 75mm hull gun and two machine guns was on paper an impressive piece of kit. The 47mm was the best weapon of its kind at the time and the tank's steering system was ahead of anything the Germans had. The 1st Panzer Division discovered how ineffective its 20mm and 37mm guns were against the thickly armoured Char B1-bis around Juniville. A 2-hour tank battle resulted in heavy German casualties before they prevailed. Similarly a second French tank attack was driven off with difficulty. The B1s were able to give a good account of themselves, but generally they saw little action against the invading panzers.

At the outbreak of war France's tank forces consisted of two very different formations: the Chars de Combat (the Army's original tank formations) and the regiments of former horsed cavalry. Although Lieutenant Colonel Charles de Gaulle had argued for a professional mobile armoured force made up of career soldiers rather than conscripts, in 1934 the French government was not receptive to such radical ideas.

Such a concept ran counter to France's defensive policy and even when two armoured divisions were authorised they were not ready for battle until 1940. Crucially this meant France's armoured strength was dissipated. Apart from the armoured divisions equipped with the Char B and the fast Hotchkiss H-39 light tank, most of the tank battalions were deployed on infantry support duties. When it came to French infantry tanks they were hampered by inadequate speed, communications, range and the size of the turret.

However, France pioneered the first armoured division with the Division Légère Mécanique (DLM – light mechanised division) combining tanks, armoured cars, motorised infantry and artillery. Like many of other countries in 1940, France's cavalry consisted of some units still mounted on horses while others were wholly mechanised. Notably in the mid-1930s France created two entirely motorised and armoured light divisions, which were equipped with the brand new Somua S-35. In reality while dubbed 'light', these well-equipped units were equivalent to a German panzer division, with 300 armoured vehicles including 190 tanks. A third DLM was created in early 1940 and a fourth ended up as part of the 'de Gaulle Force'.

In 1939 the French Army formed the Division Cuirassée (DCR), its first real tank division and by the following year had three DLMs and four DCRs. The Char B1 tank, supported by some of the older Char D2, constituted the main striking force of the DCR, while the H-35/39, R-35 and S-35 tanks equipped the DLM and the light battalions of the DCR.

While the French had some excellent tanks, the myriad of different types compared to Germany understandably proved a logistical headache. For example, French ordnance officers were faced with tanks ranging from the tiny Renault FT, through the modern Somua S-35 to the heavy Char B. Also the design of French tanks resulted in crews feeling isolated from each other.

Ultimately it was the French insistence on breaking up their tank force into penny packets that greatly aided the Germans. While France could field around 3,000 tanks, 500 were in units in the process of forming and others were in reserve. The light mechanised and new armoured divisions accounted for 1,292, the rest were split up among the infantry divisions.

French infantry divisions were supported by armoured battalions of around 100 tanks which were clearly too weak to provide any real punch. To make matters worse few French tanks had radios and those that did found that they were frustratingly unreliable. Coupled with this the general slowness of French tanks meant that the panzers would run circles round them.

The French mindset was to treat tanks as armoured cavalry using them for reconnaissance and screening work. Added to this was a lack of training and importantly tank radios. The failure to coordinate effectively with the rest of the French Army was to have one simple outcome. When war came France's armoured units were too dispersed in defensive formations, air cover was non-existent (thousands of French aircraft remained at safe airfields) and French anti-tank guns remained in storage.

On 2 September 1939 Colonel de Gaulle was appointed to command the tanks of the French 5th Army. This force, sheltered by the Maginot Line, covered Alsace with its headquarters in Wangenbourg south of Saverne. Instead of an armoured division, which he had so long lobbied for, de Gaulle's units consisted of five scattered

battalions equipped with R-35 tanks. On 12 September some of his tanks went into action for the first time when one or two companies launched a raid on Shweix, a German frontier post near the camp at Bitche in front of the Maginot Line.

It was not until just before the German invasion had commenced that de Gaulle was appointed to command and organise the new French 4th Armoured Division. Frustratingly for de Gaulle on 15 May 1940 he was only able to gather three tank battalions, less than a third of his armoured strength and less than half his officers. He was expected to launch a counterattack with this force and in the process lost a quarter of his tanks to mines, anti-tank weapons and Stukas. The heavy French B1-bis under Major Bescond gave the 1st Panzer Division a nasty surprise but the intervention of 10th Panzer and the death of the major forced them to retreat.

In terms of infantry units, the 14th Infantry Division was purportedly one of the best in the French Army. General de Lattre de Tassigny took command in January 1940 of this 'active' rather than reserve formation recruited mostly from Alsace. It consisted of two infantry regiments, a demi-brigade of Chasseurs, a reconnaissance group and divisional artillery. Like so many units, de Lattre found the division afflicted by the general malaise infecting the French Army, namely apathy, inadequate welfare services and allowing the Germans to take the initiative when it came to patrolling the front. Fortunately for the 14th Division de Lattre was a man of action and he set about shaking his command up. Like all infantry divisions, its anti-tank capabilities were not very good.

In 1940 the best anti-tank gun available to the Allies was the venerable French Puteaux '75', which was not designed as an anti-tank gun and was vulnerable to superior German field artillery. This was still the standard French field gun in 1940 and various upgrades had improved its range and cross-country mobility. The '75' was the first modern quick-firing field gun and its appearance in 1897 heralded a revolution in the design and capability of artillery (an on-carriage recoil system, one-piece round, shield and quick-action breech). By 1914 although the Puteaux was a superior direct fire weapon, tactically it was obsolete because its low trajectory was ineffective against targets concealed by folds in the ground or field works.

Most of France's medium and heavy guns were mainly late First World War or immediate postwar models. In keeping with the French preference for positional warfare there was a notable lack of mobility with the larger calibre guns. In addition French gunners lacked tactical flexibility, target-spotting techniques and were slow to concentrate their fire. The French firms St Chamond and Schneider pioneered the development of self-propelled guns during the First World War and some of these such as the 194mm self-propelled gun saw combat during the battle for France. However, lacking armour and being slow they were easily outmanoeuvred by the panzers or knocked out by German dive-bombers.

In the air the Allies theoretically had numerical superiority in fighter aircraft but

most were obsolete types and the Allies were in reality outnumbered in part because of the chronic serviceability of French aircraft. The French Armée de l'Air could field 1,562 aircraft while RAF fighter command contributed 680 and RAF Bomber Command 392. The Germans were able to pit 836 Bf 109s against 764 French, 261 British and 81 Belgian fighters. Of these only the French Dewoitine D.520 and British Hawker Hurricane were capable of taking on the German Messerschmidt Bf 109.

The Dewoitine D.520, which first appeared in 1938, was easily the best French fighter at the time of the German invasion. Unfortunately from an overall order of 2,320, only 36 D.250s had been delivered by 10 May 1940. Production continued and the D.250 Groupes de Chasse of the Armée de l'Air claimed 114 victories and 39 probables for the loss of 85 aircraft. In contrast the Morane-Saulnier MS.406, which in terms of numbers was the most important French fighter in service, fared poorly in combat with the Bf 109. About 150 MS.406 were lost in action and up to 300 through other causes. America moved to assist the Armée de l'Air during the Phoney War taking orders for 140 American Curtiss P-40 Kittyhawk fighters and 370 Douglas Boston DB-7 attack bombers, but they were not delivered in time and diverted to the RAF instead.

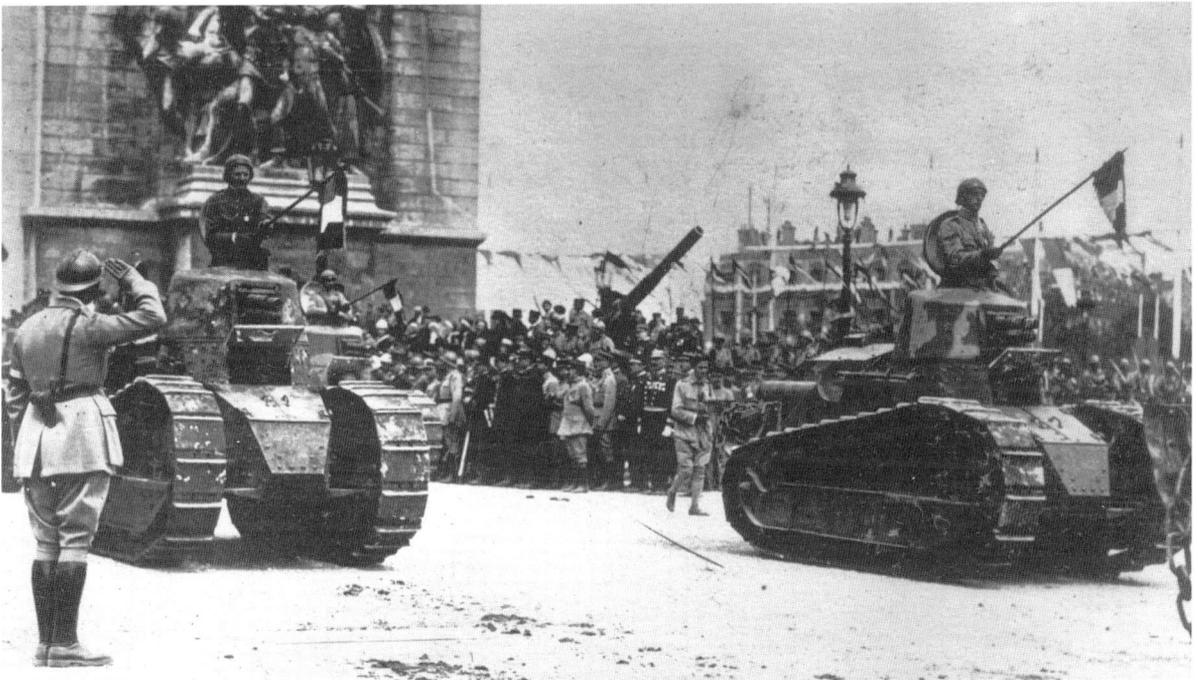

French Renault FT-17 light tanks on parade in the mid-1930s. During the First World War France helped pioneer armoured warfare with the Schneider and St Chamond assault tanks. The subsequent two-man FT-17 went into service with the French Army in 1918 and was widely exported and copied round the world. The standard production model was armed with a 37mm Puteaux gun and around 1,600 were still in use in 1940 making up half of the French tank fleet, although by then they were completely obsolete.

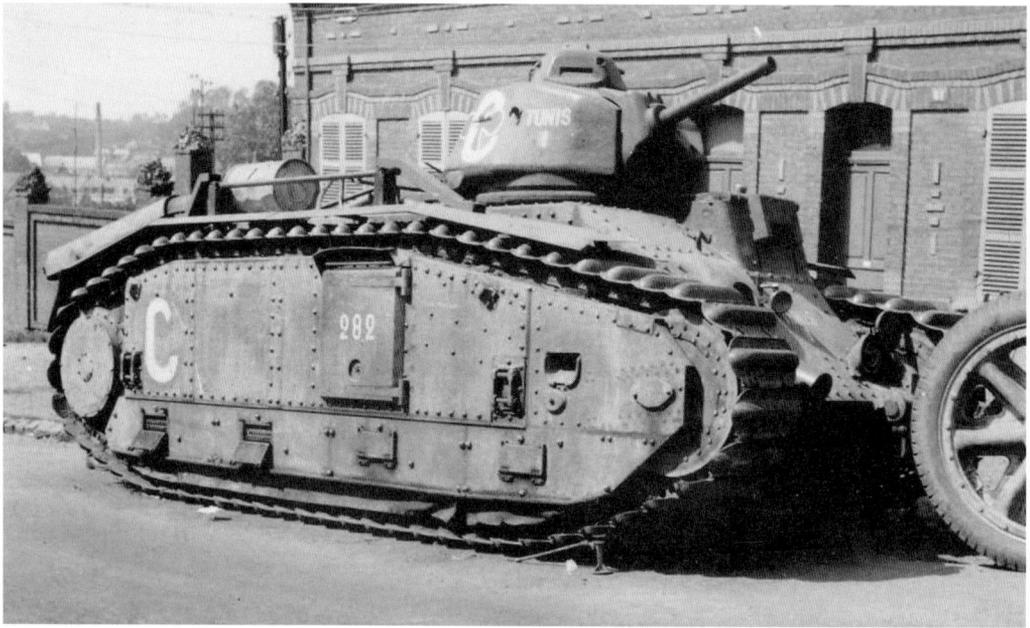

The Char B1 heavy tank, seen here in side profile and head-on, in contrast was a much better proposition as its thick armour could withstand everything except the German 88mm gun. Like the Italian M11/39 and the later American M3 Grant/Lee tanks, its main armament was hull-mounted, thereby greatly limiting its traverse. While the principal weapon was a 75mm gun, it also carried a 47mm gun in the turret, making it one of the most formidable tanks in service. About 365 of the final production model, known as the Char B1-bis, had been built by 1940, which were issued to the four French armoured divisions and independent tank companies.

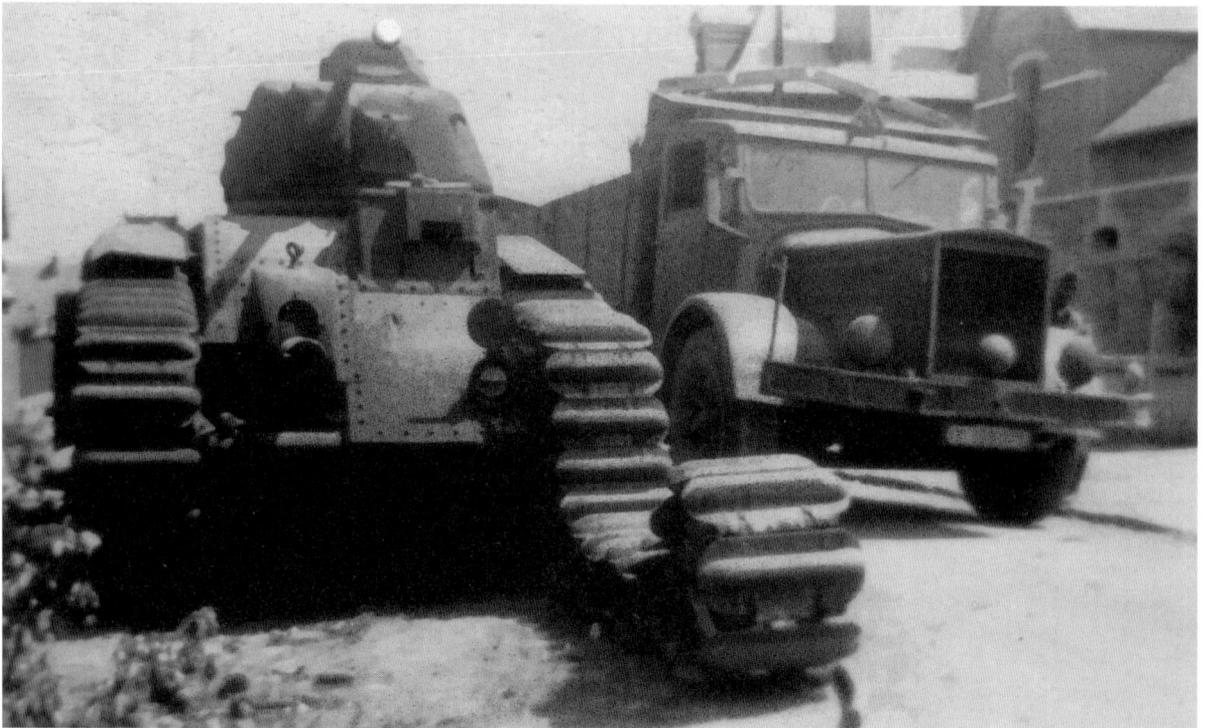

Likewise the Char Somua S-35 medium tank was well armoured with good mobility and firepower. Its turret was identical to that of the B1-bis and D2 tanks armed with the 47mm SA 35 gun and a 7.5mm Model 31 coaxial machine gun. This meant it had the usual disadvantage in that the commander had to also act as the gunner and loader during combat. About 500 had been built by the time of the German invasion.

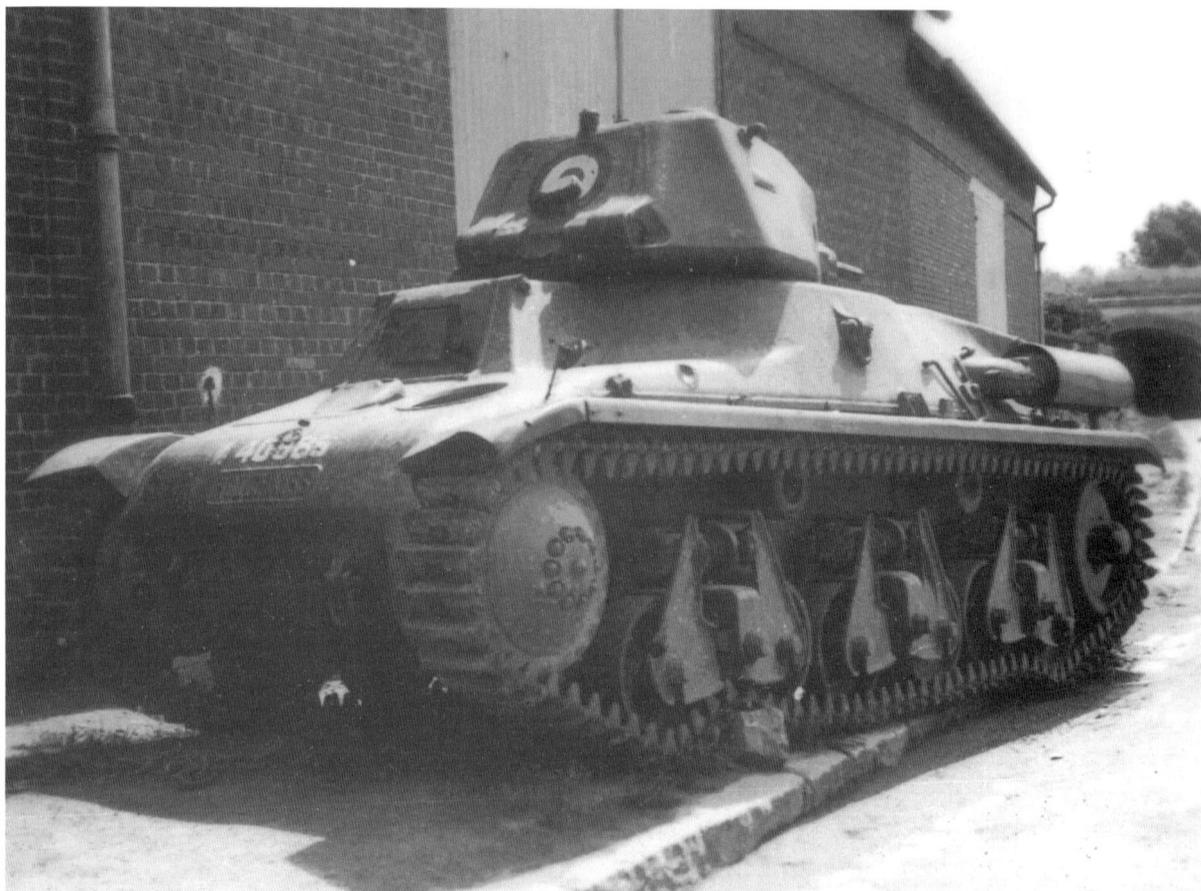

Above and opposite: The Char Léger (cavalry tank) Hotchkiss H-35 appeared at the same time as the Renault R-35 and both were alike in appearance. However the H-35 used narrower coil springs on its suspension system rather than the wide rubber washers and this made room for one extra road wheel either side which allowed better cross-country performance and a higher speed. The later H-39, seen in the photograph opposite, top, had the same calibre gun but was upgraded with a longer barrelled variant to become the H-39, seen opposite, below. While the infantry opted for the R-35 the cavalry accepted the H-35/39 as their principal tank. Over 1,000 Hotchkiss tanks were produced and with the S-35 formed the backbone of the cavalry's Division Légère Mécanique, or light mechanised divisions, as well as subsequently equipping most of the light battalions in the Divisions Cuirassées formed in 1939–40 which were France's first real tank divisions.

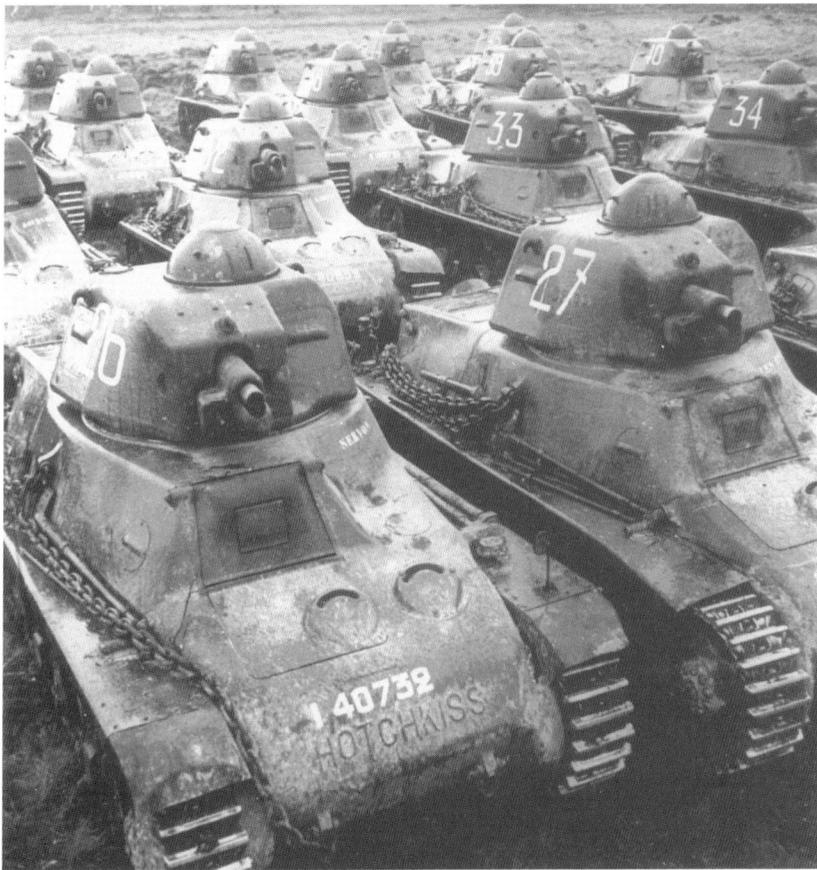

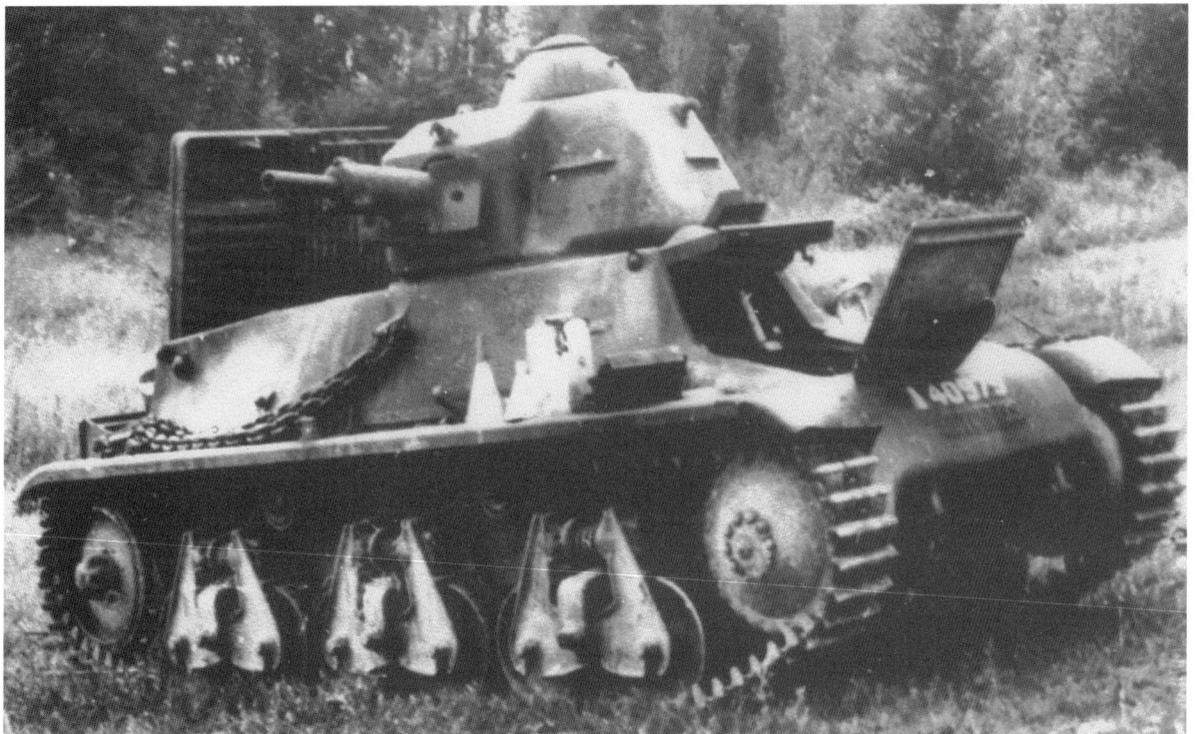

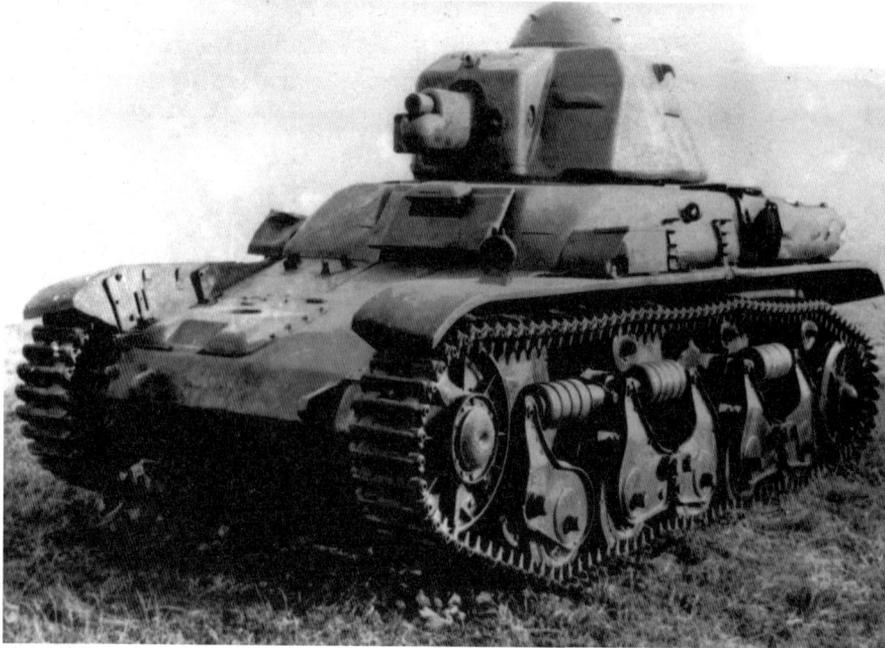

Two good views of the Char Léger Renault R-35, which was designed and built to replace the FT-17. It was a two-man light tank of just under 10 tons and was intended to re-equip the tank regiments supporting the infantry divisions. This meant that it had heavier armour and could only manage around 12mph. When war broke out although R-35 production had not completely replaced the FT-17 in the infantry tank regiments, sufficient numbers had been produced to equip twenty-three battalions.

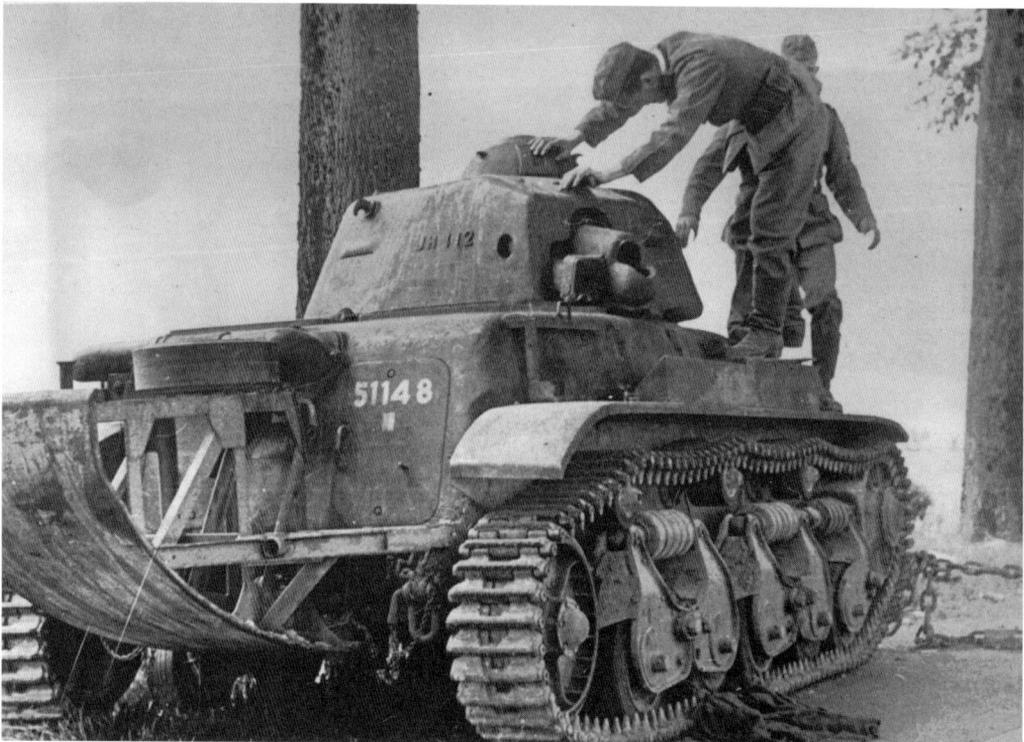

This rather grainy photograph features a Renault AMR-33 VM (Auto-Mitrailleuse de Reconnaissance) light tank of which only 120 were built. This two-man tank armed with just a 7.5mm machine gun was designed for cavalry reconnaissance work. Almost 200 of the follow-on Renault AMR 35 ZT were also produced, some of which were armed with a 25mm anti-tank gun. In parallel Renault came up with the AMC 35 ACGI but only 100 were built and some were supplied to the Belgian Army.

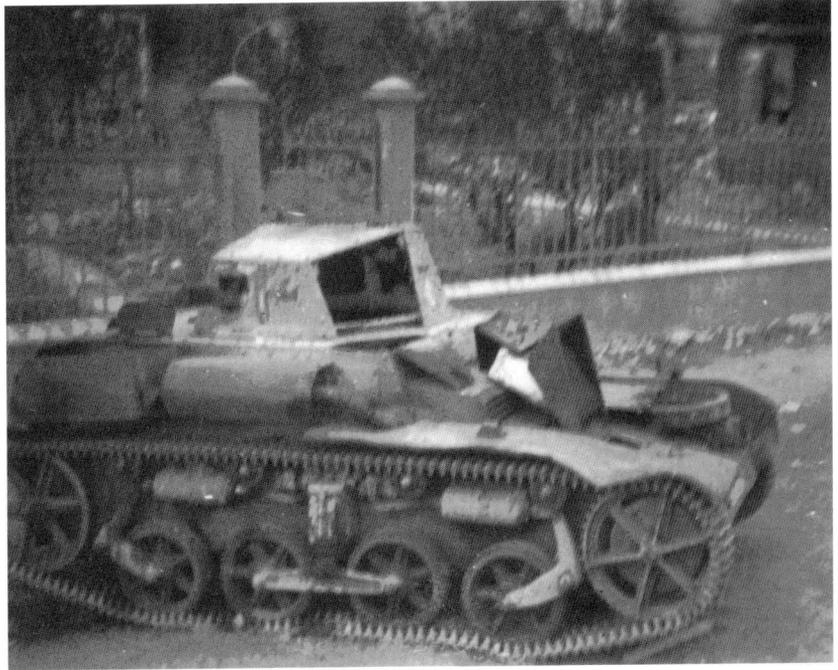

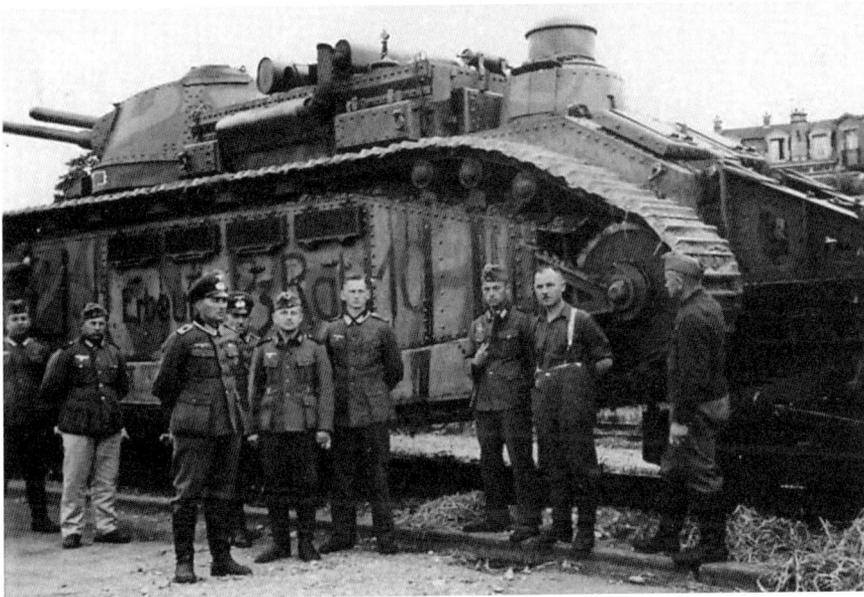

Like the Russians who produced the massive T-35 tank, the French also produced a lumbering heavy tank dubbed the Char 2C, which weighed in at 70 tons and required a crew of twelve. Just ten had been built by 1922 and the surviving six serving with the French 51st Tank Battalion were destroyed or captured by the Germans while still on their railway flat cars.

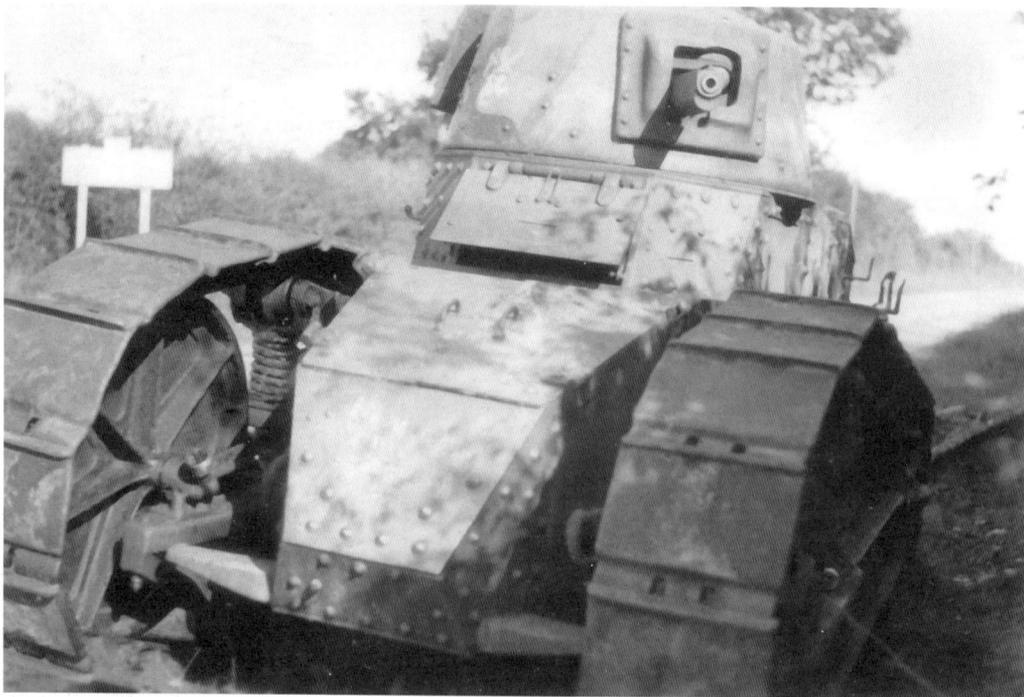

Two more photographs of the compact FT-17 light tank. The German soldier peering out of the second vehicle gives some idea of how small this tank is. The French military found it useful for police duties in France's colonial possessions such as Morocco, Syria and Tunisia but against the panzers it was all but useless.

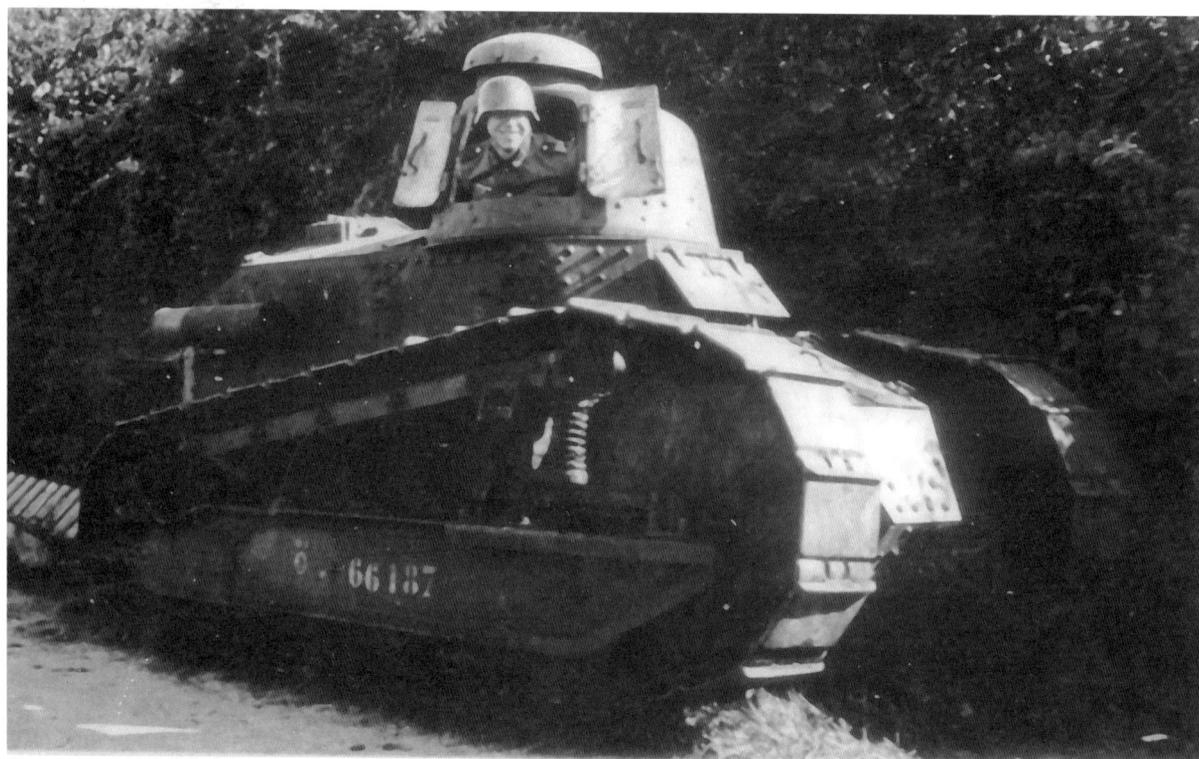

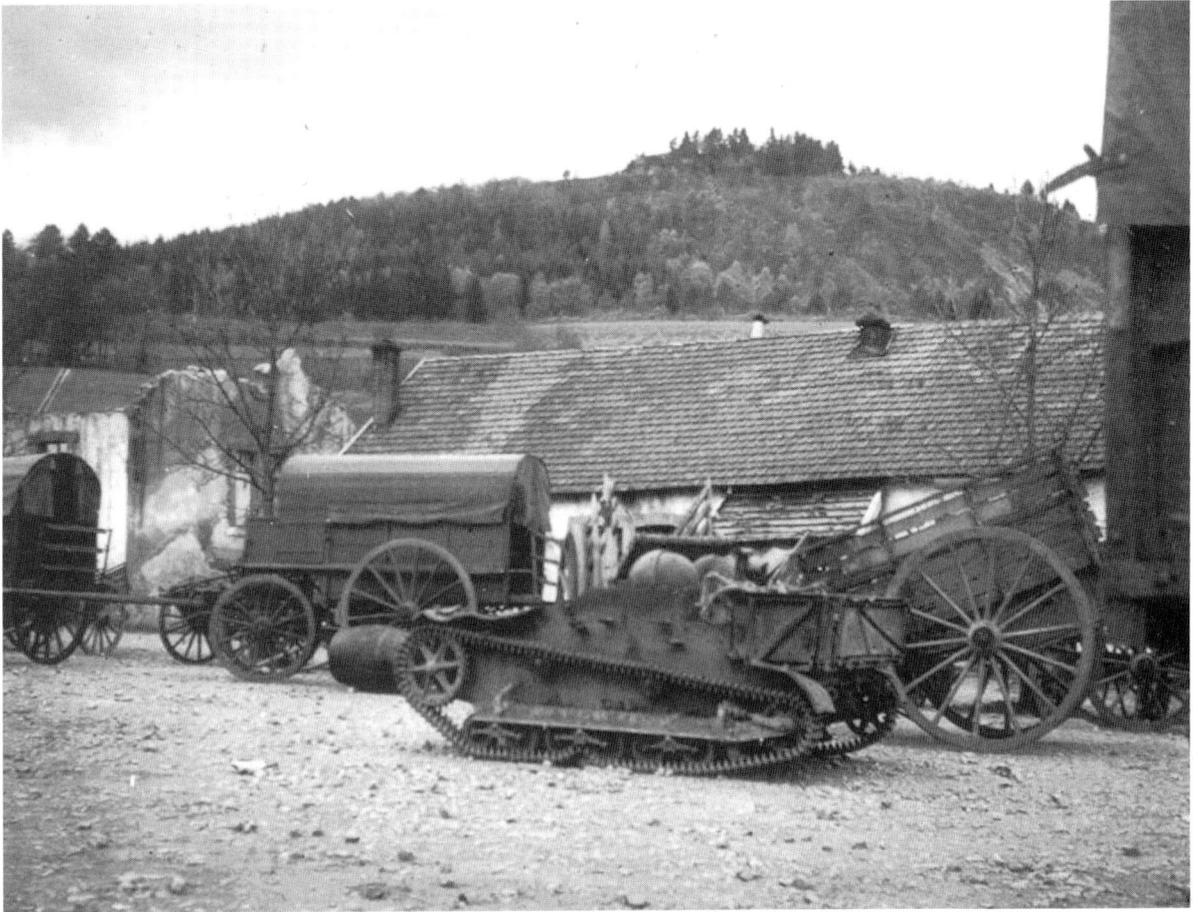

This small carrier is a Chenillette d'infanterie Renault Type UE. It was produced in large numbers from 1931 onwards to provide French troops with an armoured supply tractor. It normally came with an open tracked trailer that could carry 500kg. The two armoured domes covered the driver's and passenger's heads.

Like the B1 and S-35, this was another good piece of kit. The Auto-Mitrailleuse de Découverte (AMD) Panhard Type 178 armoured car entered French service in 1935. This modern-looking vehicle was the first four-wheeled, four-wheel-drive, rear-engined armoured car to go into series production. The Panhard Type SK 105HP engine gave it a maximum speed of 45mph. Standard armament was a 25mm high-velocity gun and one 7.5mm machine gun mounted coaxially in the turret. It was employed for long-range reconnaissance duties by the mechanised cavalry in the reconnaissance regiments of the Division Légère Mécanique and in the reconnaissance groups of the infantry divisions.

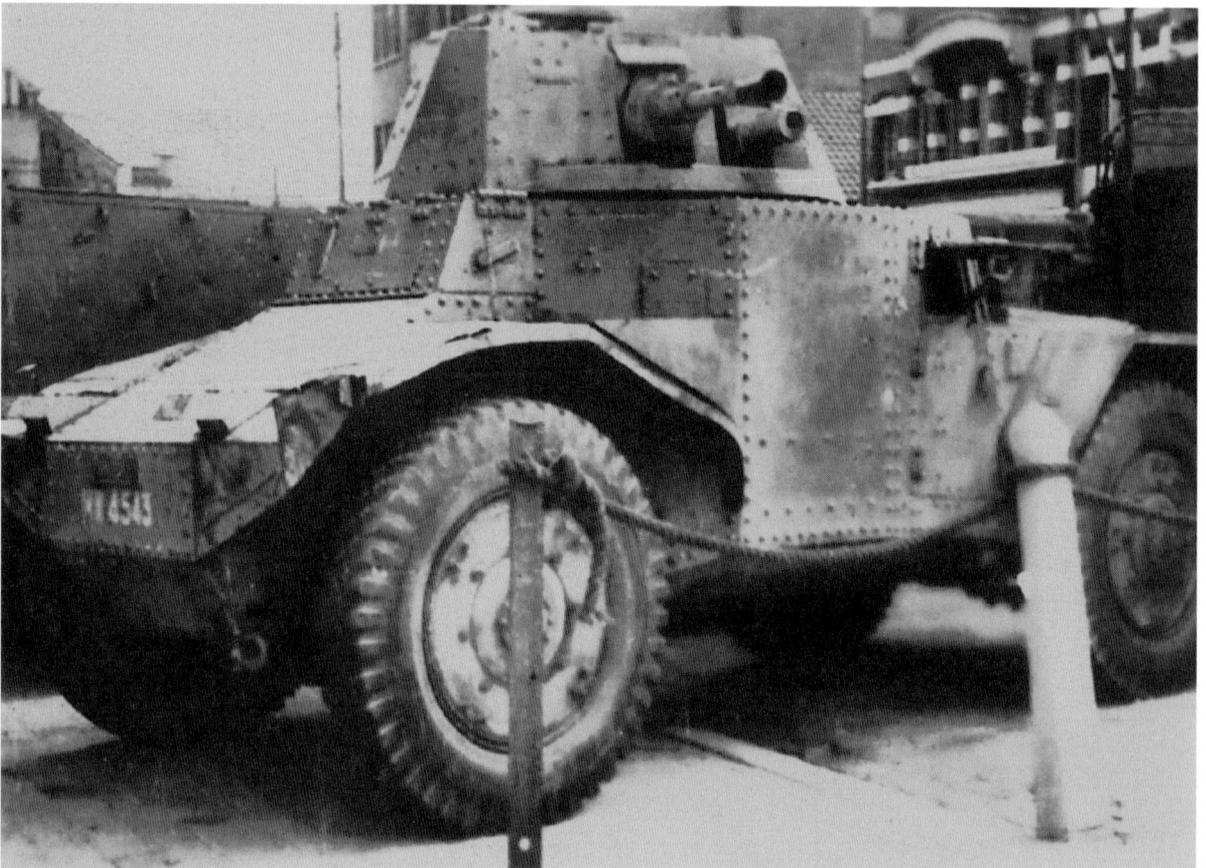

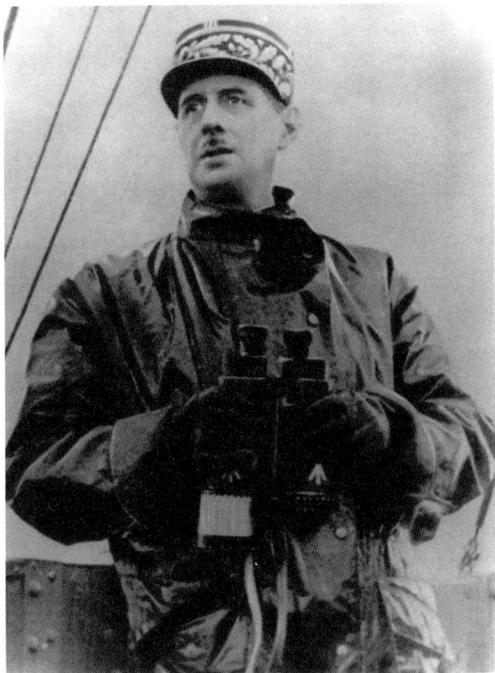

Charles de Gaulle followed General Estienne's commitment to armoured warfare and argued long and hard that France needed to gather her tanks into powerful tank divisions rather than dissipating them among the infantry. In 1939 he took command of the tank forces deployed with the French 5th Army defending the Maginot Line in the Alsace region. Just before the German invasion he was appointed commander of the French 4th Armoured Division and subsequently fought with distinction.

This was the reality of many European armies. By 1940 although parts of France's cavalry divisions had been mechanised many units still relied on the horse. The fighting in Poland in September 1939 showed how powerless mounted cavalry were in the face of Hitler's panzers. Both France and Britain had remained committed to their mounted cavalry regiments.

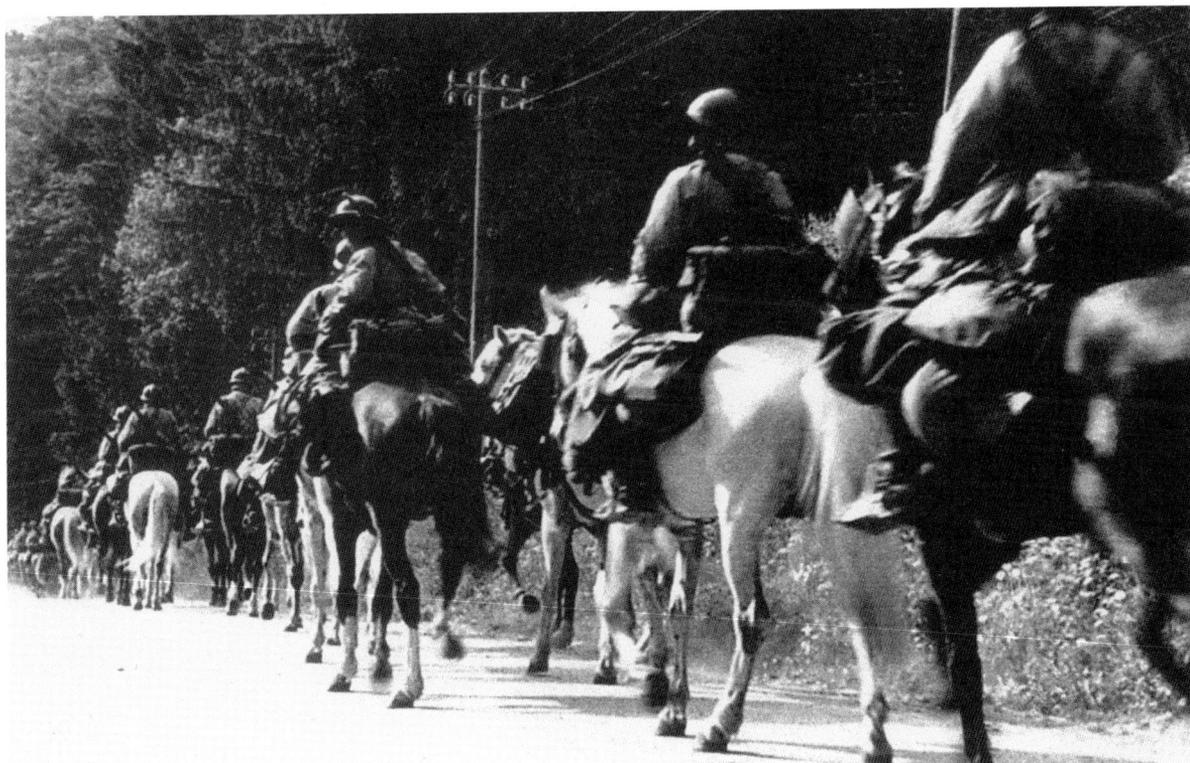

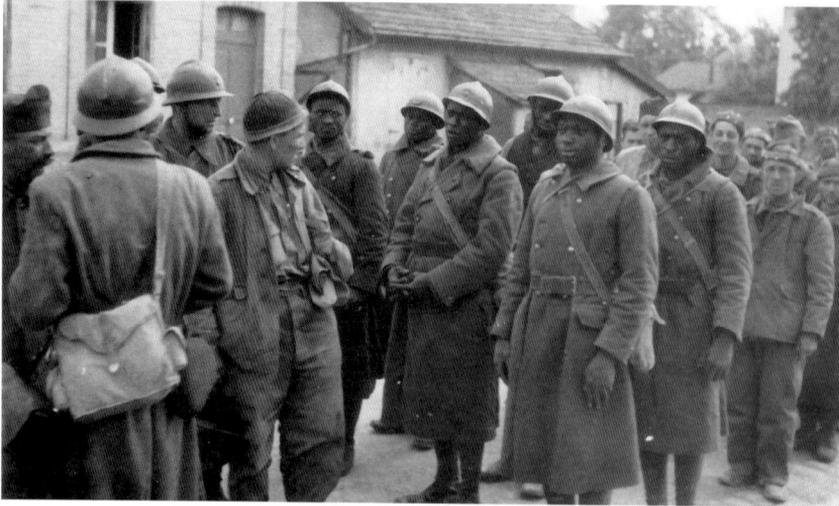

This photograph seems to show an air of racial tension. French infantry units in mainland France included colonial infantry divisions from West Africa. Notably the weak French 2nd Army holding the Sedan area included an infantry division from Senegal. By 1940 France had mobilised a third of its male population raising 5 million men, but less than half were deployed in northern France.

Confident and ready for battle, this French tank crew are posing by the back of their Char B1-bis. In fact it had four crew consisting of the driver/gunner, wireless operator, loader and commander. The loader had the awkward job of supplying both the hull-mounted 75mm gun and the 47mm in the turret. The man on the left is wearing the distinctive 1935 pattern motorised troops' helmet, which was normally associated with motorised dragoon and armoured car units. Both he and the crewman on the right are wearing the 1935 pattern heavy utility leather jacket. The man in the middle has on the 1935 pattern overalls that were made from a heavy red-brown canvas. The two bulbous tankers helmets look far from comfortable.

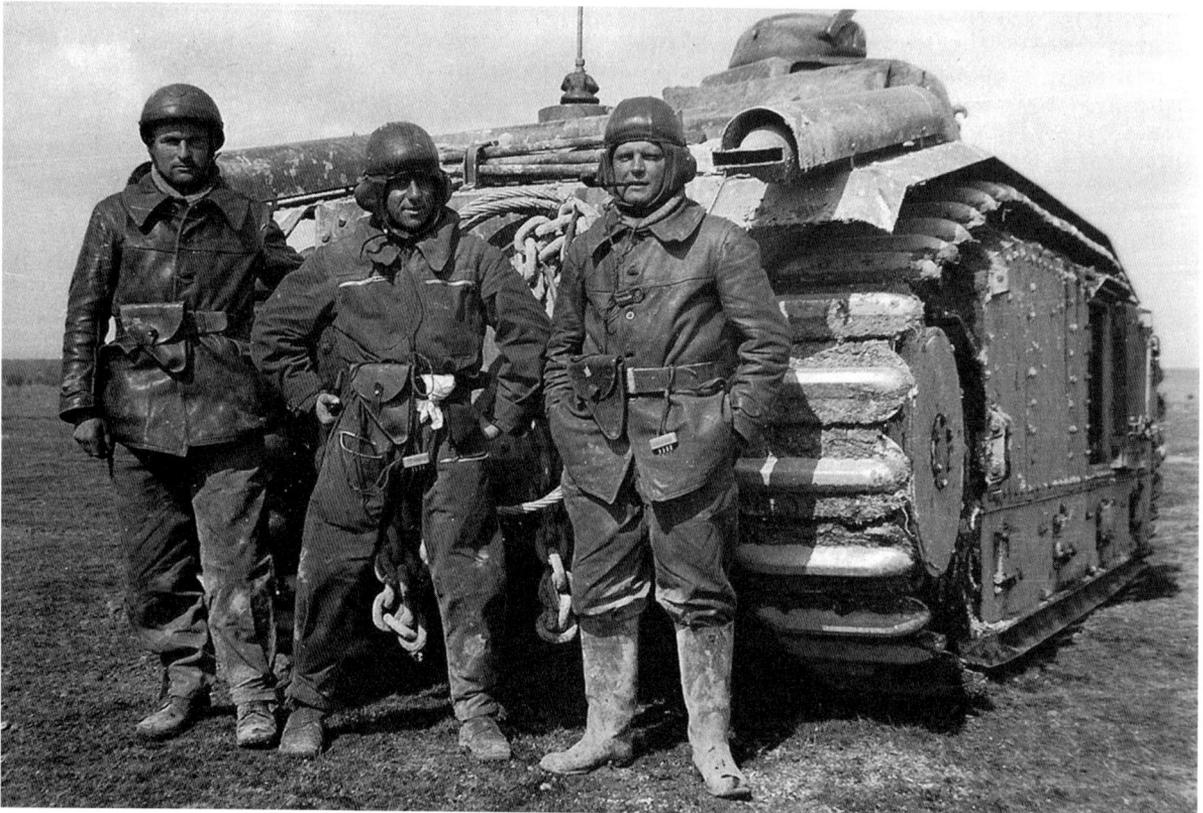

Chapter Two

Shield But No Sword

The French government considered the Maginot Line the jewel in the crown of the country's defences despite the fact that during the First World War Krupp and Skoda howitzers had smashed forts from Belgium to the Urals. It was at Verdun that the Germans tried to deliver the French Army a body blow from which is could never recover. Fought on the hills of north-eastern France just north of Verdun-sur-Meuse, the battle lasted from 21 February to 18 December 1916.

Within the French Army Verdun became a byword for slaughter and bravery in equal measure. This bloodbath resulted in over ¼ million dead and at least ½ million wounded. Many of the casualties were victims of the 40 million artillery shells fired by both sides. The battle was popularised by General Robert Nivelle's order of the day on 23 June 1916, 'They shall not pass'. This sentiment still pervaded in France twenty-four years later.

Following the painful political and economic upheavals in the wake of the First World War the French eventually built fixed fortifications along the Franco-German border named after Minister of War, André Maginot. He had argued that if France was to be faced by positional trench warfare again she might as well be well prepared with state of the art ferro-concrete defences. Maginot himself had fought in the trenches during the First World War as an infantry sergeant so had seen the horrors first-hand. He proposed defensive works following the French border from the Channel to the Swiss border. This was not to be a collection of separate forts but a continuous subterranean defensive line whose only visible features would be retractable steel turrets for the artillery and smaller cupolas for anti-tank guns, mortars and machine guns.

The overall flaw in France's defensive strategy was its lack of manpower and the speed with which it could mobilise its reserve. The Maginot Line was not only intended to deter an aggressor and repel him if necessary, it also had to defend Alsace and Lorraine with fewer and less mobile units while buying time for the reserve call-up. The reality was that France was relying on older and therefore less-fit reservists who would take longer to mobilise and would harm French industrial production once they were back in uniform.

In a stroke France passed the military initiative over to Germany in any future

war. The French also fell down when it came to training. As a result of their fixation with their border defences, many of the troops were only trained to man the static fortifications. This gave them minimal tactical awareness and flexibility when it came to mobile warfare despite Charles de Gaulle's best efforts. When the Germans invaded Poland the French Army shut themselves up in the Maginot Line and waited for the Nazi onslaught.

Despite the German outflanking move of August 1914, in order to avoid offending the Belgians and because of the cost the Maginot plan was modified, halting the defences at Montmedy near the junction of the French and Belgian/German borders. The gap between Liège and Maastricht was covered by the Belgian fortress of Eben Emael, built during the 1930s and thought to be impregnable. Conventional attack on this was all but impossible for as well as being protected by a ditch it was guarded on the German side by the Albert Canal. In addition the Belgians were smug in the knowledge that the Germans had no super heavy artillery that could penetrate the concrete. Unfortunately the two things it could not do were fend off airborne assault or hollow charge demolition mines.

Work on the Maginot Line commenced in 1930 and took seven years to complete at a cost of $200 million, soaking up most of the country's military budget. The defences consisted of an 87-mile-long string of underground forts facing the German frontier which were protected by tank traps, barbed wire and pillboxes. Behind these were rows and rows of concrete gun emplacements armed with machine guns and anti-tank guns. Beyond these were a series of blockhouses designed to slow the enemy down while the garrisons in the main fortresses or ouvrages prepared their defences. At 3 to 5-mile intervals were vast concrete fortresses that extended up to 100ft below the ground.

In reality all the Maginot Line did was tie down large numbers of French troops thereby doing German leader Adolf Hitler a favour. The peacetime French Army consisted of sixty-four line regiments, twelve of which were 'Fortress Infantry' Regiments. In the spring of 1940 they were reorganised into five fortress divisions, which utilised the existing infantry and artillery units supplemented by engineers and signallers. These were purely static divisions with no offensive capabilities and were reliant on other Army units for basic medical and supply services. In total France had to commit thirty-six divisions to hold the Maginot Line in Alsace and Lorraine.

When it was built, where money permitted, the Maginot Line was state of the art with the defences varying in depths of anything from 12 to 16 miles deep. The main line of resistance began about 6 miles from the border and comprised infantry casemates or bunkers and ouvrages of varying sizes. The main fortresses were the anchor stone of the Maginot Line and were blast-proof and contained the heaviest artillery. Like self-contained battleships, each had generators, ventilation, stores, water storage and contained barracks and mess halls for up to 1,000 men. They

were linked by field telephones in order to coordinate fields of fire. Beyond these were infantry reserve shelters and natural flood zones. In total the line included almost 600 ouvrages and casemates as well as 5,000 blockhouses.

While the Maginot Line may have been state of the art, like all underground structures if the sump pumps and air conditioning were not maintained it became damp and the air stale. Heavy rains often filled the lower galleries with water and mildew grew on the walls. When possible the fortress units often avoided spending the night in their concrete quarters, preferring barracks nearby on the surface. The guns also had to be constantly maintained or they became fouled or froze solid in the cold weather. Likewise the retractable turrets had to be kept clear of debris or they could become jammed and the mechanism damaged.

This mindset that certain terrain was tank-proof and other terrain could be held by concrete and steel fortifications meant that the best mobile armoured units of the French Army were simply not deployed in a manner to enable them to conduct immediate and concentrated counterattacks. This meant that there was every likelihood of the light mechanised divisions and new tank divisions being flung piecemeal into battle only to be swamped by superior concentrations of enemy tanks. Most of France's armoured commanders were ineffective and the outnumbered British tank force was not in a position, except for one outstanding effort, to make a decisive contribution to the battle for France. France had a shield but no sword with which to strike back.

After September 1939 the French and British forces worked to extend the Maginot Line to the coast. In the event France's static defences saw very little action. When the Germans overran France's border defences with Belgium they captured several forts in the Maubeuge area held by the French 101st Fortress Infantry Division. On 19 May 1940 south-east of Sedan the German Army captured petit ouvrage La Ferte after an attack by combat engineers support by heavy gunfire. The entire garrison was killed during the assault.

Thanks to the Blitzkrieg the Maginot Line was cut off from the rest of France by early June. The Germans then attacked the line between St Avold and Saarbrücken in mid-June as well as attacking defences in northern Alsace and the Vosges Mountains. Significantly although some of the forts were attacked from the rear, the Germans were unsuccessful in capturing any of the main fortifications. Although some garrison commanders were prepared to hold out, the French surrender forced them out of the Maginot Line and into the hands of the Germans.

Although the fortifications had deterred a direct attack, they were rendered strategically redundant by the German invasion through the Low Countries. The likes of de Gaulle who had argued that mobile armoured formations not static concrete defences were the way forward can have taken little pleasure in being proved right.

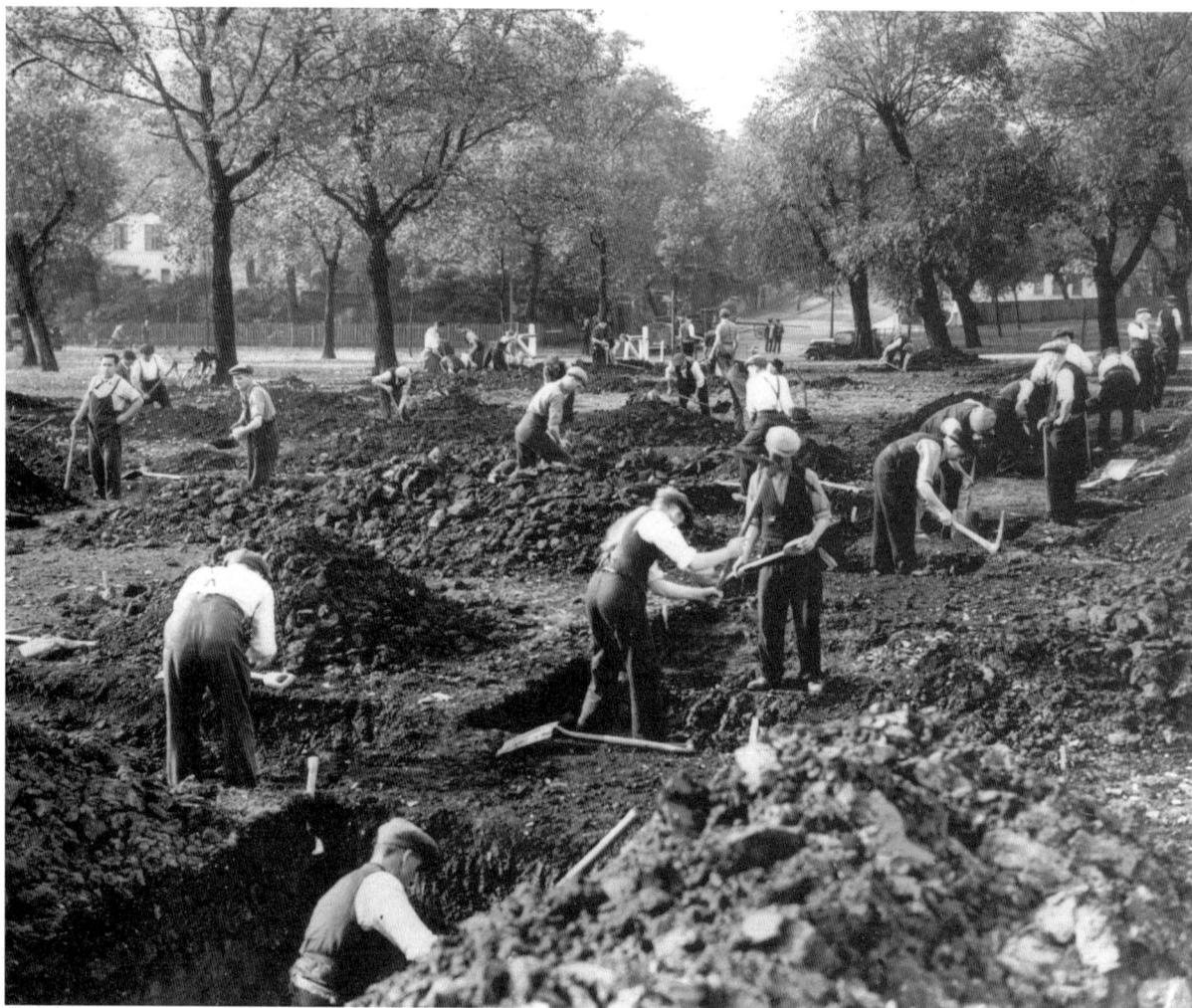

French workers laying the groundwork for France's defences. Through the 1930s France embarked on a massive programme to create the concrete fortifications of the Maginot Line facing the German border. This was considered the jewel in the crown of the country's defensive measures that sought to emulate the stronghold of Verdun, which had held out against the Germans during the First World War.

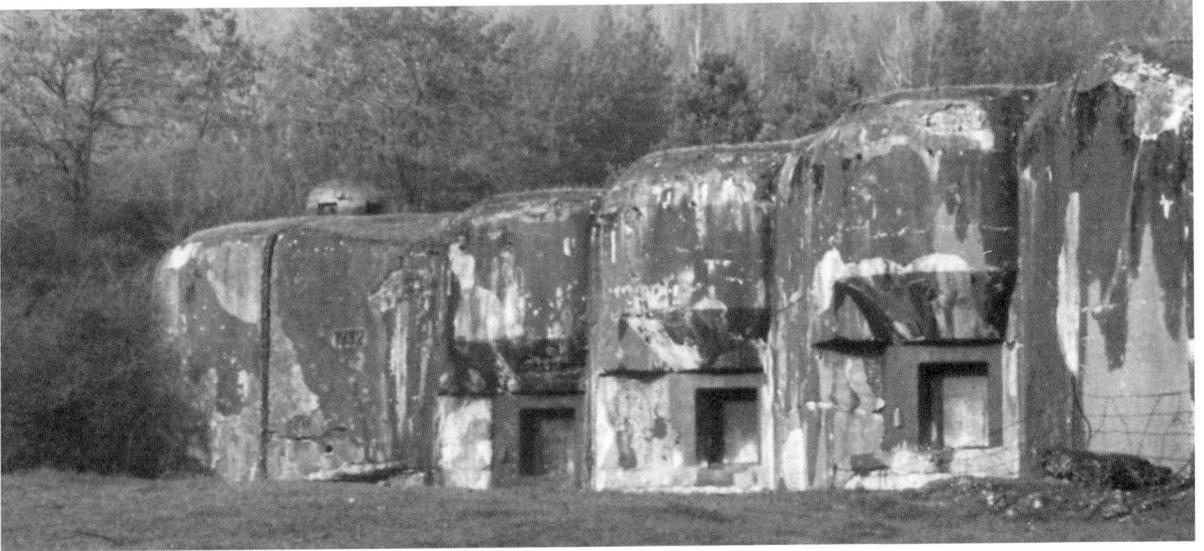

It was hoped that the concrete forts such as the ones seen here would deter Germany from ever attacking France again. While the subterranean defences of the Maginot Line were elaborate consisting of massive fortresses, underground tunnels and weapons cupolas, General Heinz Guderian's panzers simply drove through the unprotected Ardennes sector.

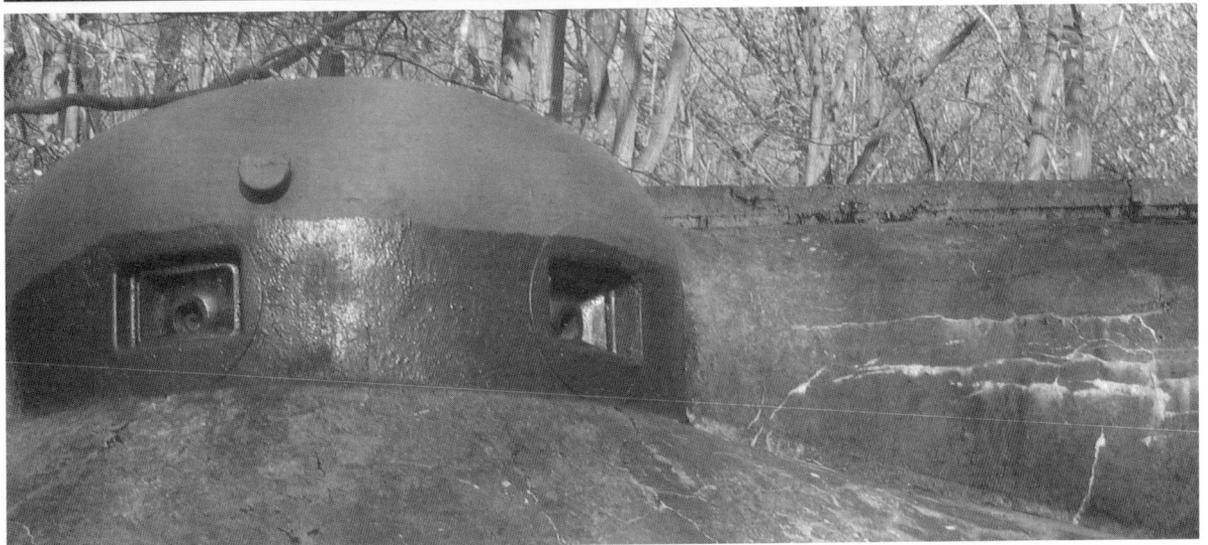

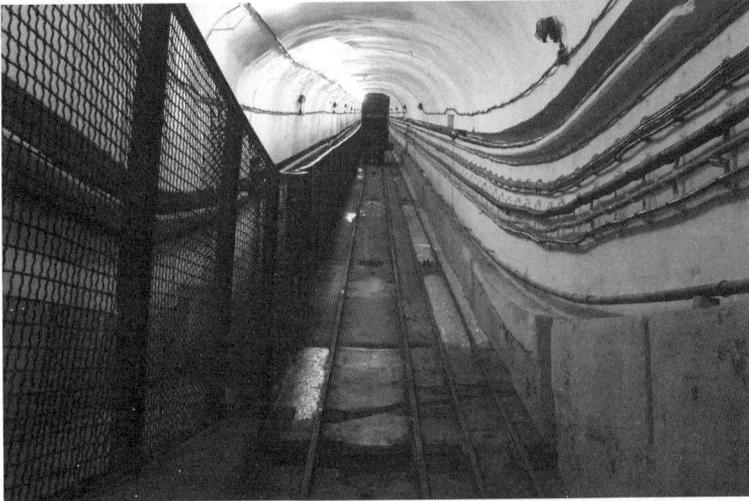

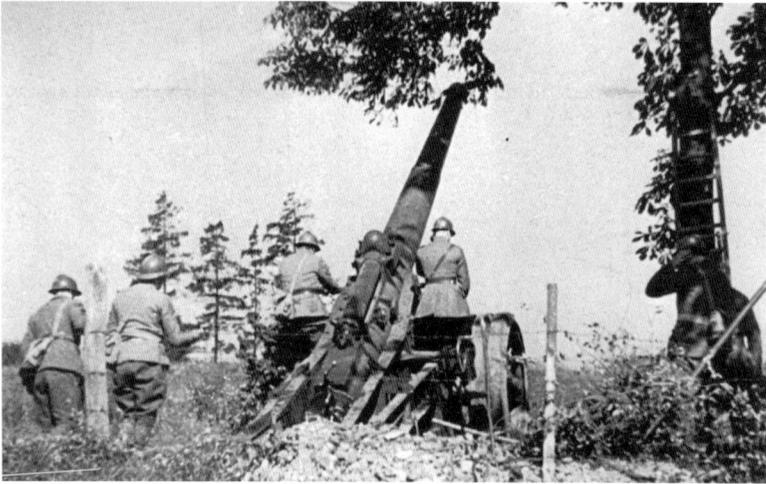

This looks like a scene from the First World War but the photograph was actually taken in early October 1939. This heavy French gun is in the Strasbourg area shelling German positions on the far side of the Rhine. The French Army not only deployed troops in the Maginot Line but also behind it such as this heavy field gun. Two whole French army groups were tied up holding France's fixed defences while another was earmarked to help defend the Low Countries.

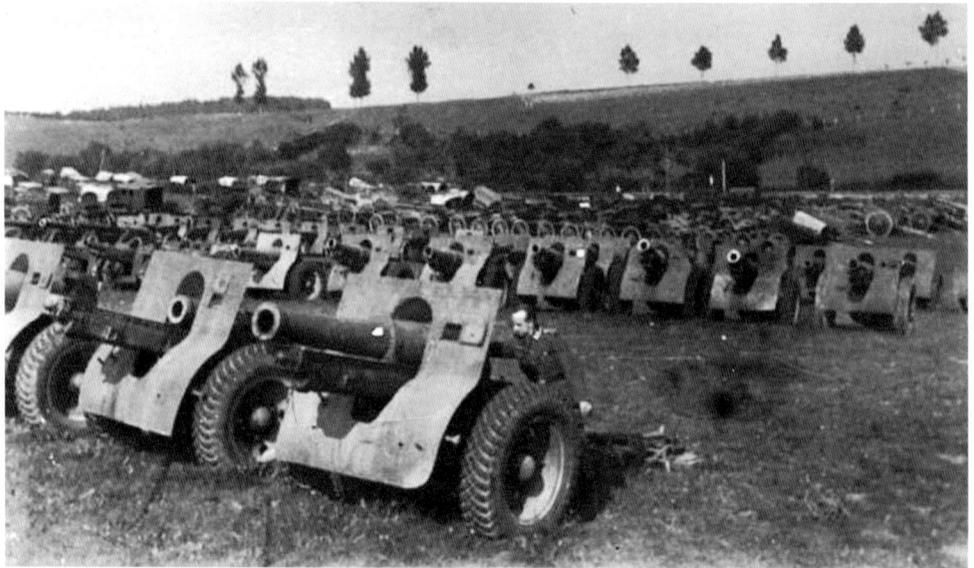

The French had plenty of artillery but the doctrine for their deployment was very inflexible – these shots show howitzers and mountain guns respectively. The weapons in the second row of the photograph to the left are 1937 Puteaux 47mm anti-tank guns, and the French Army was also equipped with the 1934 Hotchkiss and 1937 Puteaux 25mm anti-tank guns – both of which were obsolete. Most French units were up to 50 per cent below their establishment for anti-tank weapons.

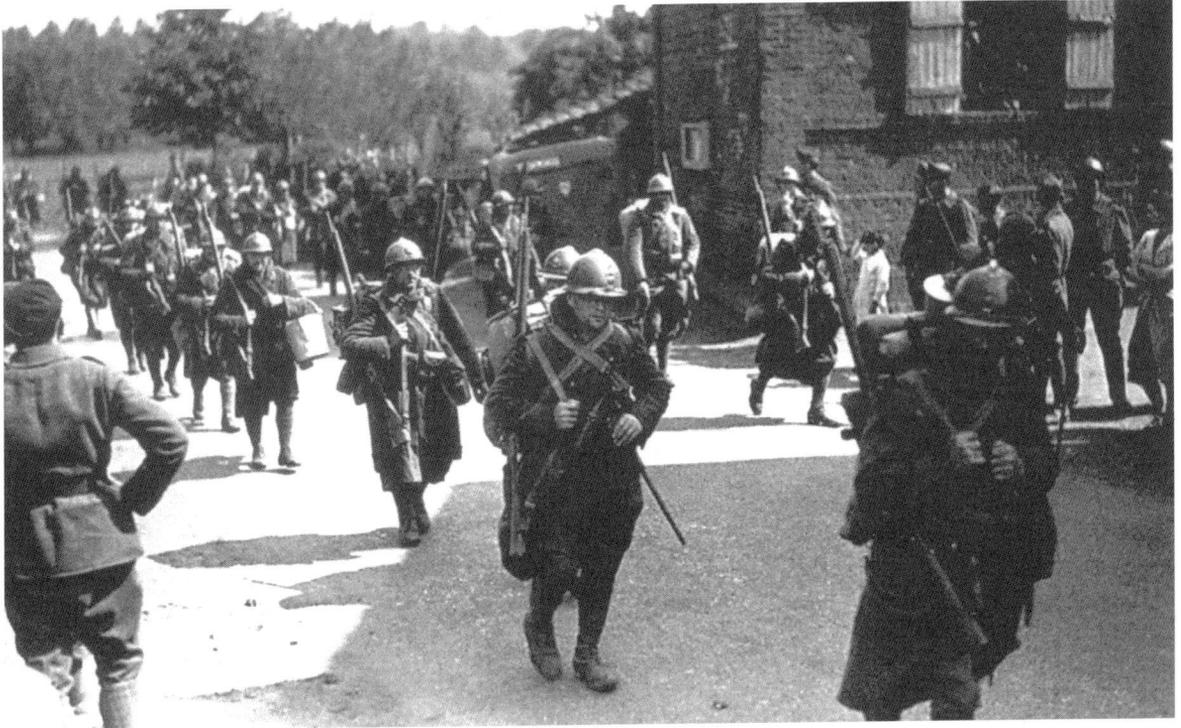

The basic French Army uniform had changed very little since the First World War. The most common type of helmet was the M1926 which was a direct descendant of the 1915 Adrian helmet worn during the First World War – however, there were also M1935 and M1936 pattern helmets. The most common type of rifle was the MAS36.

In opposition to the Maginot Line the Germans built their second Siegfried Line along the western frontier of Germany. This would eventually come into use in 1944–5.

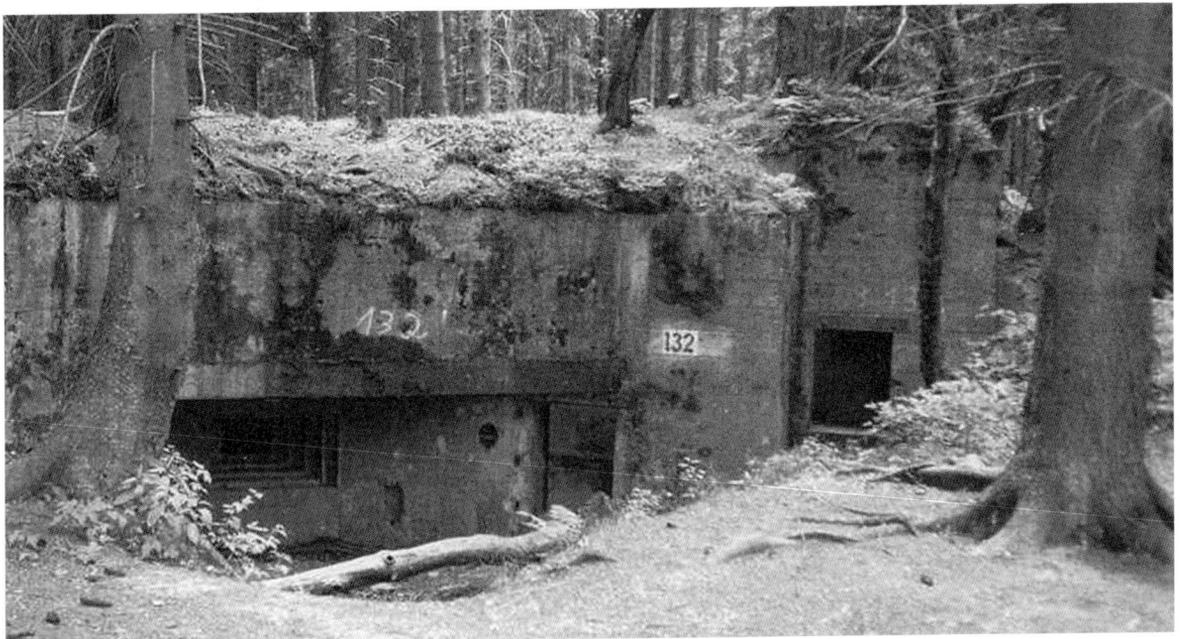

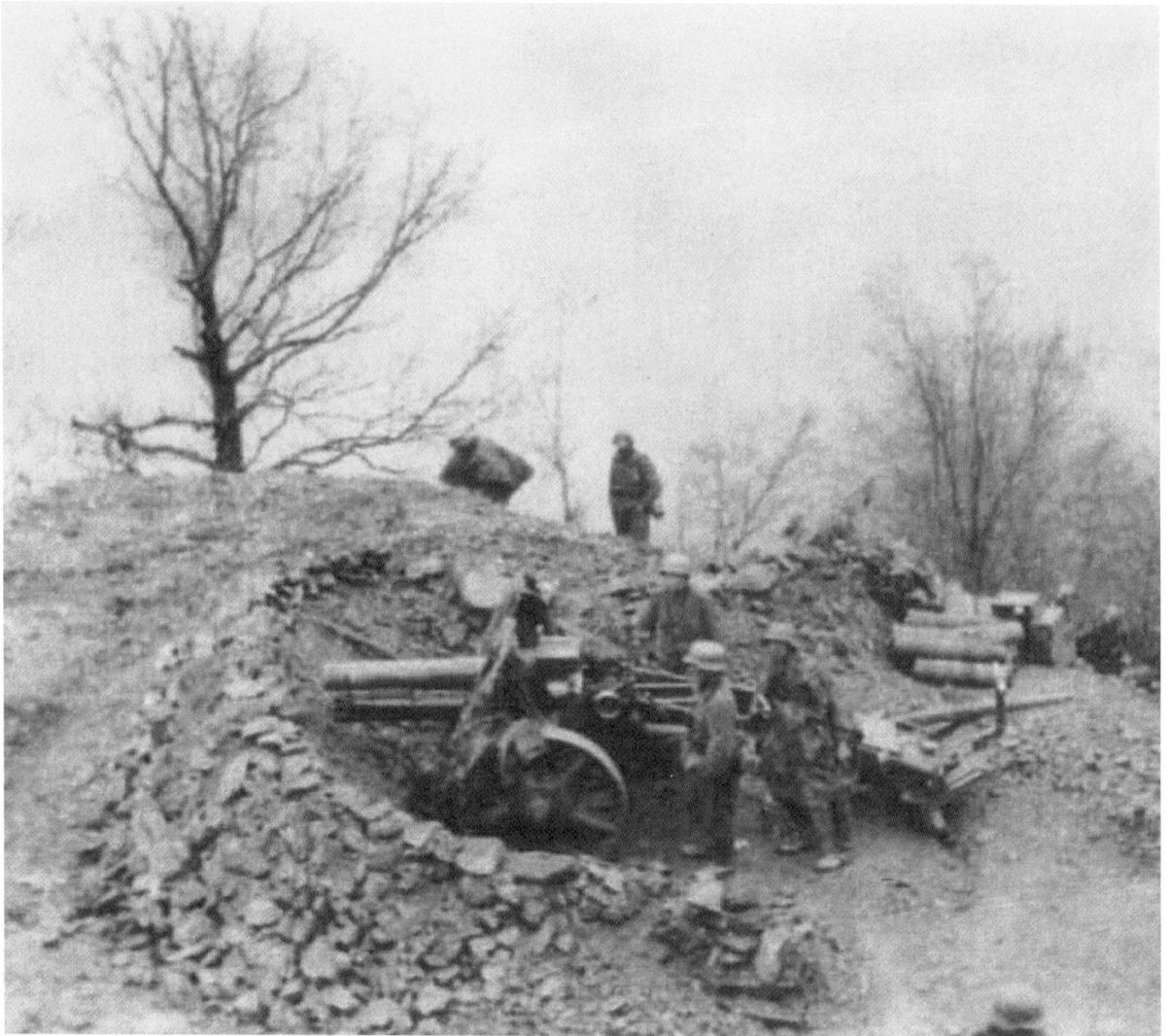

An emplaced German howitzer – the Phoney War of 1939 was characterised by intermittent shelling and patrolling. The German armed forces had to keep units in the shape of Army Group C's eighteen infantry divisions in front of the Maginot Line, while Army Groups B and A made their right hook through the Low Countries and the Ardennes.

Snow-covered French FT-17 light tank and French field guns. During the winter of the Phoney War, 1939–40, the British and French armies were largely inactive while gaining a false sense of security from the defences of the Maginot Line. During the spring of 1940 France's fortress infantry regiments were reorganised into five fortress divisions.

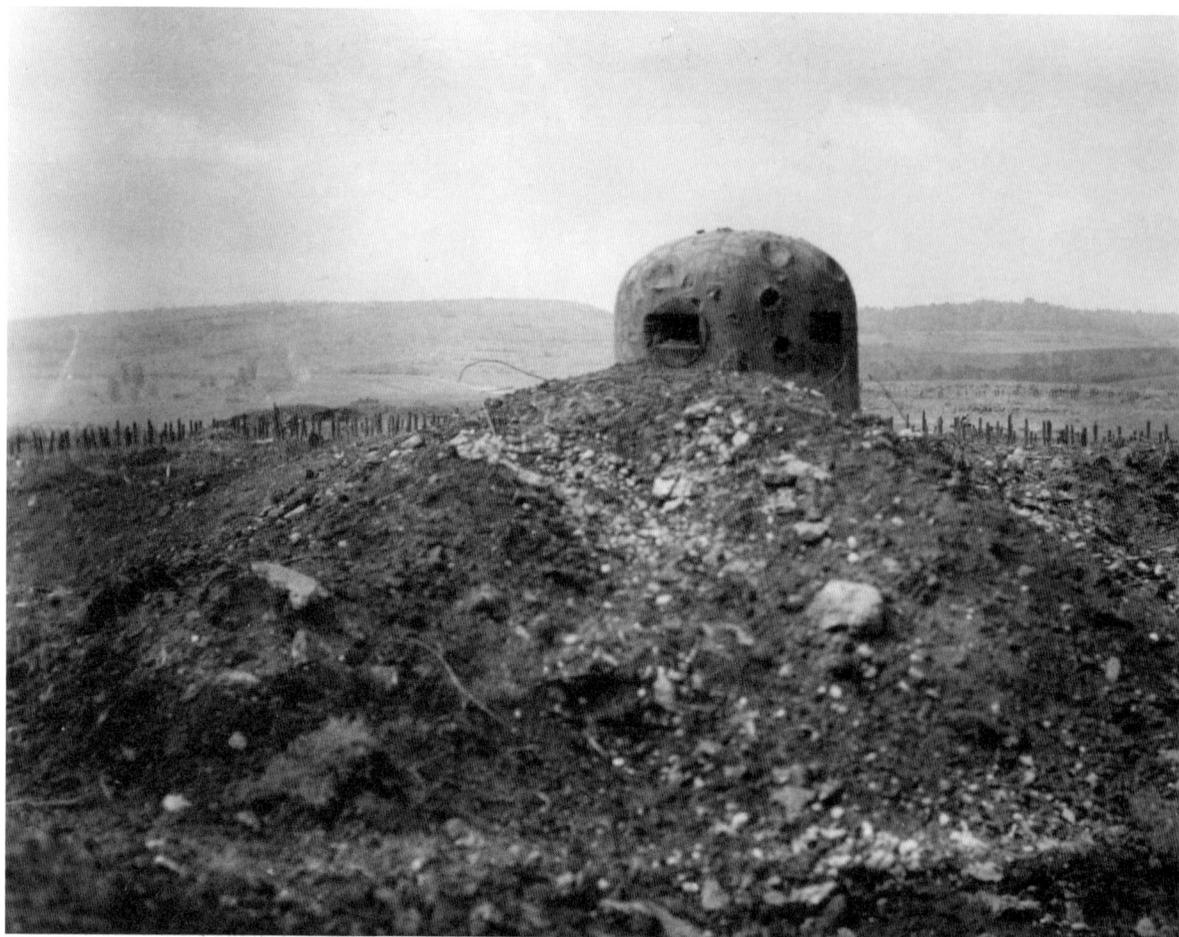

Although largely ignored by the Germans, this was the fate of some of the Maginot's Line's strongpoints. This particular observation cupola has survived a series of direct hits while the ground around it has been churned up by the heavy shelling.

Chapter Three

The British Expeditionary Force's Matildas

By May 1940 Britain only had a single armoured division and this was still undergoing training at home. In the meantime deployed to France was the 1st Army Tank Brigade consisting of two battalions of 'I' or Infantry tanks. Also with the BEF were seven light armoured regiments equipped with light tanks. Their task was reconnaissance similar to the traditional cavalry role.

On 9 May 1940 the BEF had a total of 210 light tanks with the light armoured regiments and 100 'I' tanks with the 1st Army Tank Brigade. An additional 174 light tanks and 156 new cruiser tanks with the 1st Armoured Division were ready to cross the Channel as battle commenced. Nonetheless the greatest thing that hampered both the British and the French armoured forces was lack of training and experience. In contrast the German panzer crews had cut their teeth in Poland and knew exactly what they were doing.

The French Chief of staff was General Gamelin, while General Georges was his theatre commander for the North-east Front. Georges organised his forces with General Huntziger's 2nd French Army on the coast, then General Gort's BEF, followed by Corap's French 9th Army, with Blanchard's French 1st Army on the Meuse and Sambre and finally Giraud's 7th Army covering Sedan. On paper these forces looked impressive, but their lack of flexibility and mobility was to be their undoing.

Britain's paucity of tanks at the outbreak of war was a glaring deficiency for the British Army. Those tanks available were too lightly armoured and their guns lacked a punch capable of tackling Hitler's panzers on anything like equal terms. Most of the BEF's tank strength was made up of the Mk VIB light tank armed with two Vickers machine guns, which went into production in 1936. Although designed as a reconnaissance tank, it was often used in a cruiser role, and its inadequate armour and armament invariably lead to heavy losses when facing anything heavier than a Panzer I. They served in the 1st Army Tank Brigade's Headquarters.

The much heavier Matilda I (A11) Infantry Tank was also first delivered to the

British Army in 1936. It was a fine example of penny-pinching utilising a lorry engine and initially the suspension kept shedding the tracks. The first batch of 60 was ordered in April 1937 later increasing to 140, all of which had been delivered by the summer of 1940. Like the Mk VI, it was armed with just a machine gun and was not capable of withstanding the panzers.

In contrast the Matilda Mk II Infantry Tank was the exception in the British inventory. Designed in the mid-1930s by Colonel Hudson's team at the Mechanisation Board, it benefited from work conducted on the A7 medium tank, which never saw the light of day. In late 1937 165 Matilda IIs were ordered, but due to the shape and size of the armour castings the tank was not easy to mass-produce. When war broke out in 1939 there were just two in service. Although heavily armoured, some 78mm on the front (this was more than twice that of the Panzer II and III), cross-country it was slow and its 2-pounder (40mm) main armament lacked real penetrating power.

Within the 1st Army Tank Brigade three battalions of the Royal Tank Regiment (RTR) were to be equipped with the Matilda II, consisting of the 4th at Farnborough, 7th at Catterick and the 8th at Perham Down on Salisbury Plain. Unfortunately the only unit ready to be shipped to France was the 4th Battalion equipped with fifty Mk I Infantry Tanks and seven Mk VI light tanks. Production of the Matilda II remained grindingly slow and it was not until the eve of the German Blitzkrieg that the 1st Tank Brigade HQ and the 7RTR shipped to France. Frustratingly 8RTR was not up to strength and was left behind, but 7RTR arrived on the Continent with 23 Mk IIs, 27 Mk Is and 7 light tanks. The unit commander Brigadier Douglas H. Pratt found himself under the direct control of the Commander in Chief BEF General the Viscount Gort, who had a total of nine divisions under his command.

Two days after the Germans launched their offensive in the West Brigadier Pratt and his men moved toward Brussels. In the meantime over ninety German divisions swarmed into Belgium, France, the Netherlands and Luxembourg. Lacking tank transporters, Pratt's armour was shipped by train while the rest of the Brigade struggled up the line by road. Little did Brigadier Pratt realise what a key role his Brigade was to play in the unfolding disaster that was about to engulf the Allies in northern Europe.

While the air forces of France, Belgium and the Netherlands fielded a large number of aircraft, the RAF initially only had four squadrons of Hawker Hurricanes and two of Gloster Gladiators deployed to France during the period known as the Phoney War from September 1930 to May 1940. These formed part of the Advanced Air Striking Force providing fighter cover for the RAF's Battle and Blenheim light bombers and the Air Component attached to the British Army.

The RAF like the Royal Navy and the Army struggled to secure a share of

government resources during the economic difficulties of the 1930s. In the mid-1930s RAF Fighter Command had been promised at least fifty-three squadrons by 1939. When Hugh Dowding became Commander in Chief in 1936 he found he only had fifteen regular and three auxiliary squadrons. This was expanded to twenty-four regular and six auxiliary squadrons by 1938, but this was still well short of the total envisaged and they were all equipped with a variety of outdated biplanes.

The RAF's Fairey Battle and Bristol Blenheim light bombers were to prove highly disappointing. The Battle only had a single engine and its three-man crew and bomb load ensured that it was slow and vulnerable to flak, while its single machine gun offered little protection against nimble enemy fighters. Nonetheless between 1937 and 1940 2,185 Battles were built and as well as the RAF were also supplied to four other air forces. The twin-engine Blenheim, another export success, also proved vulnerable to flak and enemy fighters.

When Hitler's Bliztkrieg commenced on 10 May 1940 the RAF could muster 2,750 front-line aircraft, but only 1,000 of these were fighters. Once the Nazi attack commenced the RAF moved to assist the French and in the first two days of the Blitzkrieg four more fighter squadrons were sent across the Channel. On the 13th a further thirty-two Hurricanes and pilots flew to France. Four more fighter squadrons were assigned to Coastal Command for convoy protection duties.

Dowding was in the uncomfortable position of having been forced to commit a third of his fighter force to France, which was intended to defend British skies. He was swift to warn the government that on the present rate of attrition within two weeks the RAF would not have a single Hurricane left in France or Britain. He badgered the Air Ministry to specify what level of strength was required to defend Britain. Shortly after British Prime Minister Winston Churchill ordered that no further fighters cross the Channel no matter what France's need.

The Belgians began mobilising just before Hitler attacked Poland and by May 1940 had gathered 18 infantry divisions, 2 divisions of Chasseurs Ardennais (partly motorised) and 2 motorised cavalry divisions, totalling 650,000 men. While they were supported by 1,338 artillery pieces they only had a few French-built AMC 35 light tanks. The standard Belgian anti-tank gun was the 47mm FRC, towed by truck or the tracked armoured Utility B tractor. This gun was much more powerful than the standard German 37mm anti-tank gun.

Belgian combat vehicles also included 200 T13 tank hunters armed with the 47mm anti-tank gun plus a coaxial FN30 machine gun in a turret. The Belgians also possessed forty-two T15s and although dubbed armoured cars, these were actually fully tracked tanks with a 13.2mm turret machine gun.

The Aéronautique Militaire Belge (AéMI – Belgian Air Force) had only just begun to modernise and was equipped with 250 combat aircraft. Less than 100 were

fighter aircraft, with just 12 bombers and 12 reconnaissance aircraft. On 10 May 1940 AéMI had just 50 modern aircraft and only 78 fighters and 40 bombers were operational.

Manpower posed a severe problem for the neighbouring Dutch Army. It could muster 48 infantry regiments and 22 border defence battalions numbering about 400,000 men; in contrast Belgium, despite a smaller and more aged male population, fielded the equivalent of 30 divisions when smaller units were included. The Dutch had a total of 676 howitzers and field guns, not surprisingly just 8 of the 120 modern 105mm guns ordered from Germany had been delivered at the time of the invasion. The Dutch also had 386 Böhler 47mm L/39 anti-tank guns which while effective were too few in number. The Dutch Air Force, which was part of the Army, had just 155 aircraft. All in all on the eve of the German attack things did not look good.

Above and opposite: Following Hitler's invasion of Poland in September 1939 Britain and France found themselves at war with Germany. London's response was to despatch the BEF to support the French armed forces while also preparing the defences of the British Isles, as seen opposite.

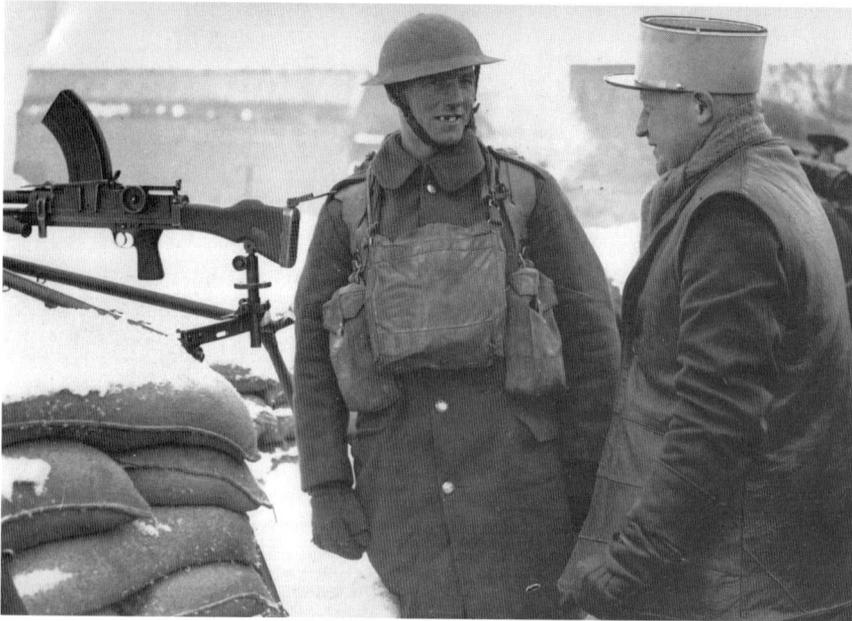

A British and French soldier photographed during the winter of the Phoney War, 1939–40. The British Army committed over a dozen divisions to the defence of northern France supported by an armoured brigade and an armoured division. Within four months of this photograph being taken these men would find themselves on the receiving end of Hitler's Blitzkrieg.

This British gunner has turned a machine gun taken from a German bomber back on the Luftwaffe.

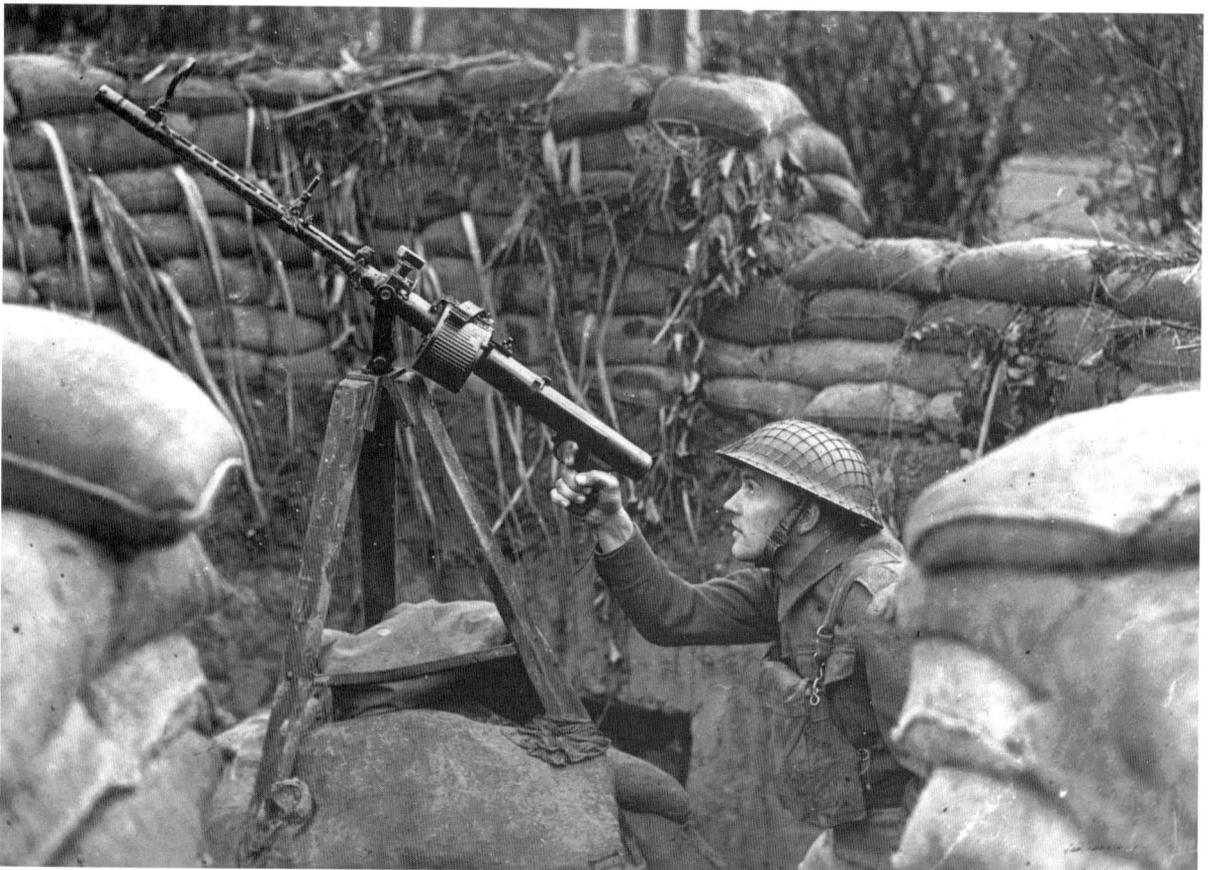

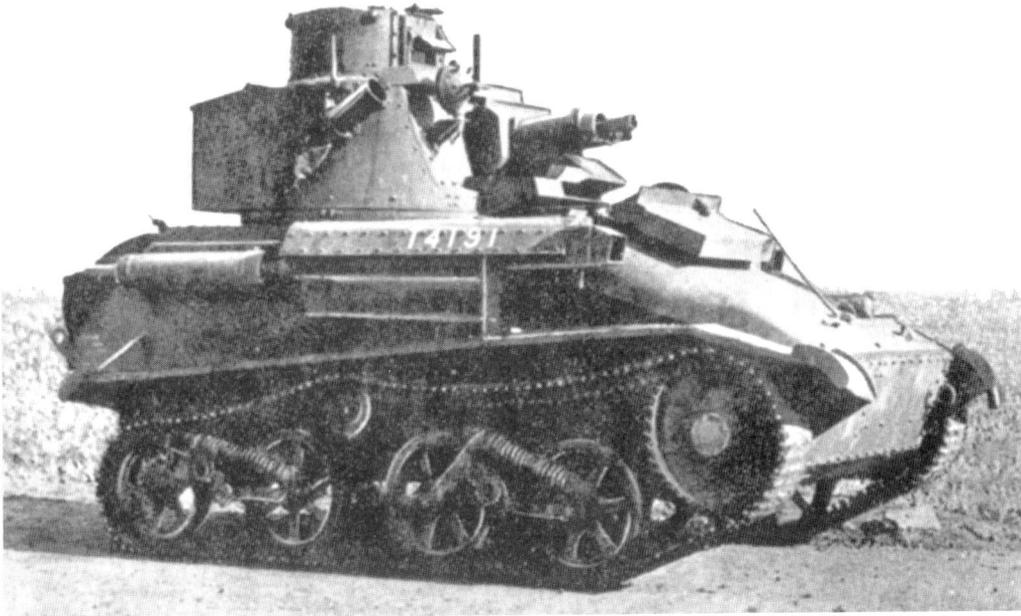

The British Mk VI series of light tanks were numerically the most important armoured fighting vehicles of the British Army in 1939–40. Mk VIBs were deployed with all the divisional cavalry regiments of the BEF and as HQ tanks with the 1st Army Tank Brigade. Likewise Mk VICs formed the bulk of 1st Armoured Division's tank strength due to the delay in the delivery of the newer cruiser tanks.

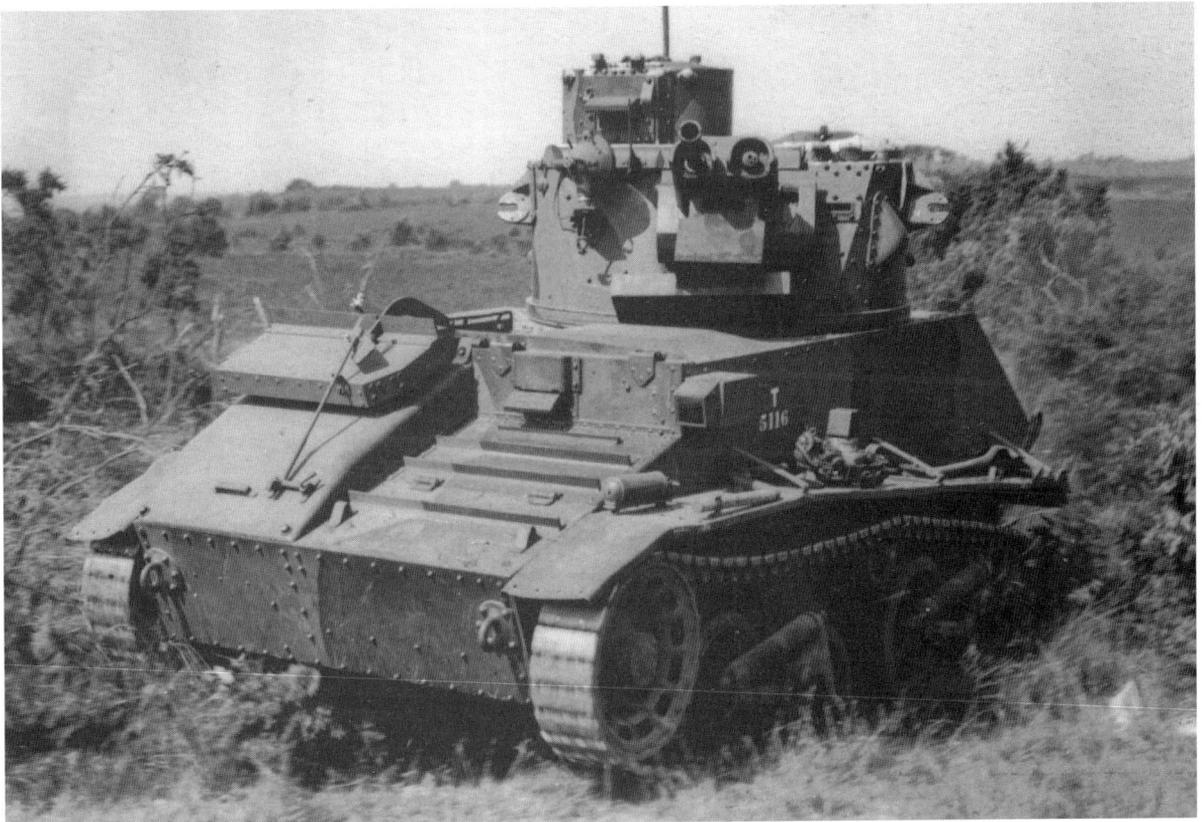

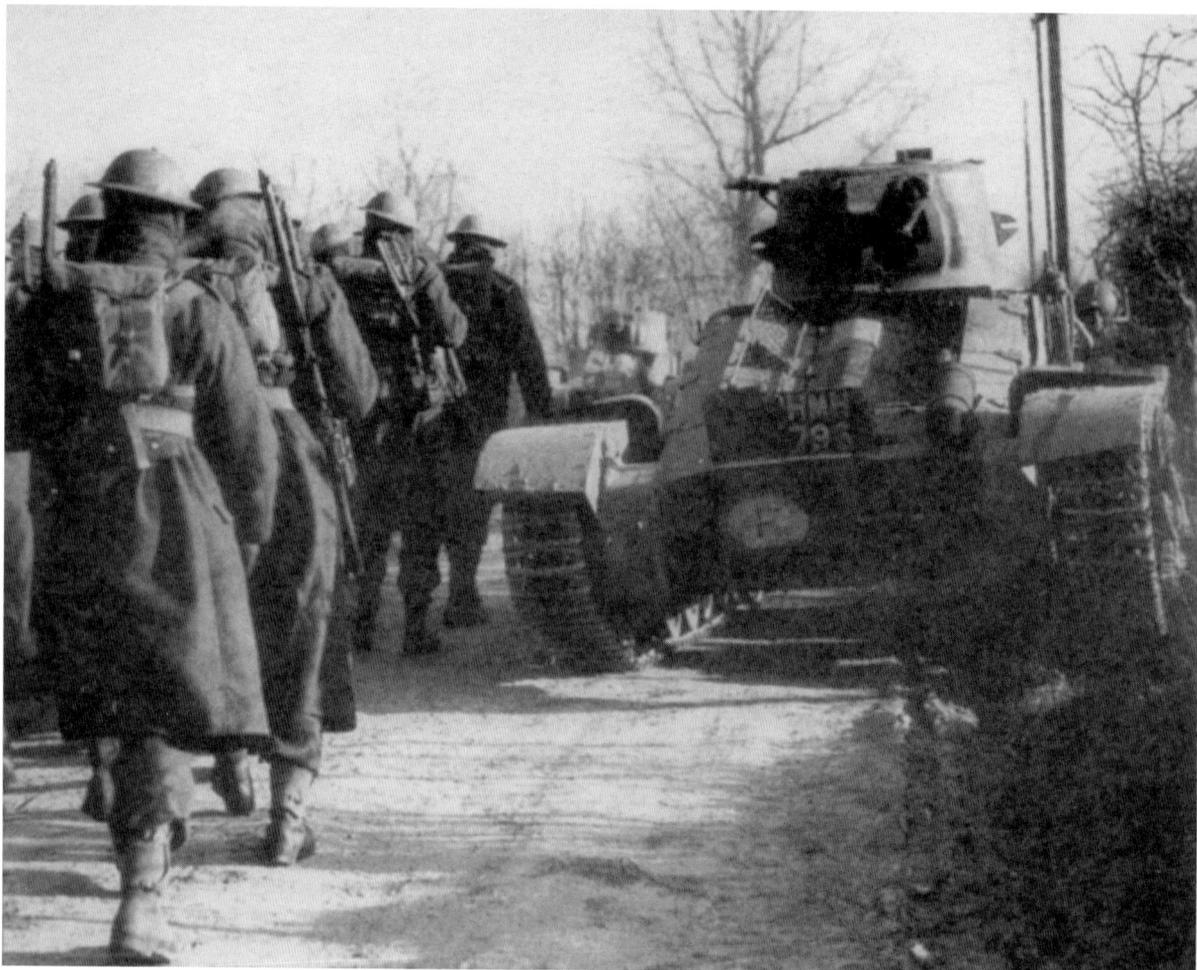

The Infantry Tank Mk I or Matilda I was much bettered armoured than the light Mk VI, but was very slow and again armed with just a machine gun. In 1937 an initial order for sixty was placed with Vickers-Armstrong, and a further sixty were ordered the following year with a final batch of nineteen in 1938. They were used to equip the 1st Army Tank Brigade sent to joint the BEF.

Opposite: In 1940 the Matilda Mk II Infantry Tank was the heaviest in British service, but was not available in sufficient numbers. The early production Matilda II deployed to France is instantly recognisable by the large Vickers machine gun on the left-hand side of the turret, rather than the smaller Besa 7.92mm fitted in the later Mk IIA seen in the photograph below.

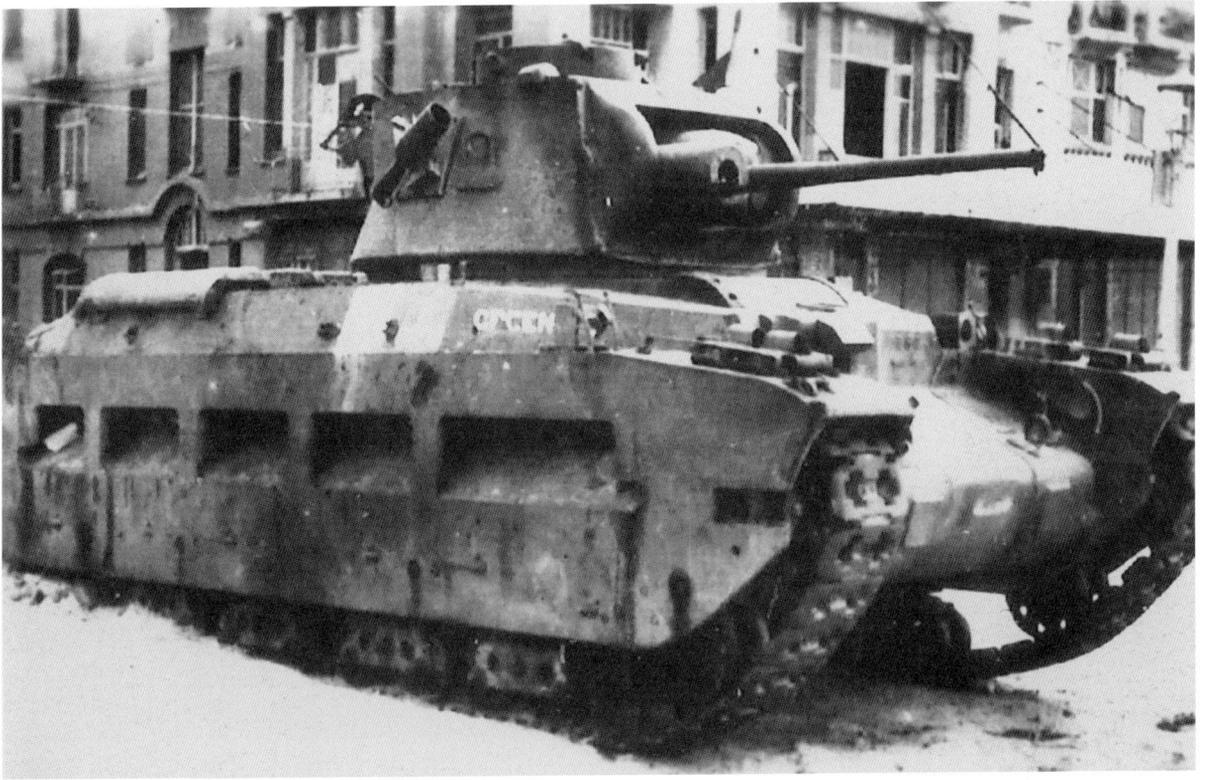

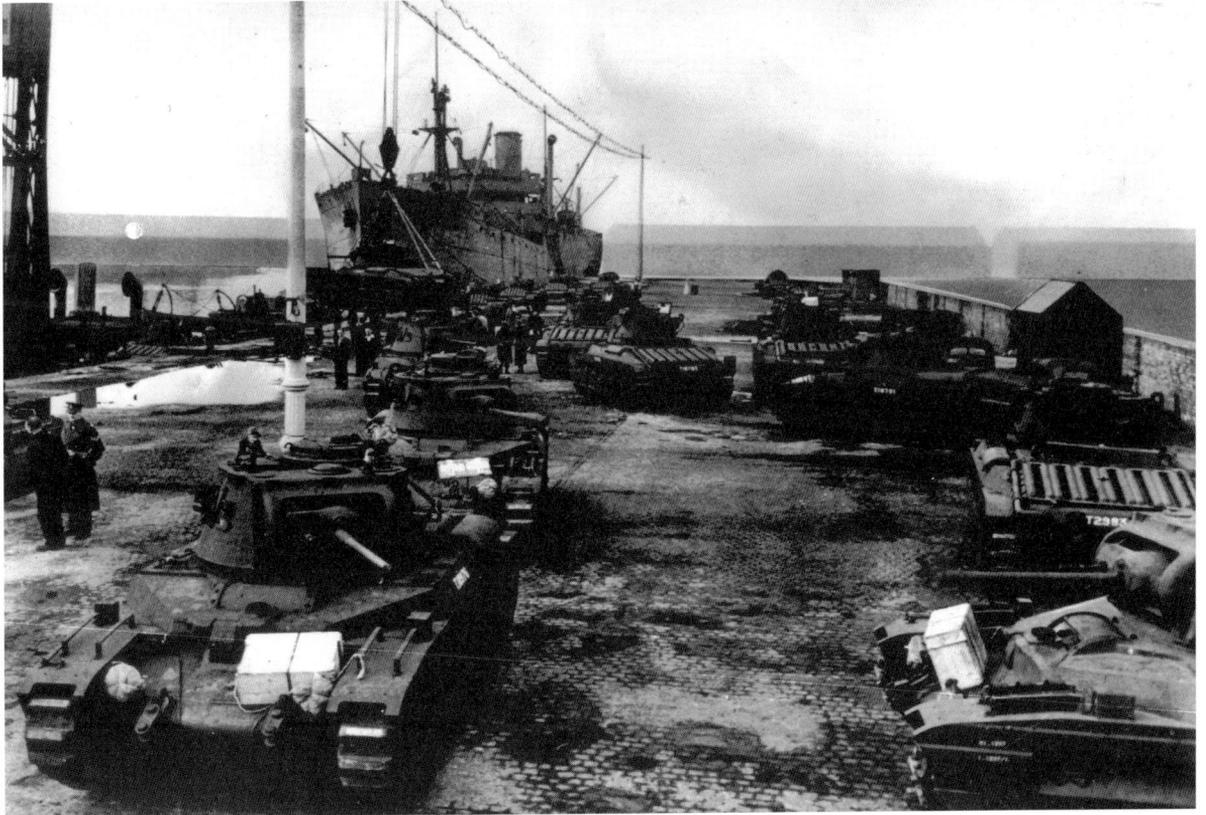

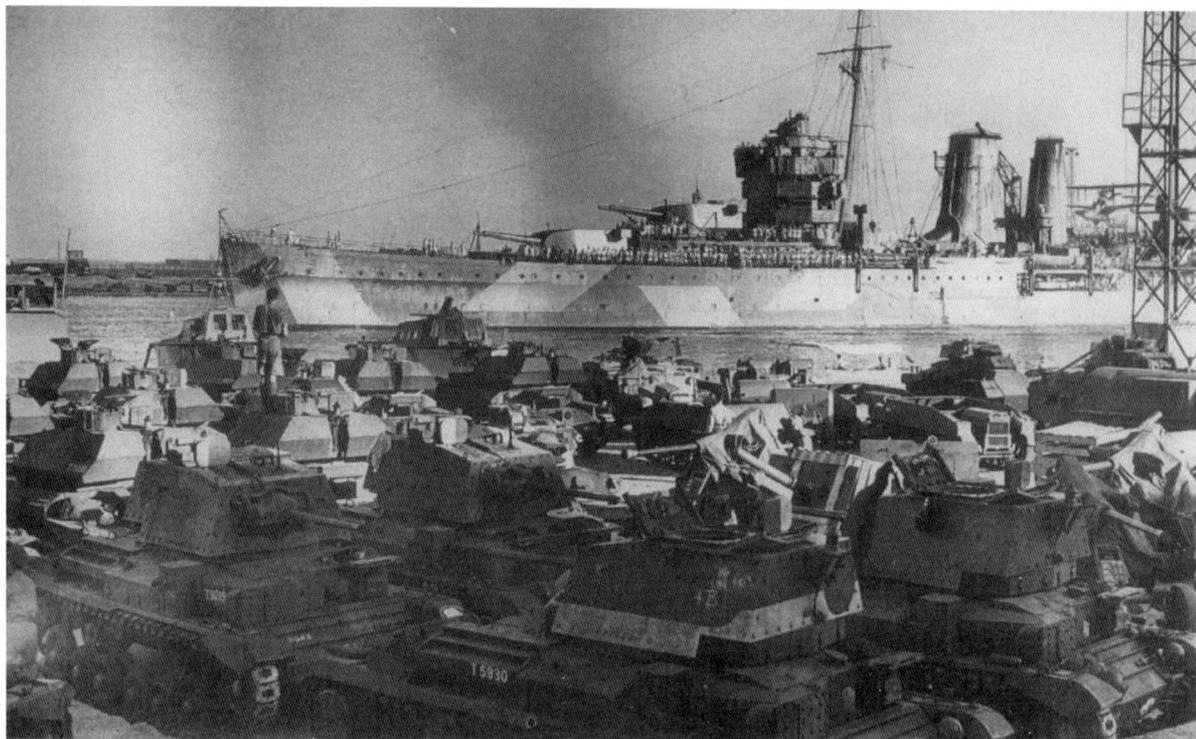

The British 1st Armoured Division was equipped with the Mk I (A9), Mk II (A10), Mk III (A13) and Mk IV (A13 Mk II) cruiser tanks, all of which saw service in France. It had been planed to arm them with a 3-pounder or 47mm gun but they ended up with the new 2-pounder or 40mm which had a higher muzzle velocity. Depending on the model, maximum thickness of the armour ranged from 14mm to 30mm. These particular Mk IIs were delivered to Alexandria for operations against the Italians.

These cruiser tanks Mk IVA (A13) belong to the 2nd Royal Tank Regiment of the 1st Armored Division deployed to France in 1940. This was essentially an uparmoured version of the Mk III and is identifiable by the V-section armour plating on the side of the turret. In addition the Mk IV and IVA are distinguishable by the Vickers and Besa machine guns mounted in the turret.

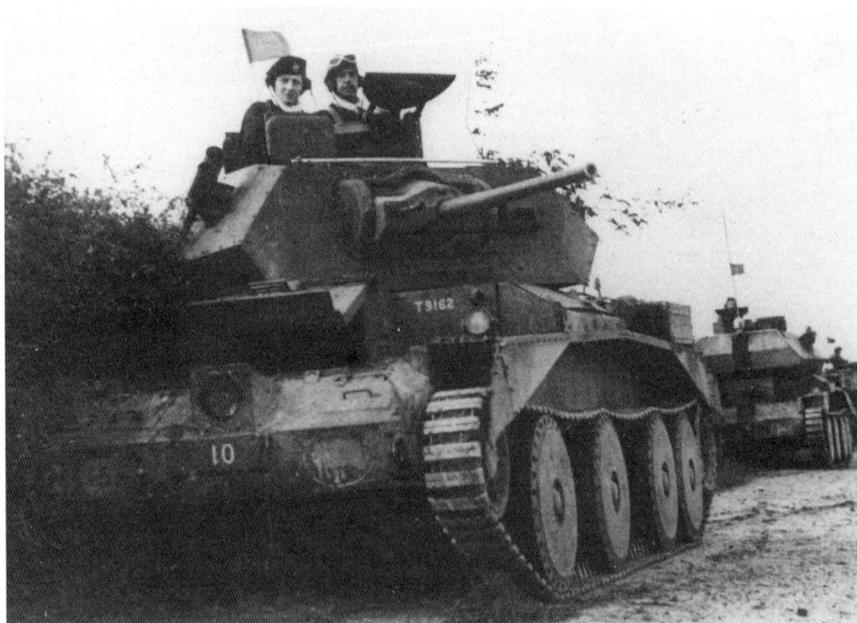

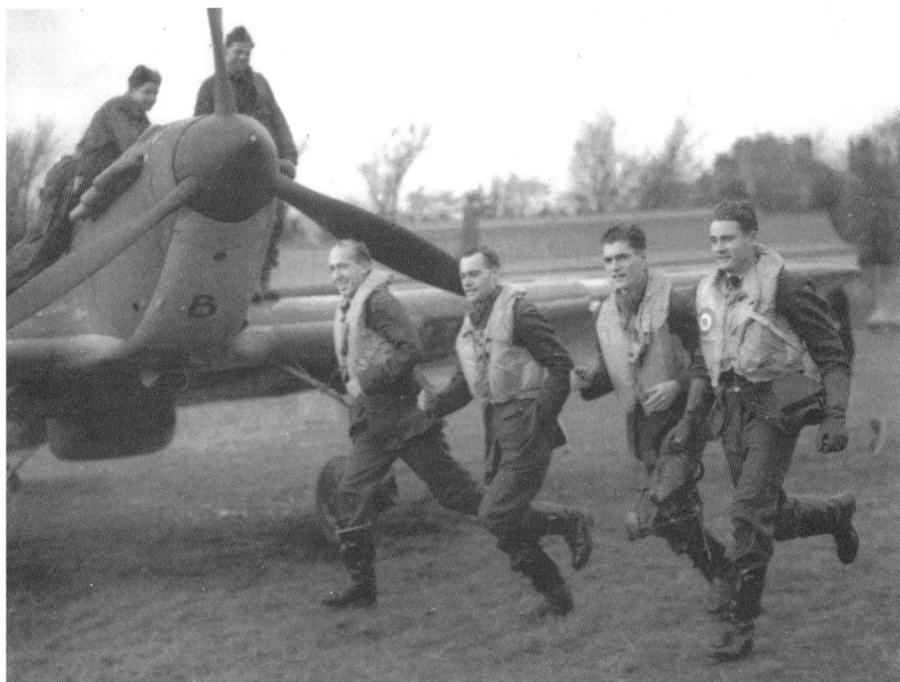

Initially the RAF had just four squadrons of Hurricane and two squadrons of Gloster Gladiator fighters deployed to France during the Phoney War. The tense waiting game would soon be over when the Luftwaffe swung into action.

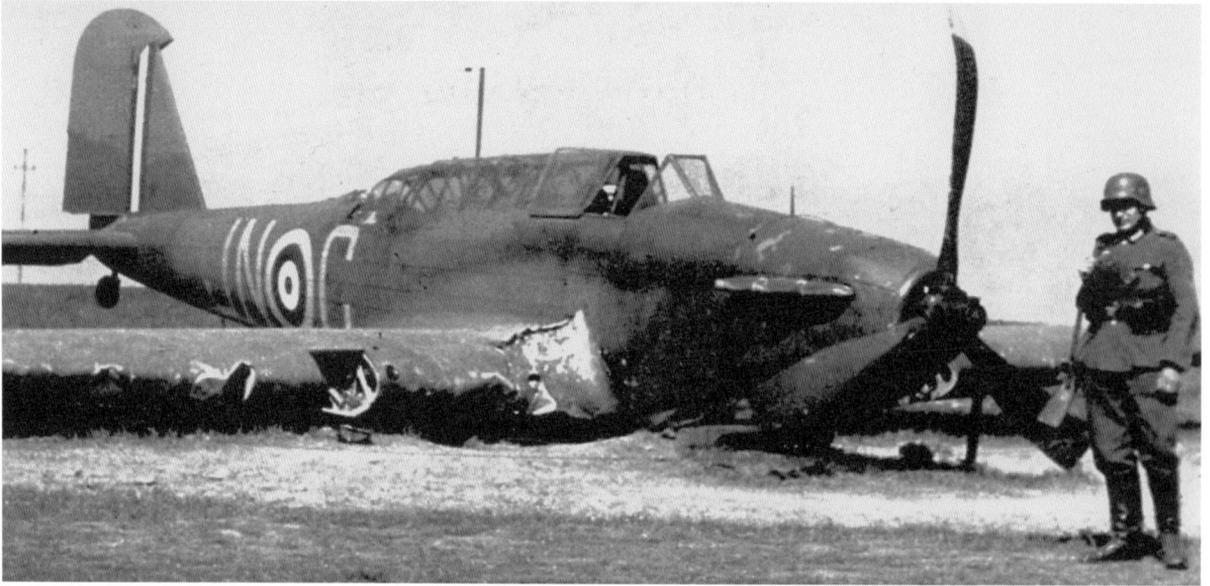

The RAF's slow Fairey Battle (seen here under German guard) and Bristol Blenheim light bombers were to prove very disappointing in France. The Battle had a single engine and easily fell prey to enemy fighters.

French General Maurice Gamelin, the Allied Commander in Chief of Allied forces in France, inspecting Canadian troops in Britain, 29 March 1940. In less than six weeks time the Germans were overrunning the Low Countries and France.

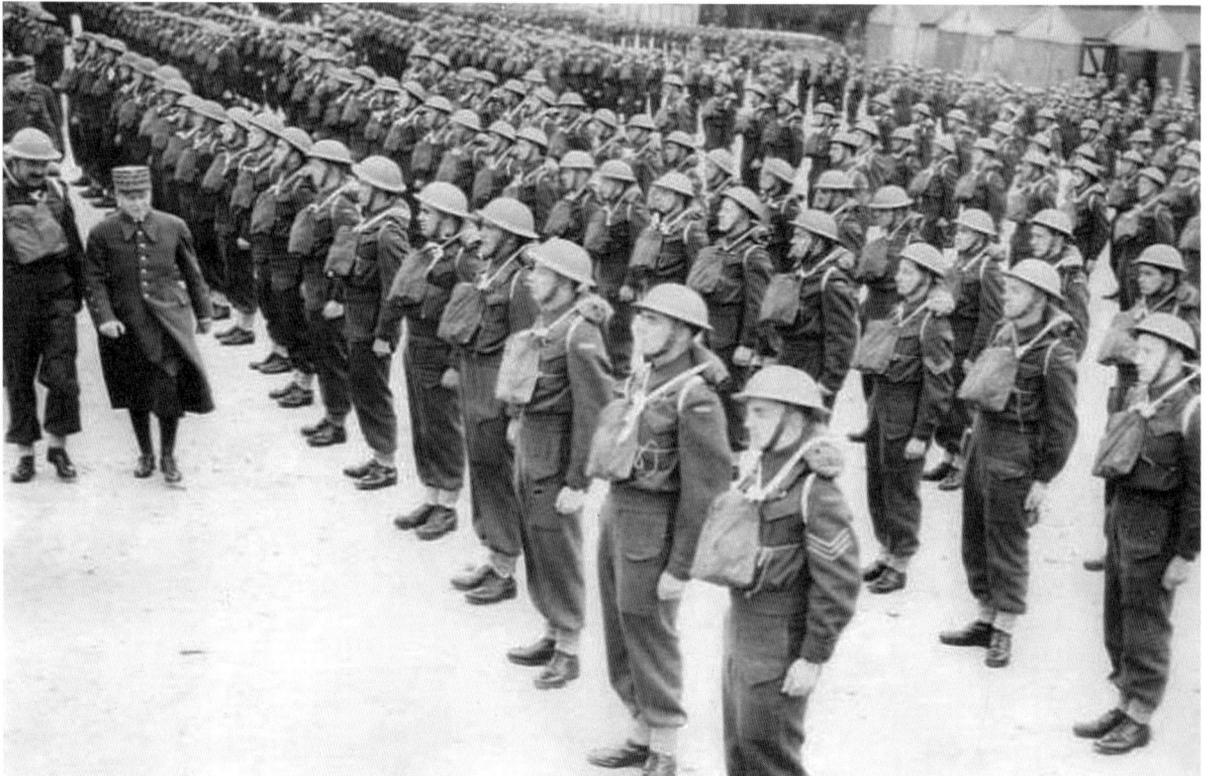

Chapter Four

Guderian's Panzerwaffe

Hitler had 3 million men available for the attack on France supported by around 2,500 tanks and 7,380 artillery pieces. Despite everything that has been said and written in the intervening years about the Blitzkrieg, the German Army was only semi-mechanised. In addition many of its best equipped and elite units were easily offset by the numerous second and third-rate divisions. Some 135 divisions were assigned to the offensive, which included 42 reserve units, however only half the German divisions available in 1940 were combat ready. Only 10 per cent of the German Army was motorised with 120,000 vehicles, compared to the French Army which had 300,000 vehicles. Most German support units were reliant on horse-drawn vehicles.

Hitler's bold plan for his assault on Western Europe relied on deception, power, speed and surprise. Along the front facing the Netherlands and Belgium he massed the thirty divisions of Army Group B which were to strike through the Low Countries in a four-pronged attack. This was really a diversionary attack for Hitler hoped that the British and French would despatch their best troops to assist the Belgians and the Dutch hold their key defences along Belgium's Dyle River.

Hitler's real attack would come further south through the forests of the Ardennes using the forty-five divisions of Army Group A which included most of his armour and motorised infantry. Hitler intended they would cut through the gap between the Maginot Line and the Dyle Line, charge across France to the English Channel then swing north to help Army Group B encircle and annihilate almost 1 million Allied troops that he hoped to trap.

Under the terms of the 1919 Treaty of Versailles the German Army was officially forbidden to possess tanks, and had to train with dummy 'paper panzers'. Secretly it tested equipment in the Soviet Union in order to circumvent the treaty. General Heinz Guderian went to Sweden in 1929 as an observer and gained first-hand experience with Swedish tanks, ironically based on First World War vintage German designs.

Hitler soon found a way round the ban and ordered the production of a dozen Land-Schlepper or 'agricultural tractors' for training purposes, which was in reality the

Panzer I chassis without the turret. When Hitler saw the experimental Panzer Mk I being put through its paces at the Army Weapons Office's Kummersdorf training ground, he turned to Guderian and said, 'That's what I need! That's what I want to have!' The 1st Panzer Regiment came into existence and soon grew into the 1st, 2nd and 3rd Panzer Divisions, with Guderian taking command of 2nd Panzer.

The number of panzer divisions was expanded with the creation of the 4th and 5th as well as four additional panzer brigades. Hitler's Panzer arm needed tanks that combined the right balance of armament, armour and speed, but deliveries of the newly designed Panzer III and IV were slow, which meant relying on the poorly armed light Panzer I and II.

When the storm clouds began to gather across Europe in the late 1930s Hitler knew only too well that German rearmament was far from complete. Despite his grandiose plans, Germany was not geared up for total war. On the eve of the Second World War his armed forces or Wehrmacht had just over 3,300 tanks, of which only 629 were Panzerkampfwagen (PzKpfw) Mk III and IV. These forces were outclassed by France's tanks and vastly outnumbered by Russia's.

General Guderian, commanding the 19th Panzer Corps, records 2,574 tanks were available for the attack on France. The Anglo-French force had in excess of 4,000 tanks. Almost 10 per cent of Hitler's tank force attacking France was in fact of Czech origin. According to Guderian the 1st Light Division, re-designated the 6th Panzer Division on 18 October 1939, deployed 106 Czech PzKpfw 35(t)s, while 228 Czech PzKpfw 38(t)s were fielded mainly with the 7th and 8th Panzer Divisions.

The 7th Panzer Division, commanded by General Erwin Rommel and nicknamed the 'Ghost Division' because it was everywhere, was single-handedly to capture 450 enemy tanks. Czech guns also served the Wehrmacht during the invasion of the Low Countries and France. A Czech 4.7cm anti-tank gun was mounted on the Panzer I chassis and between March 1940 and February 1941 over 200 were converted, and first seeing action in Belgium and France the conversion stayed in service until 1943.

Only at Arras on 21 May did the panzers suffer any real setback, when a depleted French light mechanised division with some 60–70 Somua tanks and a British armoured brigade with another 74 tanks successfully attacked 3 German divisions. Unfortunately in the confusion the British found themselves under attack by the French and knocked out four Somuas before the error was realised. The Germans eventually threw back the Anglo-French counterattack using their 88mm anti-aircraft guns in a dual anti-tank role.

Aside from his panzers another of Hitler's key assets was his air force or Luftwaffe. Under Herman Goering, a former First World War fighter pilot, the Luftwaffe had been building its strength throughout the second half of the 1930s. It had amassed almost 3,000 aircraft by August 1938; this number had increased to

3,750 by the time of Hitler's invasion of Poland on 1 September 1939. Despite losses over Poland and then over Norway in April 1940, the Luftwaffe could muster almost 5,000 aircraft by May 1940. Some 3,900 were assigned to 2 air groups, Luftflotte 2 and Luftflotte 3, which were poised to lead the Blitzkrieg in the West.

Some 1,815 combat, 487 transport and 50 glider aircraft were in support of Army Group B, while Army Groups A and C could call on another 2,286 aircraft. Again thanks to the success of the German Blitzkrieg and the Stuka dive-bomber another fallacy has arisen that the Luftwaffe was primarily focused on supporting the ground forces. In fact less than 15 per cent of the German Air Force was dedicated to close support of the Army in 1939. Fundamental to the Luftwaffe's success was flexibility; it was not tied to supporting the Army so could rapidly switch from a tactical support role to medium-range interdiction and strategic bombing. In contrast flexibility was something the Allies inherently lacked.

The Allies failed to heed the warning signs in Poland: 6 panzer divisions and 4 light divisions with a total of 3,195 tanks spearheaded the advance of 44 divisions into the country. The Luftwaffe swiftly achieved complete air superiority and the ill-equipped Polish Army staggered back before the full onslaught of the Nazi Blitzkrieg. The Poles had few tanks and anti-tank guns and despite the bravery of their cavalry the country was rapidly overrun. The Allies should have made creating their armoured divisions and beefing up their air cover a matter of the utmost urgency during the period of the Phoney War – but it was not to be.

It was during the invasion of Poland that the Germans perfected their concept of Blitzkrieg or Lightning War. In the opening phase the Luftwaffe's dive-bombers and medium bombers would strike enemy airfields and troop concentrations, roads, railways and bridges causing chaos and confusion. Then their forces would advance to contact, and under the cover of dive-bombers and a smoke screen reconnaissance units would speed towards enemy positions probing for weak points in their defences. In their immediate wake came the panzers and motorised infantry carried in armoured halftracks.

Once in contact, while outlying enemy forces were being engaged, the reconnaissance units would dash for the enemy's administrative and industrial centres. These they would bypass cutting them off ready for the main assault delivered by their infantry and artillery. Once again the Luftwaffe would strike bombing factories and communication centres. The reeling enemy ground forces would soon find themselves enveloped and cut off from outside help leaving one outcome – defeat. Any counterattacks were usually easily crushed by the concentrated power of the panzers and the Luftwaffe. The Allies singularly failed to learn from this.

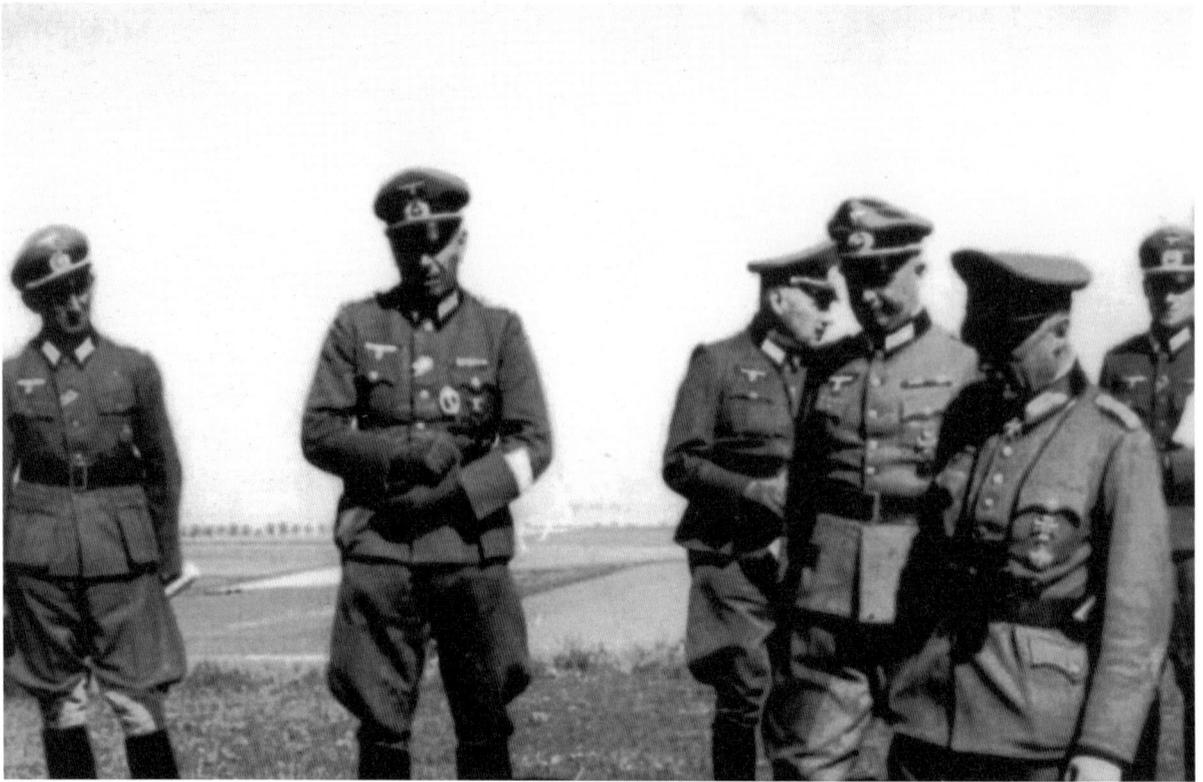

After overwhelming Poland
the German high command
was confident that it could
tackle the French Army.
General Heinz Guderian,
seen right, commanded the
19th Panzer Corps for the
attack on France. His would
be the decisive blow.

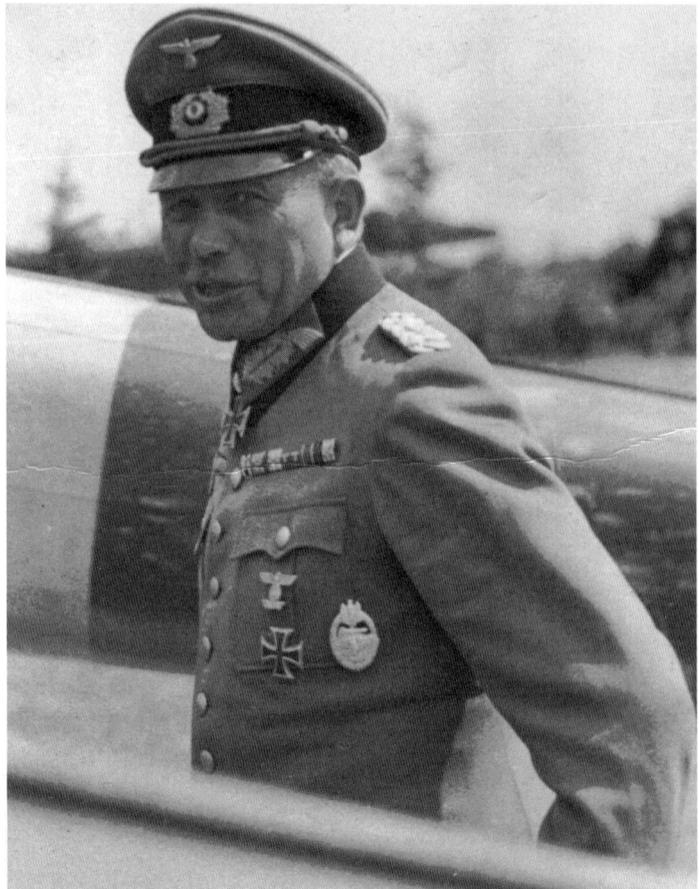

This was the tank that gave rise to modern armoured warfare and led to a tank arms race. Over 500 Panzer Mk Is took part in the campaign in the West. In the 1930s the German firms Daimler-Benz, Henschel, Krupp, MAN and Rheinmetall were asked to prepare prototypes similar in concept to the British Vickers-Carden-Loyd light tanks. The Krupp design became the PzKpfw IA followed by the Ausf A – both types were combat tested during the Spanish Civil War.

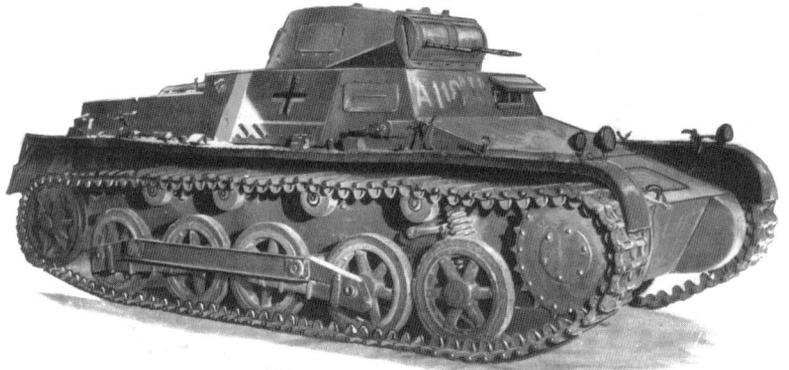

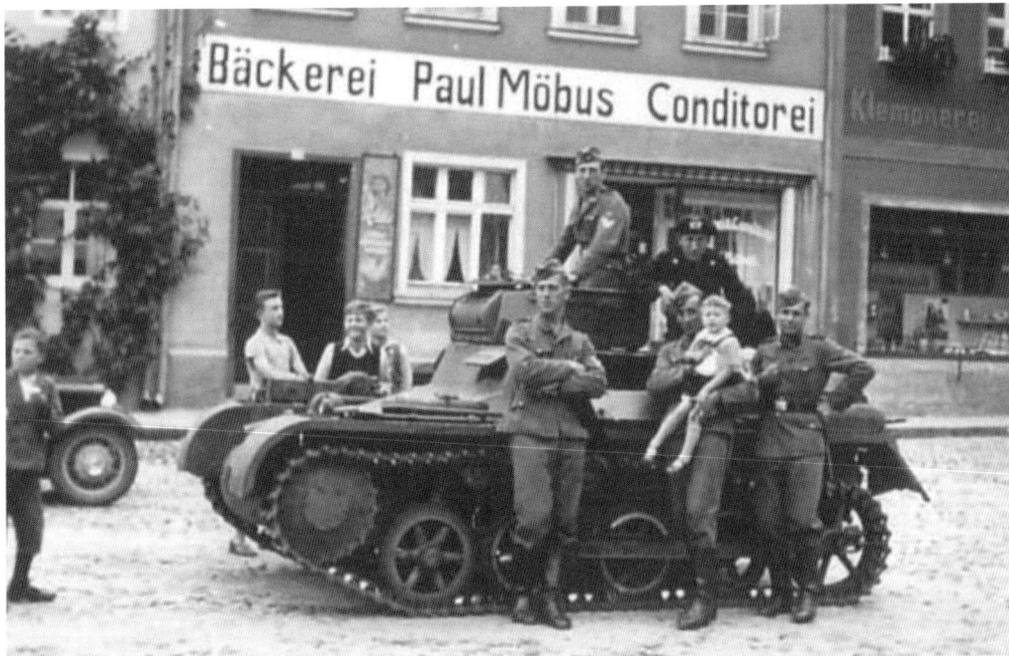

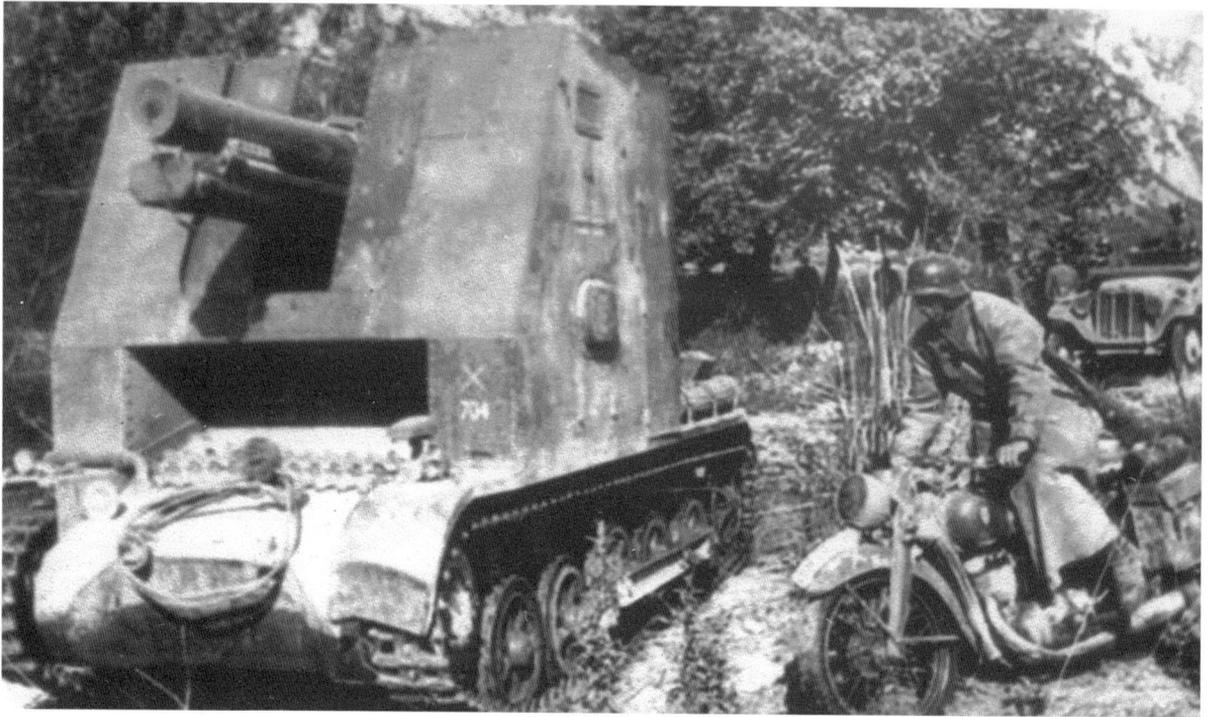

Germany's very first self-propelled gun. The Panzer Mk I chassis was used as a mount for the German 150mm gun. This top-heavy looking conversion was conducted by Alkett at the Berlin-Spandau works. Some thirty-eight were converted and first saw combat in Poland and subsequently saw action in the Western campaign.

Just to the left of this knocked out French B1-bis is a Panzer Mk II. It was employed in Poland in 1939 and in France the following year. The Germans had 950 Mk IIs in service at the beginning of the Western campaign. It could be said this tank type formed the backbone of the Panzerwaffe as it represented the highest number of any one type out of the 2,500 German tanks deployed. Unlike the Mk I that mounted a machine gun, the Mark II was armed with a 20mm cannon.

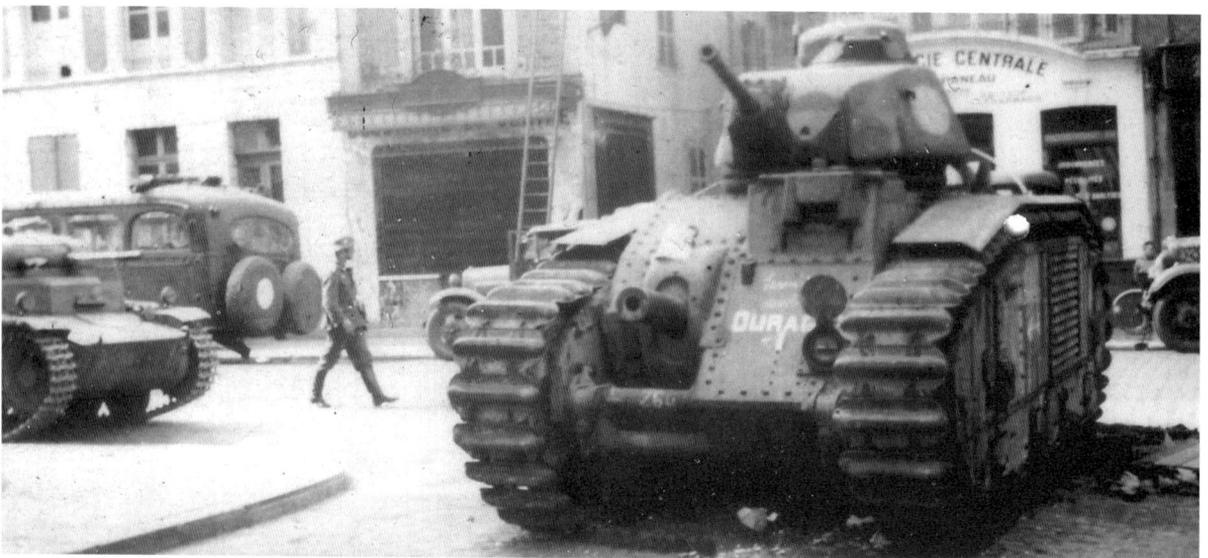

In February 1940 the Panzer Mk III Ausf A, B (seen in the photograph below) and C had been withdrawn from service due to problems with the suspension and thin armour. On 10 May 1940 there were 348 Mk IIIs mainly model E and F but with a few Gs deployed with the seven panzer divisions taking part in the attack on France. These Mk IIIs were armed with a 37mm anti-tank gun and two machine guns.

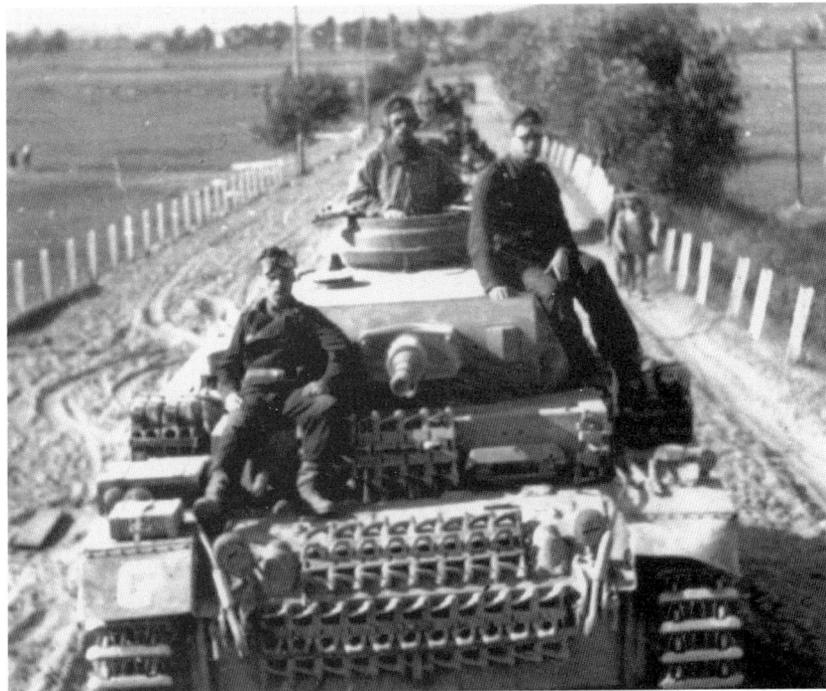

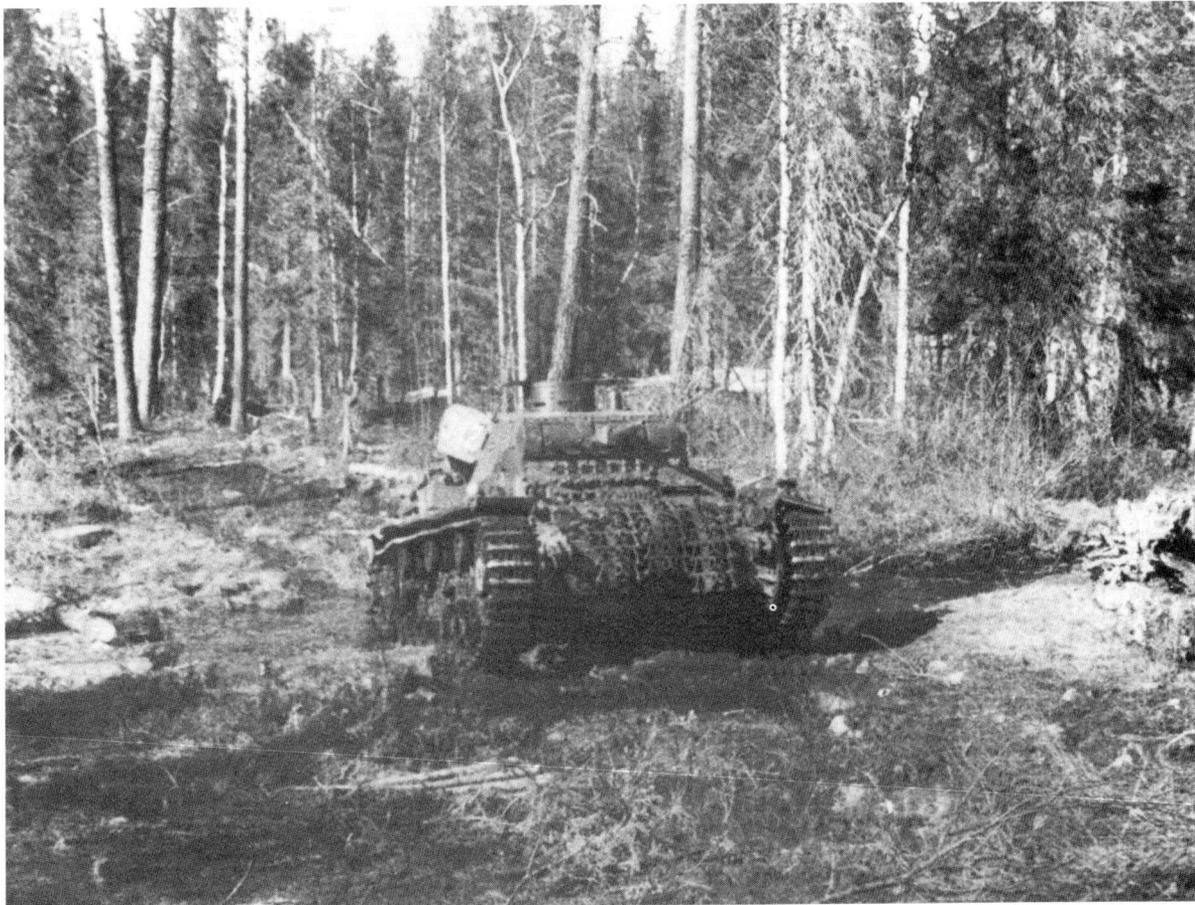

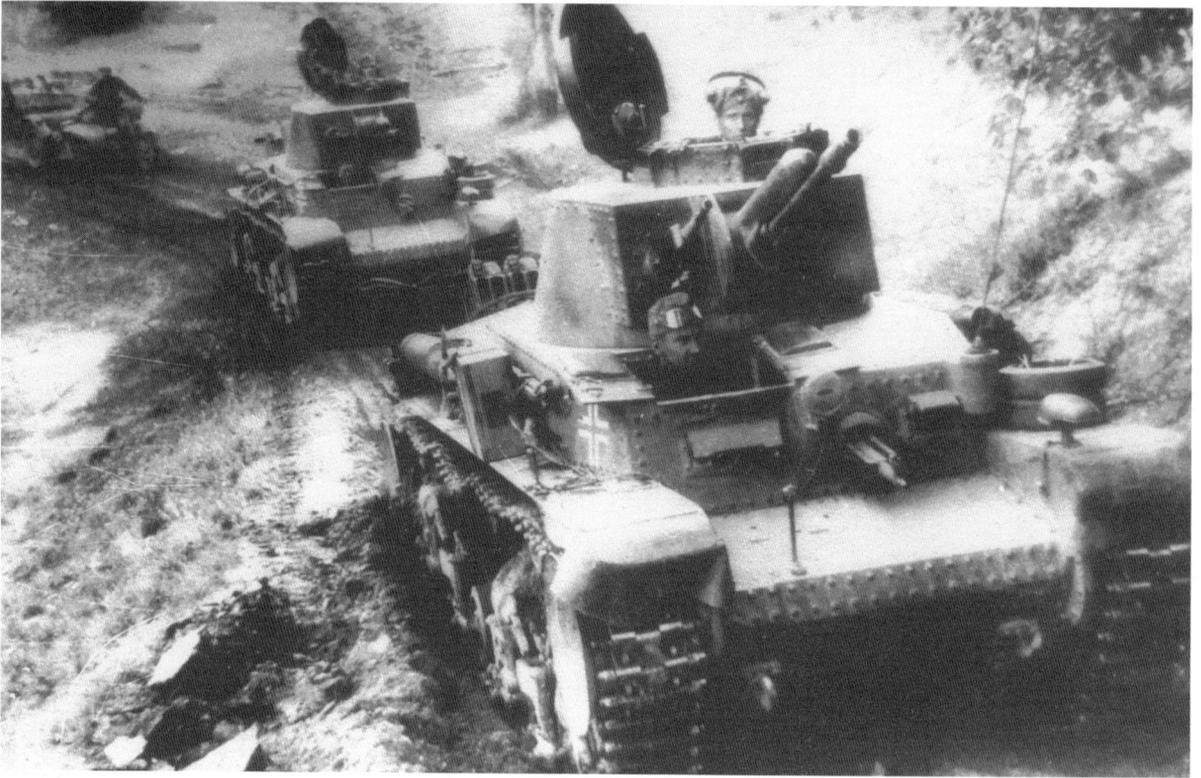

The panzer divisions also included Czech-designed LT-35 (seen here) and LT-38 tanks that were collectively known as 'Skodas' by the Germans. In fact almost 10 per cent of Hitler's attacking force was of Czech origin.

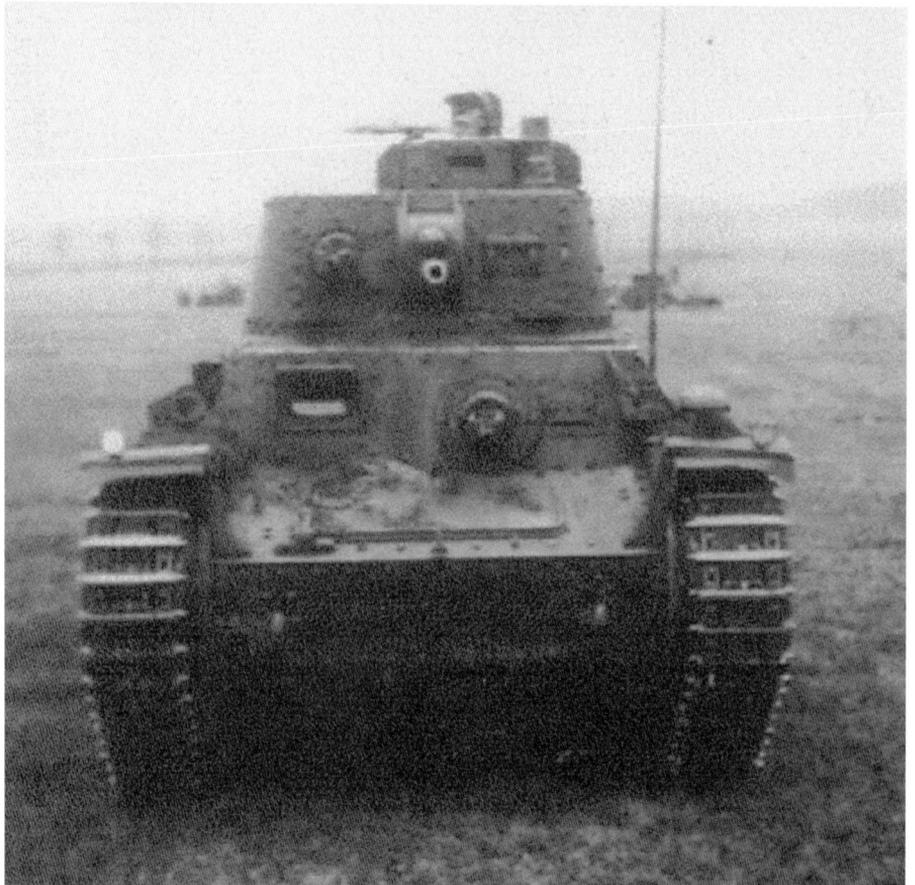

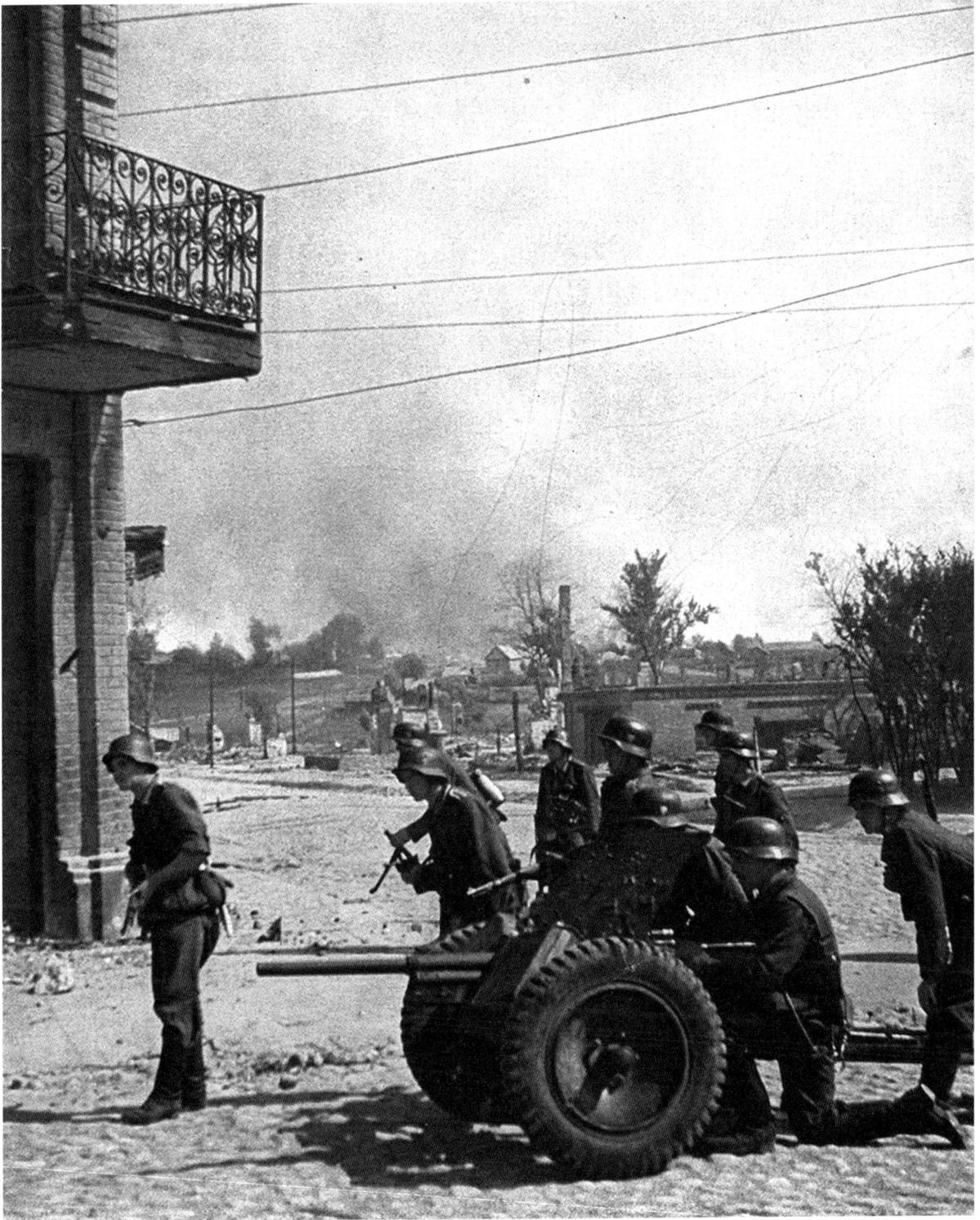

The Germans standard anti-tank gun in 1940 was the 37mm Pak 35/36, which was developed by Rheinmetall and first combat tested in Spain in 1937–8. While its penetrative power was not quite as good as some of its contemporaries, its mobility more than made up for this.

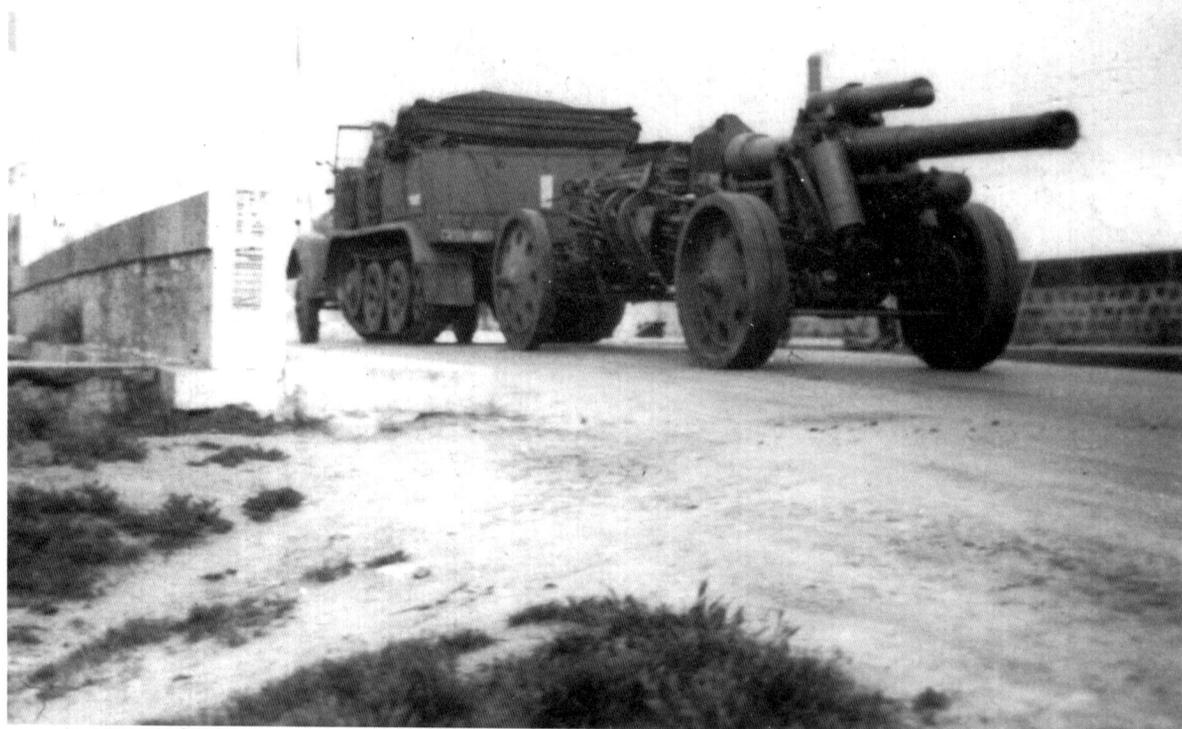

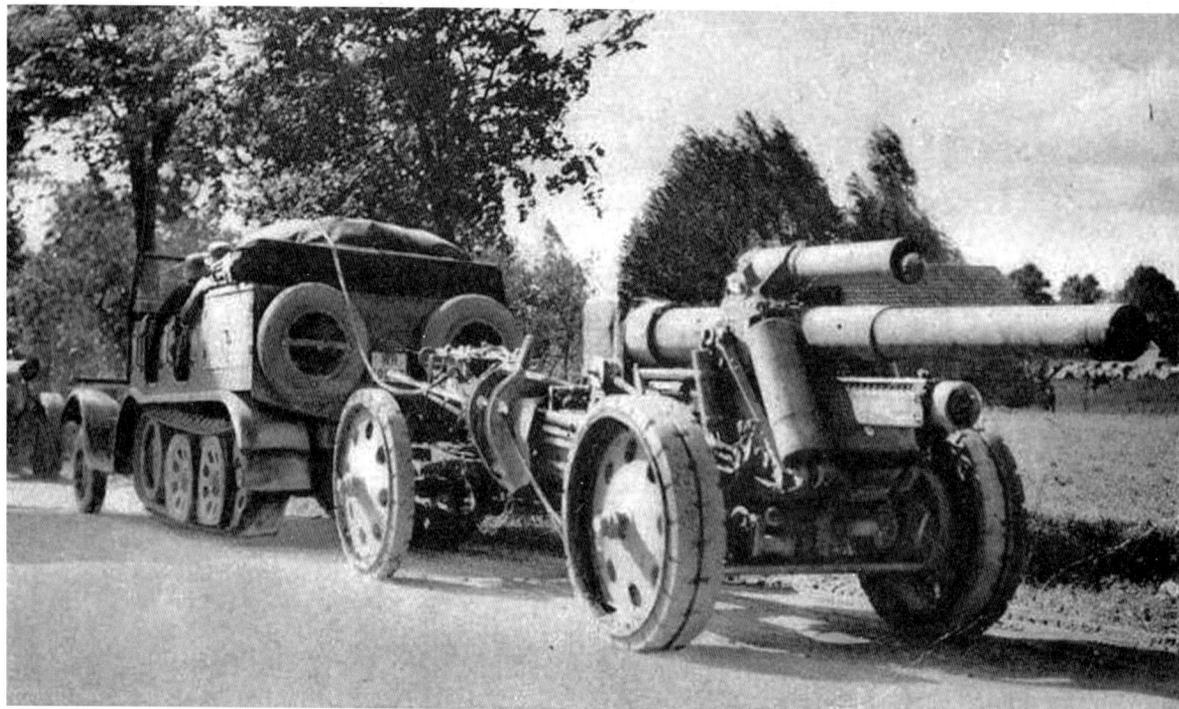

Above and opposite: The backbone of the German medium artillery during the Second World War was the sFH18 150mm, seen opposite. Developed during the late 1920s, the howitzer was by Rheinmetall while the carriage was from Krupp. The standard divisional piece was the 105mm leFH 18 field gun, seen above, also designed by Rheinmetall. While a robust gun, it was rather heavy which hampered its mobility.

Above and opposite: The German Army used both lorries and halftracks. The Sd Kfz 7 and Sd Kfz 8 semi-tractors were produced in large numbers and were variously used to tow artillery or as self-propelled gun carriages.

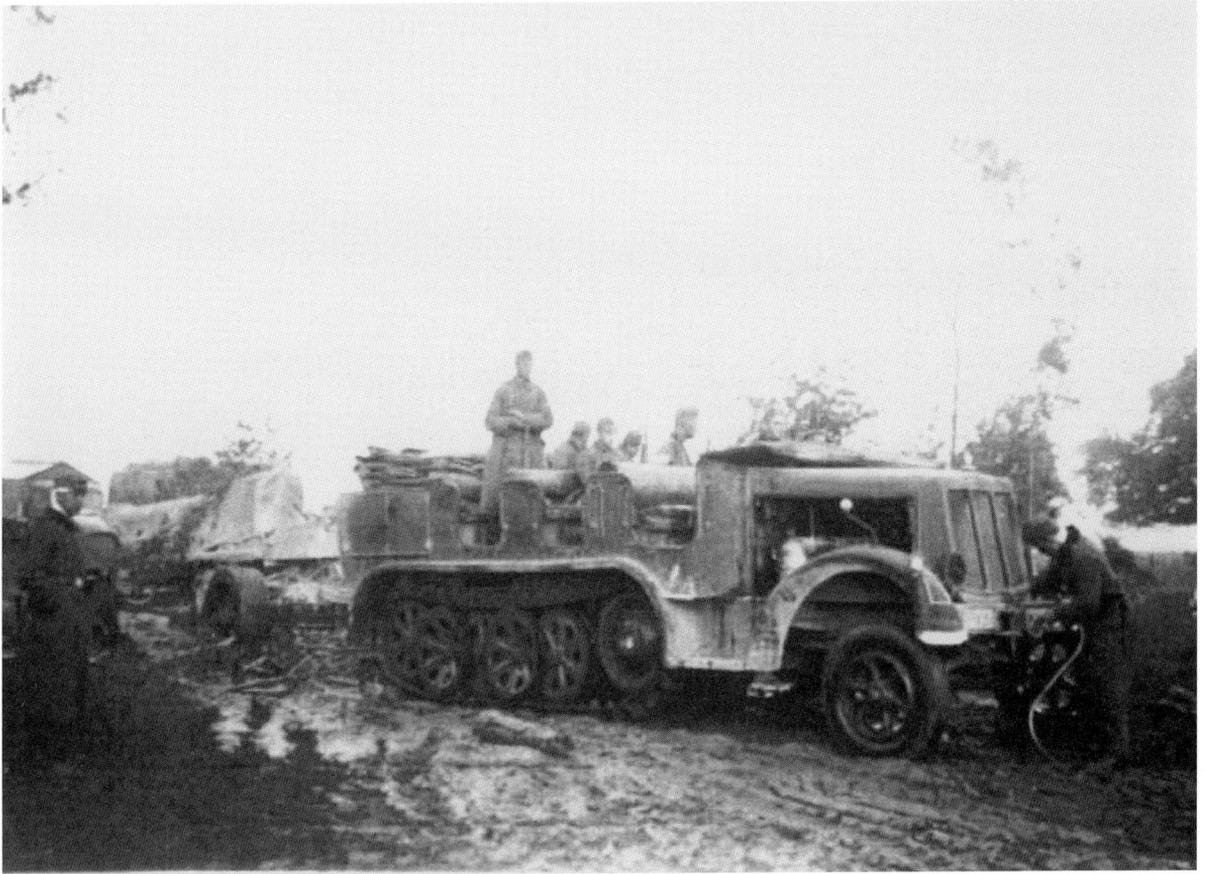

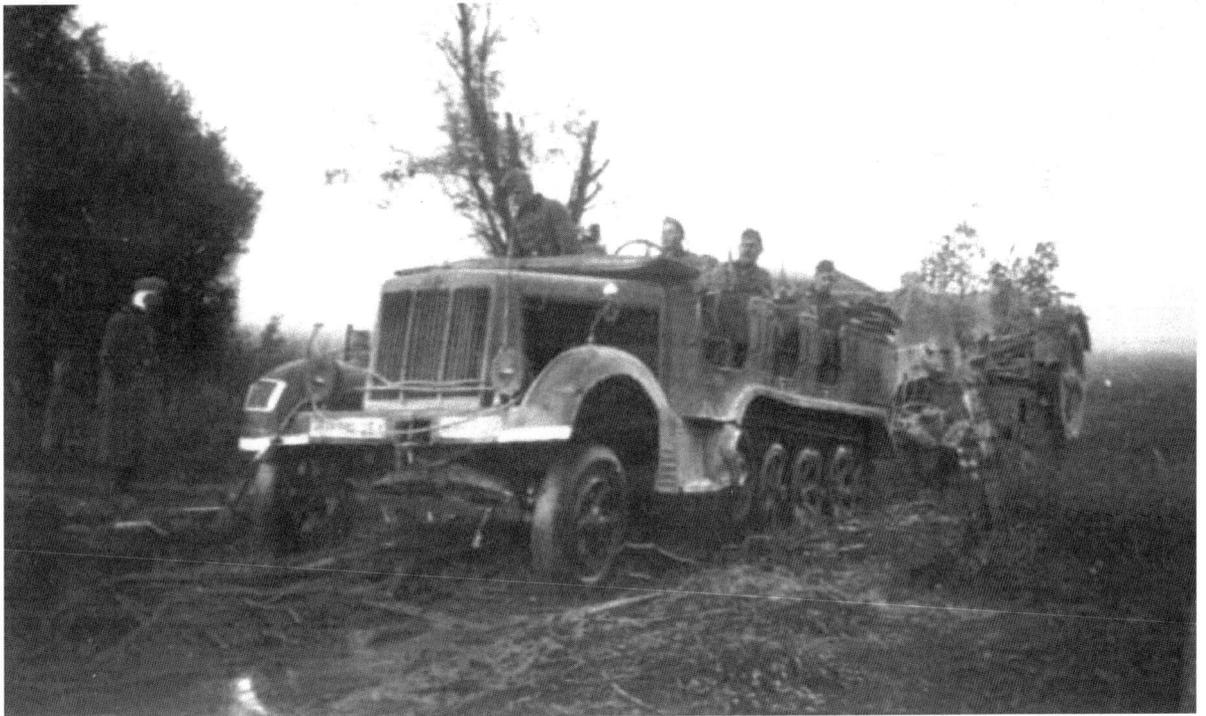

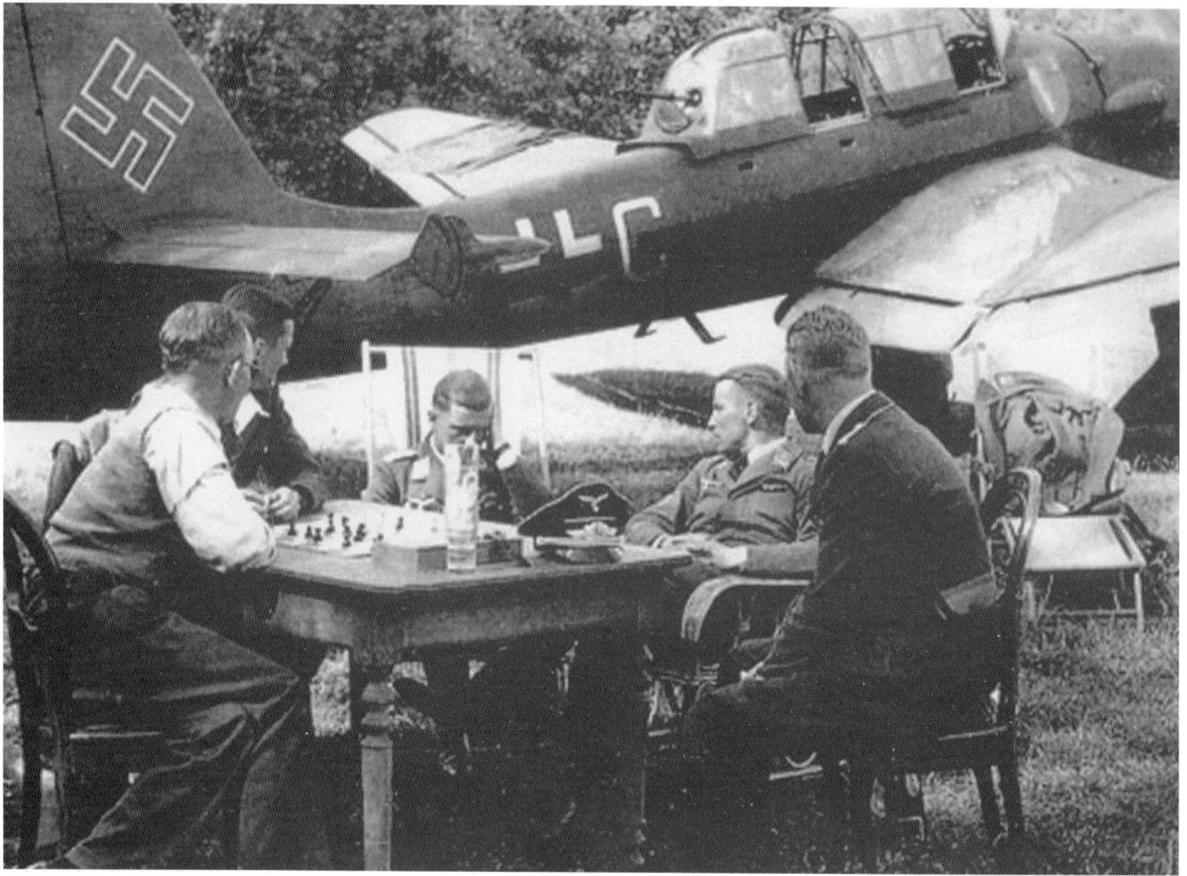

A key part of Hitler's strike force was the Luftwaffe and in particular its dive-bombers. The Stuka (an abbrevition of Sturzkampfflugzeug or dive-bomber) Junkers Ju 87 established its fearsome reputation during the Polish campaign. It proved a terrifying war machine signalling death from the skies with a screaming siren. Nonetheless it was only effective once air superiority had been achieved and otherwise was vulnerable to enemy fighters, as was proved during the subsequent Battle of Britain.

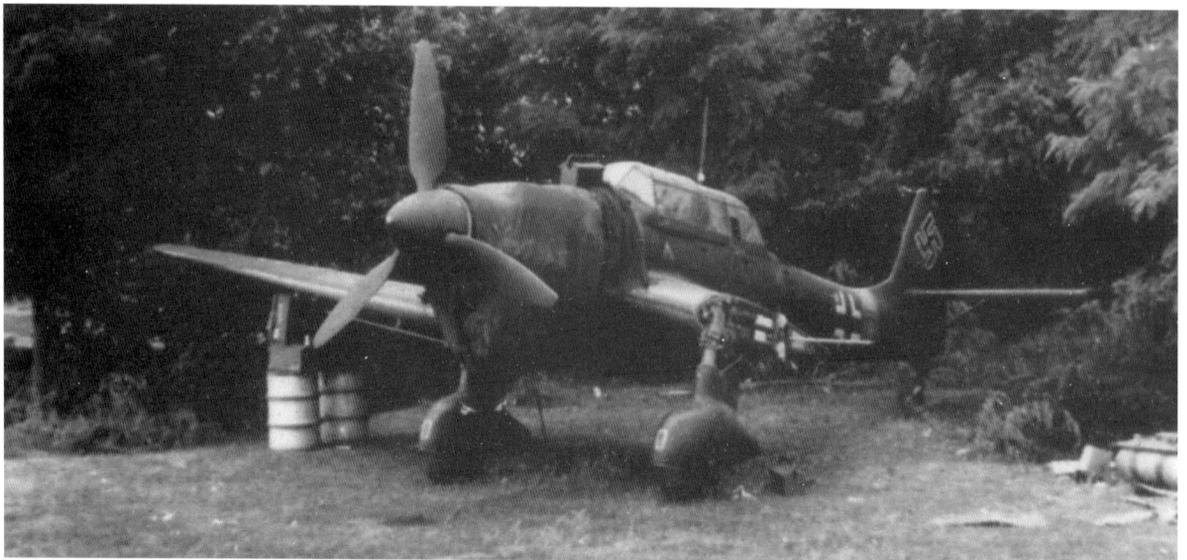

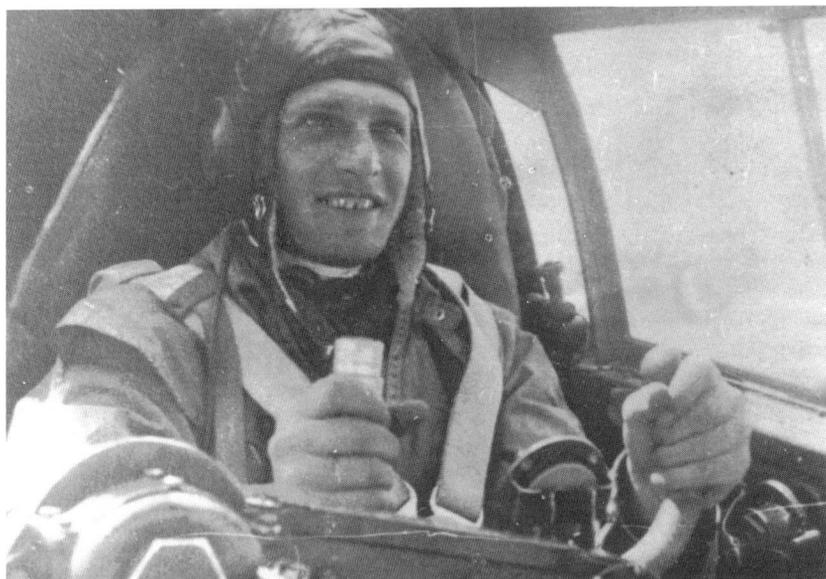

A grinning Luftwaffe bomber pilot. The Heinkel He 111 medium bomber bore the brunt of the Luftwaffe's bombing efforts in Poland in 1939, Norway and Denmark in April 1940 and France and the Low Countries in May 1940. This bomber first saw action with the German Condor Legion during the Spanish Civil War. The two seen here were shot down in England.

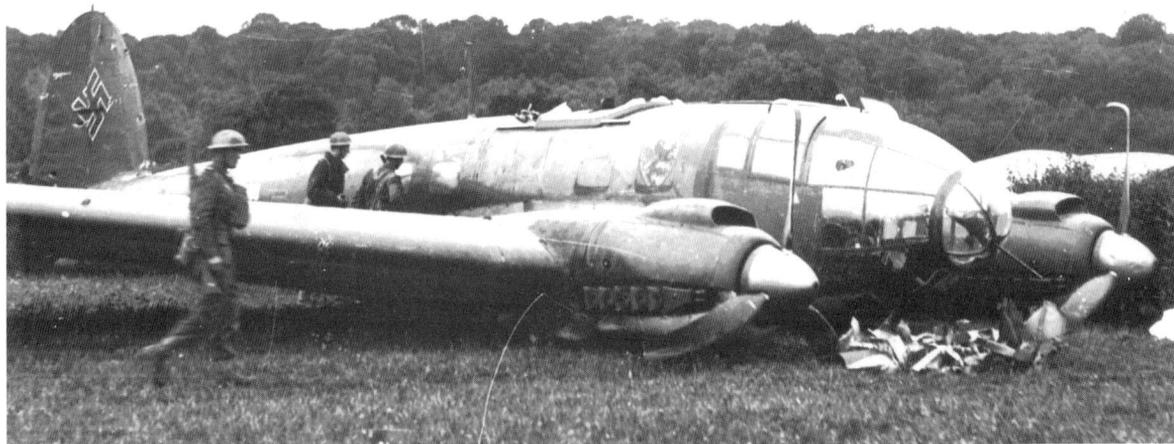

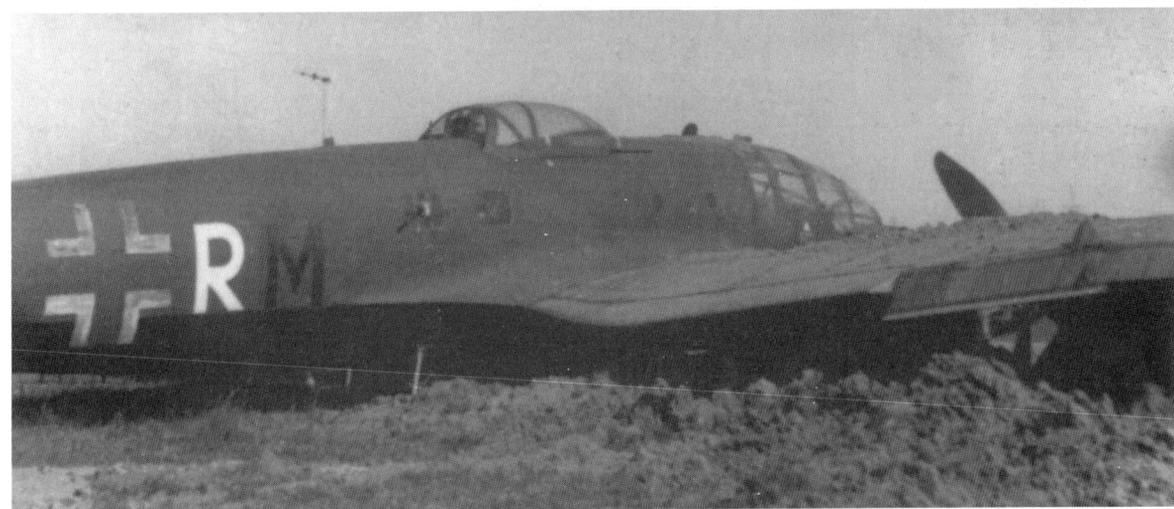

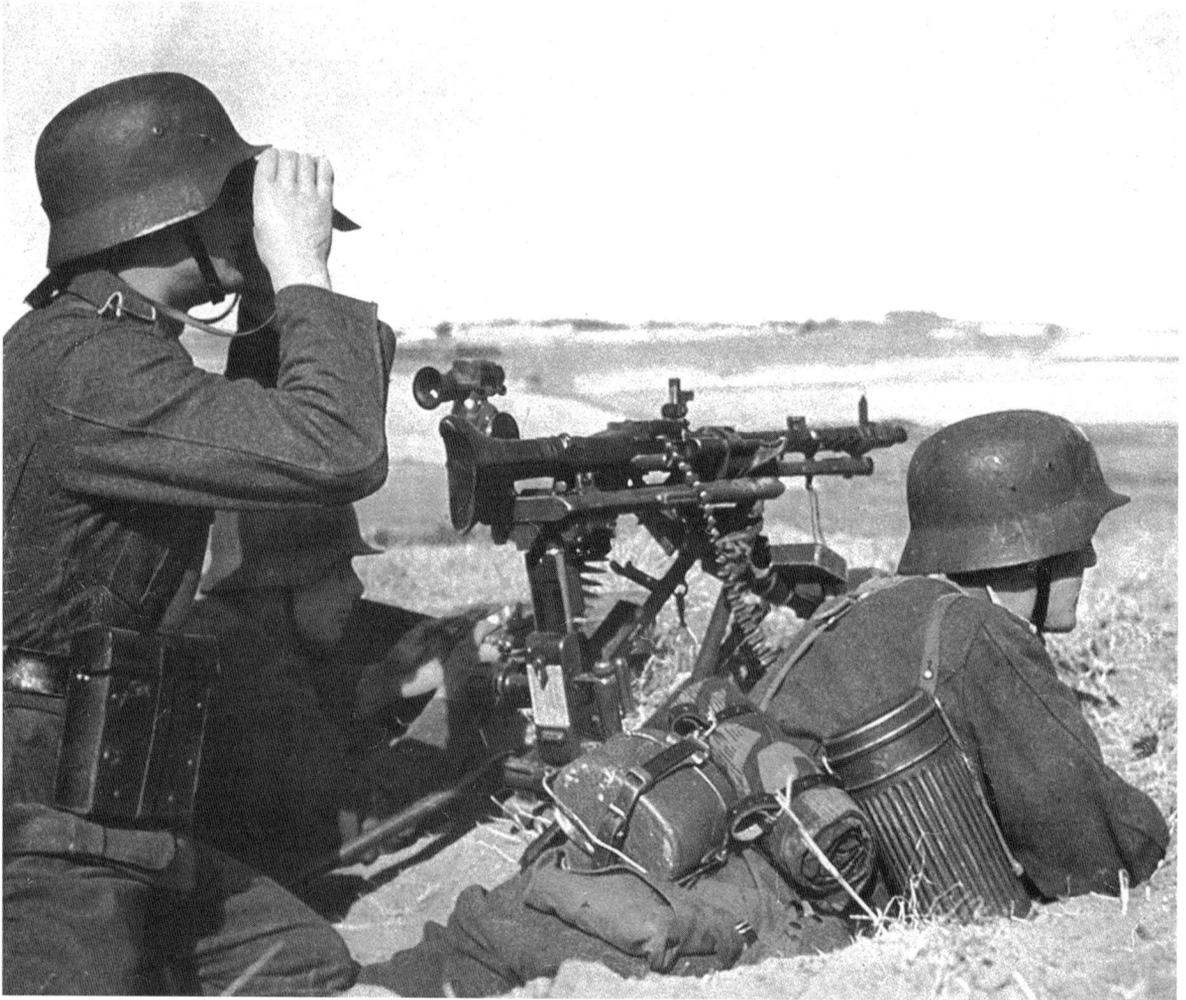

Ready for action – German troops scanning enemy positions. They are manning the Maschinengewehr MG34, which could manage a devastating 900 rounds a minute. It is easily recognisable by the round pierced cooling sleeve on the barrel.

Chapter Five

Codeword Danzig – Netherlands and Belgium

Belgium and the Netherlands had no real desire to side with Britain and France. Both may have fooled themselves they could stay out of trouble. However, in strategic terms Hitler was hardly going to leave them to act as potential springboards against his right flank during an attack on France. In addition they sat at the end of France's Maginot Line. The writing was clearly on the wall but their governments chose to ignore it.

During the uneasy months of the Phoney War the Low Countries and Scandinavia, with the exception of Finland, secretly hoped that they could remain neutral. During late 1939 and early 1940 Finland found itself embroiled in the bitter Winter War with the Soviet Union. The Finns felt they had everything to gain by siding with the Nazis if it gave them the chance to reclaim lost territory. Behind closed doors the others argued that it was not their fight. Denmark, Norway and Sweden felt that they could avoid confrontation with the Nazis. It was Britain and France who had belatedly decided to act against Hitler's expansionism following his destruction of Poland. Any misplaced sense of security they may have felt swiftly evaporated with Hitler's attack on Norway and Denmark in early April 1940.

After conquering Poland Hitler wanted to attack France as quickly as possible to secure his Western borders before turning East again. General Thomas, Head of the War Economy and Armaments Office, pointed out that Germany had a monthly steel deficit of over ½ million tons and General von Stuelpnagel, Quartermaster General, reported that current ammunition stocks were insufficient to ensure victory over the French. Hitler had to wait, but luckily for him the Allies did nothing during the Phoney War.

Hitler's forces invaded Norway and Denmark on 9 April 1940 and within 4 hours it was all over for the Danish Army. Daringly a German troop ship landed men in Copenhagen, while a motorised brigade followed by an infantry division sped over the Danish–German border as paratroops landed on the Aalborg airfield. The outnumbered Danes offered virtually no resistance, but the Norwegians with belated British and French military assistance held on until early June.

Norway was a prime example of muddled Allied defensive thinking and the hand

of Winston Churchill loomed large in this fiasco. An ill-fated operation in mid-April 1940 was designed to head off Hitler's iron-ore imports from Sweden via Narvik in Norway. Operationally there was a fundamental failure to secure proper integration of the three British armed services at the executive level. The British had no Combined Operations HQ resulting in the Army and Royal Navy issuing independent and often contradictory orders during the fighting.

To make matters worse Hitler successfully pre-empted the British with Operation Weserübung launched on 9 April 1940. German assault troops rapidly and successfully occupied Norway's main ports and airfields, taking Oslo, Stavanger, Bergen, Trondheim and Narvik. This effectively took the neutral Norwegian armed forces out of the equation and obstructed British and French efforts to intervene. Even worse the Luftwaffe quickly gained control over Norway's coastal waters, so Hitler was able to neutralise the Allies' warships. Ironically this was the first example of a modern combined operation by land, sea and air, but the Allies were not quick to learn from it.

The Royal Navy was unable to stop the German Navy or cope with the Luftwaffe, and as a result it concentrated its efforts in the north giving the Germans a free hand in southern Norway. Command and control of the Trondheim leg of the operation was jinxed from the start after losing two generals (one was taken ill and the second was lost in an air crash). The commitment of ground forces by the Allies was woefully inadequate; the French anxious about a German invasion of France sent only a demi-brigade of Alpine light infantry and the British four infantry brigades. Heavy support weapons, especially tanks, were conspicuous by their complete absence.

Allied indecision over Trondheim and Narvik played straight into Hitler's hands and completely stymied any hopes the British and French forces had of retrieving the deteriorating situation. Hitler's invasion of France sealed the fate of the operation, and by 9 June the Allies had completed their evacuation from Norway and three days later the Norwegians surrendered. The British force of 20,000 men lost 2,060 casualties; of the 11,700 Frenchmen committed 530 became casualties. The Norwegians lost 4,000 men and although the Germans lost 5,300 they maintained control of Norway and the vital shipping lanes.

Hitler next timed his attack on the Low Countries, Belgium and the Netherlands, as well as Luxembourg to coincide with his invasion of France on 10 May 1940. The German invasion of tiny neutral Luxembourg which shielded part of the Belgian and French frontier was spearheaded by the 1st, 2nd and 10th Panzer Divisions. While most of the Luxembourg Volunteer Corps stayed in their barracks, six police and one soldier were wounded in exchanges with the Germans. Elements of the French Army, including General Petiet's 3rd Light Cavalry Division supported by a company of tanks, crossed the southern border to probe the German advance but they soon withdrew back behind the Maginot Line.

The Belgian and Dutch Armies were confronted by the advance guard of Colonel General Fedor von Brock's Army Group B, which rumbled into the southern Netherlands and northern Belgium. Desperate Dutch forces were quickly driven west. General Gamelin ordered the French 1st Army into Belgium to confront the Germans. Along with the BEF they took up defensive positions around Breda, the River Dyle and south toward Sedan. Hitler and his commanders can only have watched with smug amusement as the Allies helpfully removed their forces from the vital central sector. Army Group A would eventually move to ensure the British, French and Belgian forces remained in the north by attacking the Dyle.

While Army Group B pushed west into the northern sector Army Group A's three motorised Corps, under Generals Guderian, Reinhardt and Hoth, struck in the centre toward the Ardennes. Hoth's 15th Corps included Hartlieb's 5th and Rommel's 7th Panzer Divisions. Behind Hoth came the infantry of General Hans von Kluge's 4th Army, which consisted of twelve infantry divisions. In the centre were the 6th and 8th Panzer Divisions forming General Georg-Hans Reinhardt's 41st Motorised Corps.

The full weight of the panzers lay to the south where Guderian's 19th Corps comprised the 1st, 2nd and 10th Panzer Divisions along with the elite motorised Grossdeutschland Regiment. This powerful force was designed to protect the southern flank against anticipated French counterattacks. Beyond this lay Colonel General von Leeb's Army Group C consisting of eighteen infantry divisions which were to face the formidable yet ultimately useless French fortifications of the Maginot Line.

The RAF and French Air Force did everything they could to impede the Blitzkrieg. At dawn on 12 May nine Blenheim bombers attacked a column of German troops on the road from Maastricht to Tongres and were pounced on by Bf 109s losing seven of their number. Attempts to destroy the bridges across the Albert Canal that were by now in enemy hands proved equally as futile. Five Battles braved enemy flak and fighters to bomb two bridges at Vroenhoven and Veldwezelt. German 88mm flak guns claimed four of the Battles while the fifth made a crash-landing.

The Battle of Hannut fought in Belgium between 12 and 14 May 1940 and involving two French armoured divisions was the largest tank battle of the campaign. The Germans reached the Hannut just two days after the start of the invasion of Belgium. Although the French won a series of delaying engagements and successfully fell back on Gembloux, the Germans tied down substantial Allied forces at Hannut which might have supported the decisive offensive through the Ardennes.

The defence of neutral Belgium was hampered by the Belgians almost complete lack of cooperation with the British and French armies. Just as the Germans were attacking Belgium, General Bernard Montgomery, leading elements of the British 3rd Division, was not permitted to enter the country. Nonetheless, they endeavoured to

take up positions to help defend Brussels, only to have their way blocked by Belgian troops objecting to their presence. The Belgians even fired on the British thinking they were German paratroops. The speed of the German Blitzkrieg meant the defence of the River Dyle and Brussels soon became impossible and the bickering became a pointless academic exercise.

The Germans easily brushed aside the Belgian Army's pitifully few light tanks, which included a number of British-built T13B2, T15 tankettes and some Minerva armoured cars. The Belgian Army also had twenty-five French-built AMC Renault 35 ACG 1 light cavalry tanks. None of these vehicles did them any good.

Once the Germans were slicing through the Ardennes the British forces in Belgium were soon in danger of being cut off and on 16/17 May were forced to start withdrawing. This was done in an orderly manner and at this stage no equipment was abandoned. Lieutenant Colonel Brian Horrocks, leading his carrier platoon, anti-tank battery and two machine-gun battalions, claimed to be the last British soldier out of Belgium before the remaining bridge over the Escaut Canal was blown. His next stop was Dunkirk where everything the British Army possessed was abandoned to the Germans. Ten days after the Allied withdrawal the Belgians sued for peace. Ironically the German general appointed military governor of Belgium and Northern France was Alexander von Falkenhausen, nephew of General Ludwig von Falkenhausen, Belgium's military governor in 1914–18.

The Netherlands' armoured forces were likewise non-existent. The Dutch had two-dozen Swedish-built M36/38 Landsverk armoured cars and a single Wilton-Fijenoord armoured car. They were to have received at least two batches of T15 tankettes, the first of which went to the Dutch East Indies Army, but subsequent deliveries to the Dutch Home Army were interrupted by the war. The Dutch also had forty British Vickers light tanks on order, but on completion in 1939 the British War Office took them over for training purposes

The French moved to Breda to help the Dutch fend off the 9th Panzer Division and German airborne troops intent on capturing the Dutch government at The Hague. Although the airborne attack on The Hague went horribly wrong, once the panzers had seized the bridges over the River Maas (Meuse) the Dutch were cut off. The French forces advancing without tanks bumped into the panzers and under air attack were forced to fall back. The Luftwaffe destroyed the Dutch Army Aviation Brigade within five days. All its bombers were swiftly shot from the skies. In Rotterdam Dutch Marines and the Dutch Navy bravely tried to fend off the Germans and Hitler was incensed by the delay.

The panzers were unable to break through even though the German airborne forces had captured the bridges leading into the city. Hitler ordered the Luftwaffe to break the Dutch resistance on 14 May and thousands of Rotterdam's occupants

were wounded and 800 killed. The bombing and resulting fires also left almost 78,000 civilians homeless and destroyed some 25,000 houses.

The beleaguered defenders of Rotterdam had few options in the face of such devastating firepower. The Commander in Chief of those Dutch forces still holding The Hague ordered a general ceasefire late that evening. There was no questioning Dutch courage, 2,100 Dutch troops had been killed and 2,700 wounded in 5 days of fighting. Nonetheless the Dutch Army surrendered within 6 hours still virtually intact. With the Low Countries defeated Hitler could concentrate on the subjugation of France.

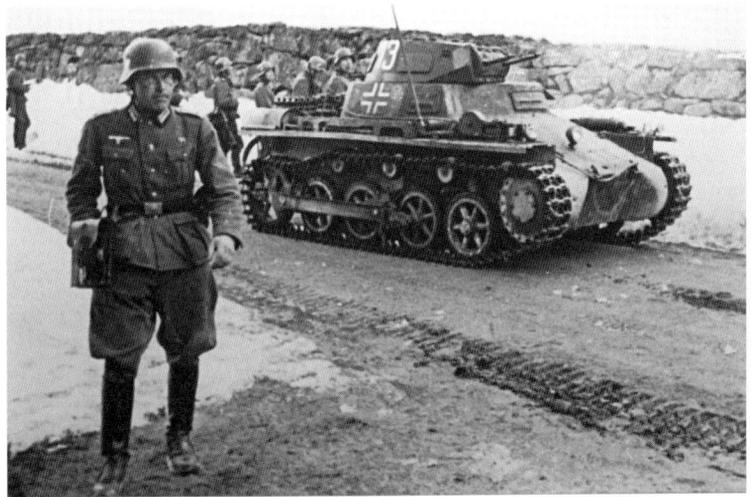

The war in the West begins – a German Panzer Mk I in Norway in 1940. Hitler pre-empted the Allied intervention in Norway by seizing the country's main ports and airfields before the arrival of the British and French. The Allies clung on until early June but ultimately Norway was lost to Nazi occupation.

Denmark was attacked at the same time as Norway and the outnumbered Danish Army offered virtually no resistance. These young Danish soldiers were part of a force that only numbered 6,600 in 1939. The helmets hung from their haversacks are probably the M1923 model.

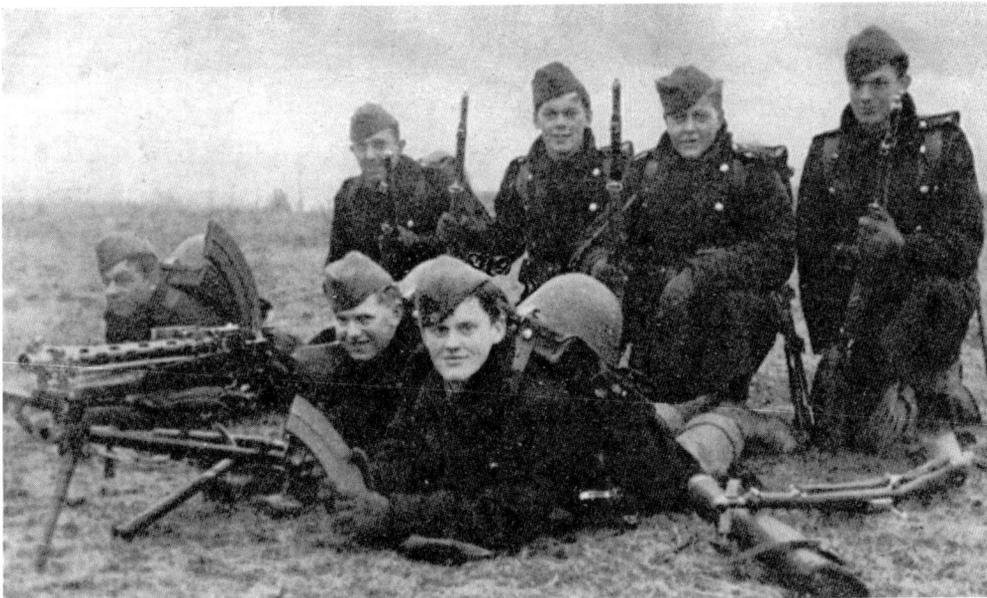

Mobile troops 1930s style. Two rather comical shots of a Dutch military band on bicycles, which epitomised the German view of the Dutch armed forces. However, the Dutch Army could muster 48 infantry regiments and 22 border defence battalions numbering about 400,000 men.

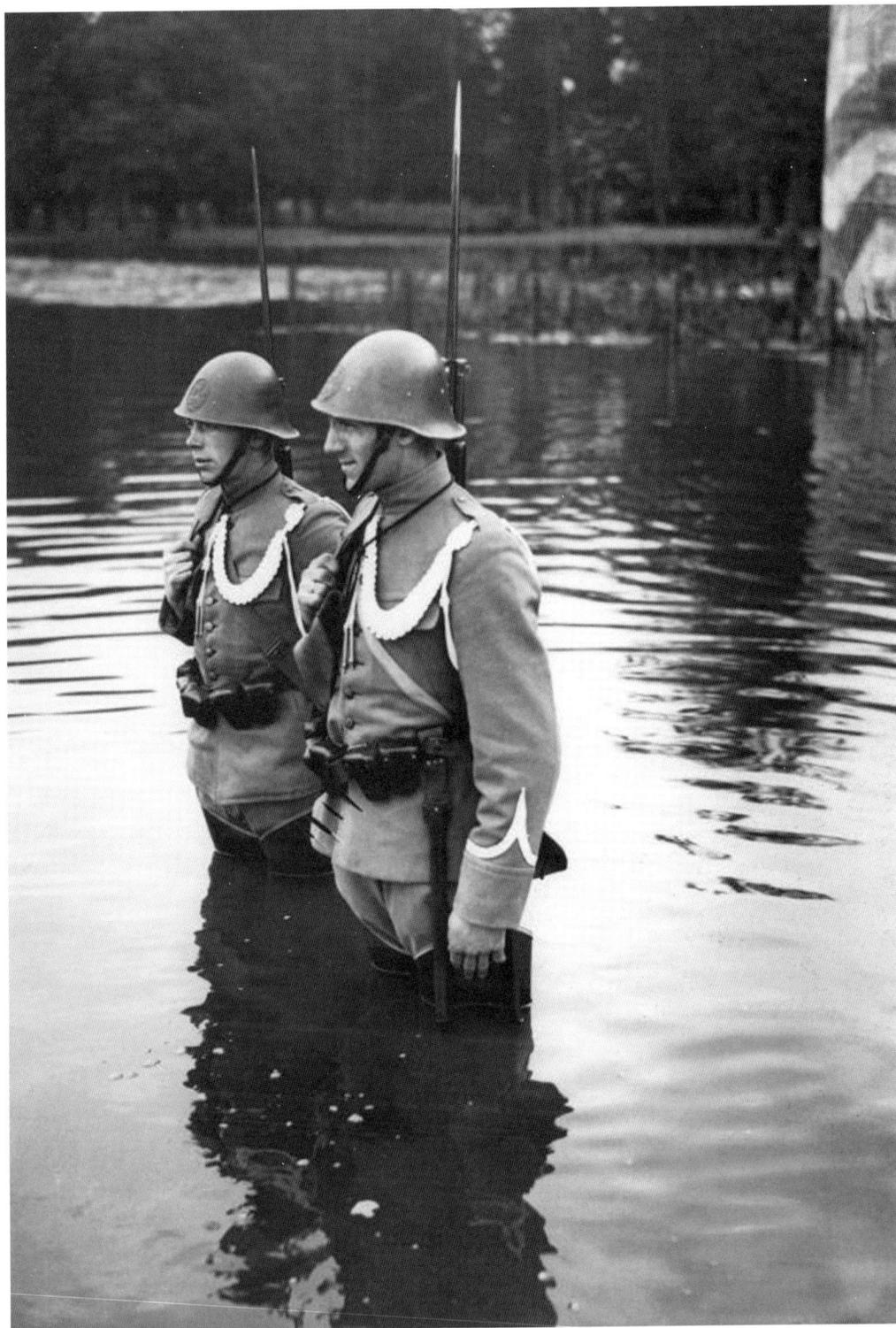

It is not entirely clear why these two Dutch border guards are wearing waders in the middle of a canal or river. They appear to be wearing the distinctive Dutch Model 1927 helmet which was also adopted by the Romanian Army.

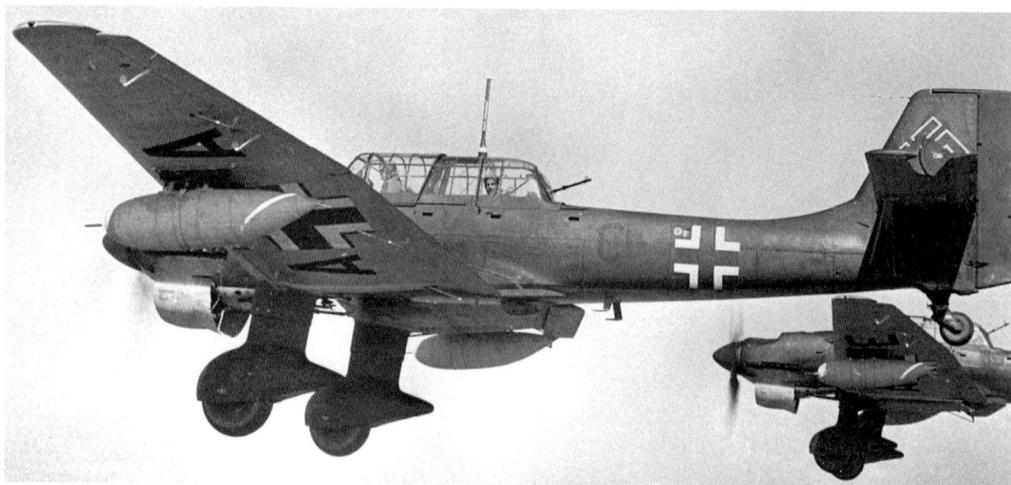

On 10 May 1940 wailing Stukas heralded Hitler's attack on Belgium and the Netherlands causing panic and confusion on the roads, which in turn hampered the movement of reinforcements.

Confident-looking German troops on the move in early May 1940 belonging to General von Brock's Army Group B. These men are believed to be panzer grenadiers who fought more lightly equipped than regular infantry as their kit was carried in armoured personnel carriers or lorries. They are wearing the M1935 helmet, while their standard infantry rifle was the Mauser Gew 98k and Kar 98 – the latter was also produced by Czechoslovakia. The pouch on the chest just above the stick grenades contains an anti-gas cape.

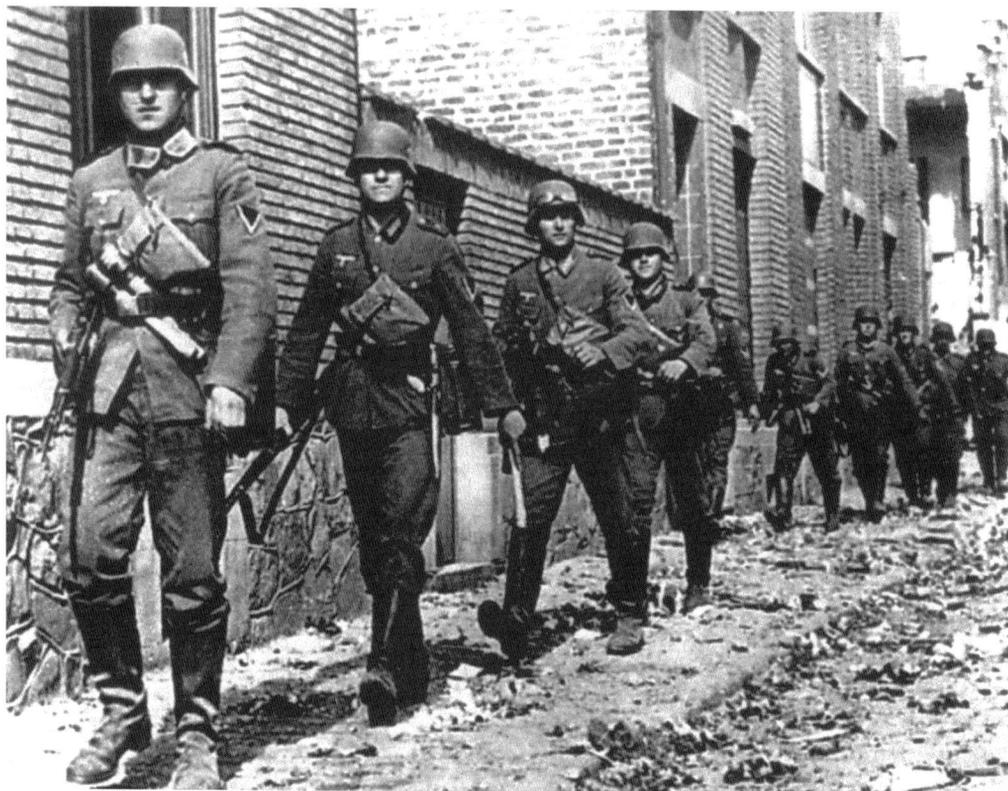

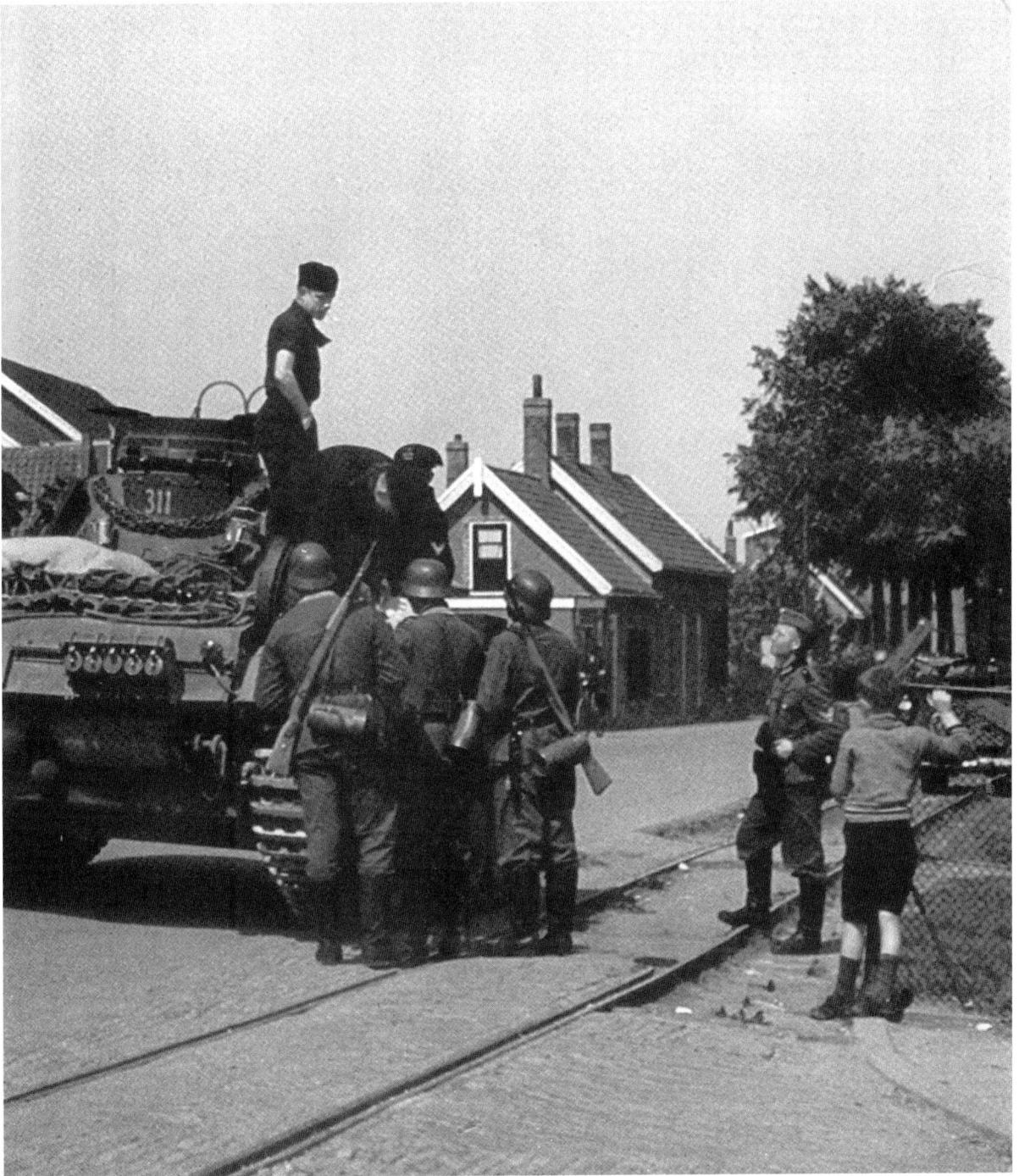

A young Dutch boy watches German infantry conferring with the crew of a Panzer Mk III. Apart from at Rotterdam, the Dutch armed forces were swiftly overwhelmed.

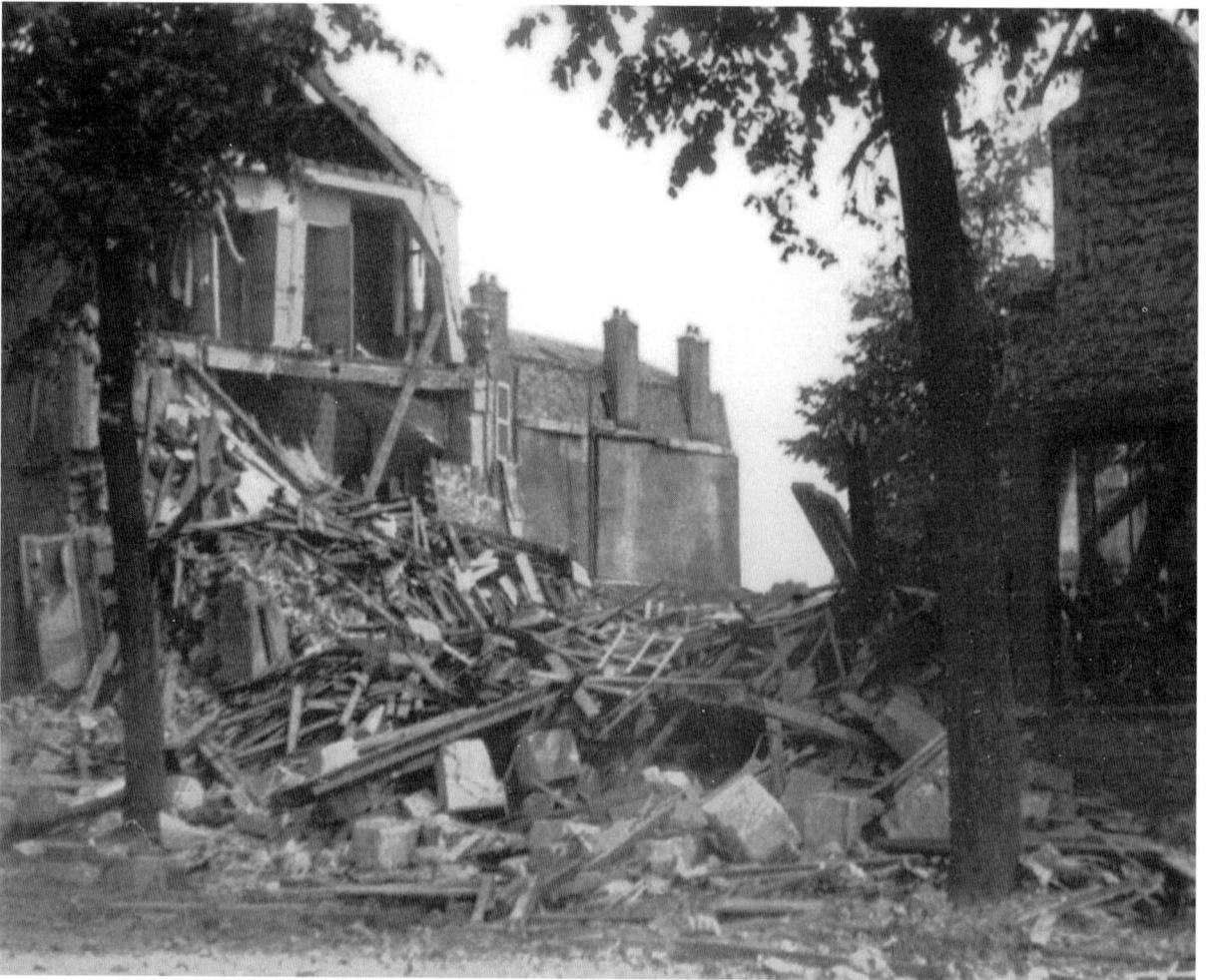

Above and opposite: The Luftwaffe had no scruples about bombing civilian areas in both Belgium and the Netherlands. The chaos caused by the resulting refugees helped to block the roads and impede the Allies trying to move forward to meet the invading German forces.

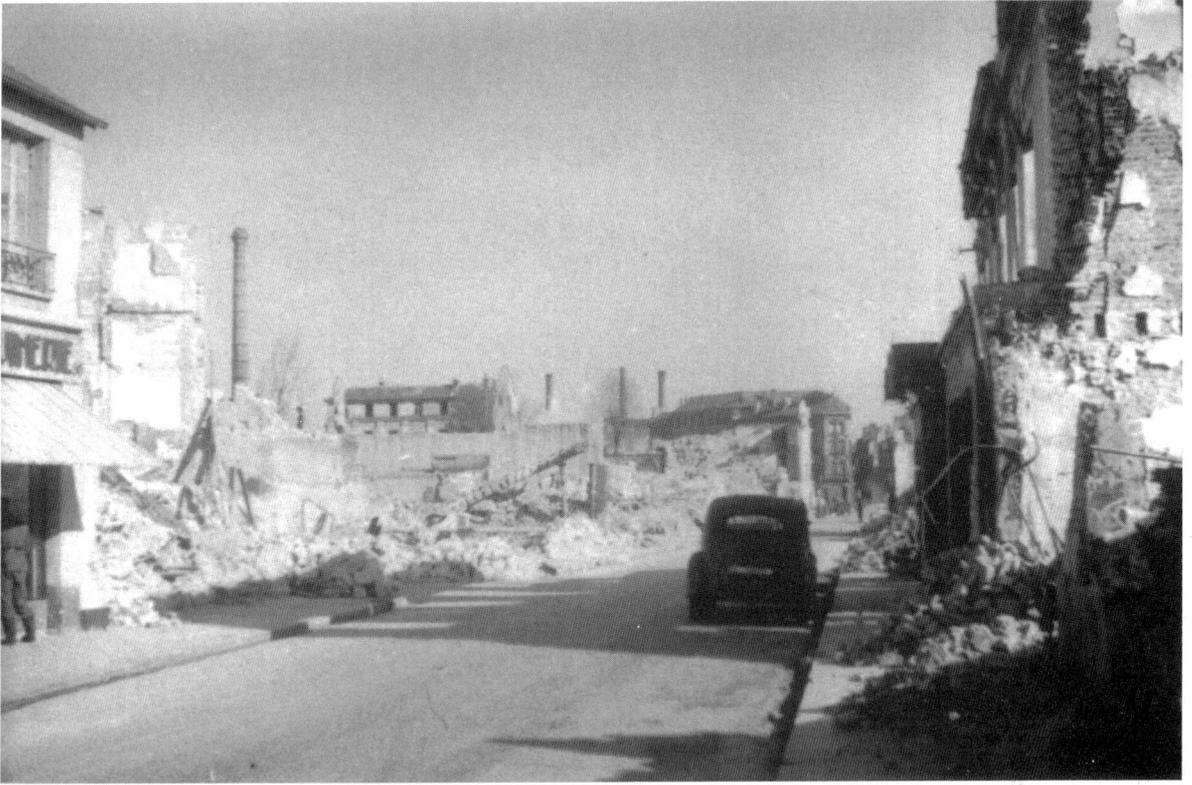

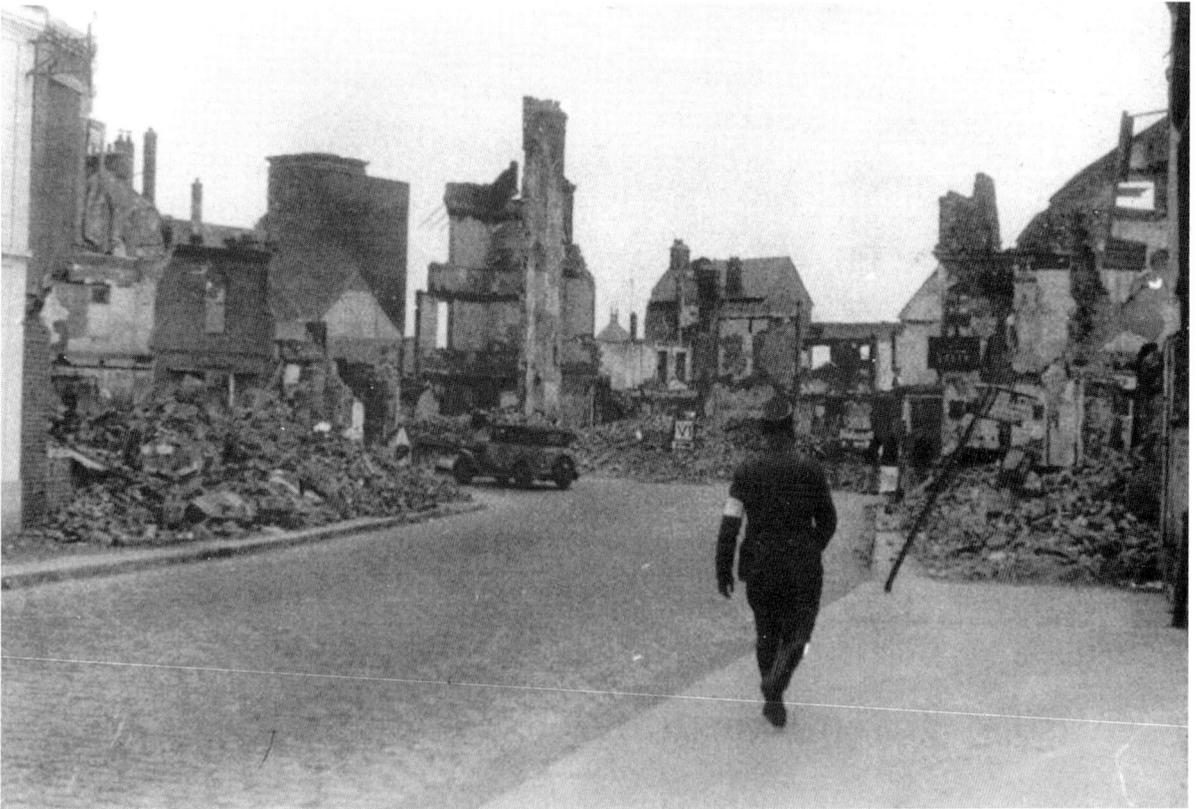

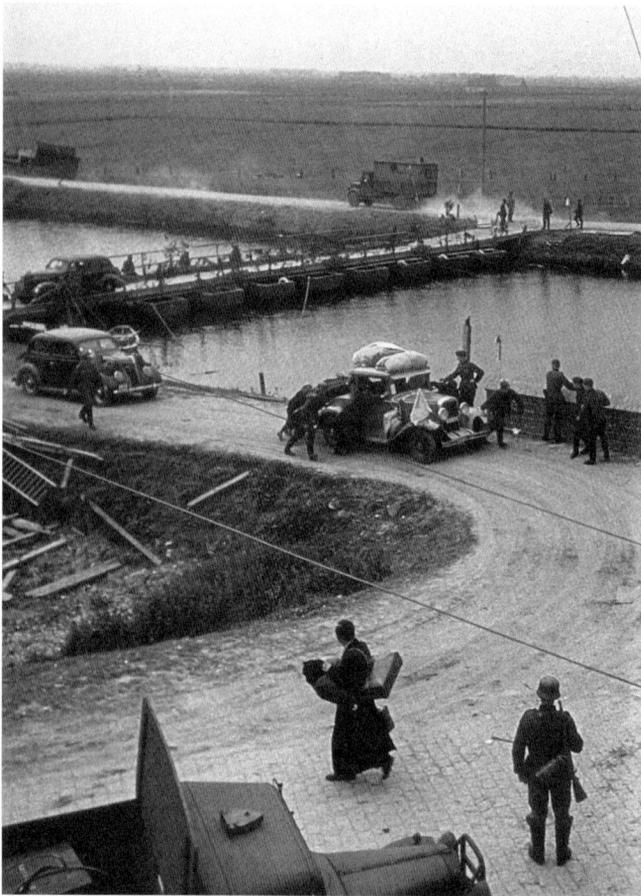

German forces crossing a Belgian canal via a pontoon bridge near the city of Nieuport, Belgium.

Dutch POWs under German guards. Their basic grey-green uniform was virtually the same as that worn during the First World War. When they finally surrendered there was no questioning Dutch courage as they had lost almost 5,000 casualties.

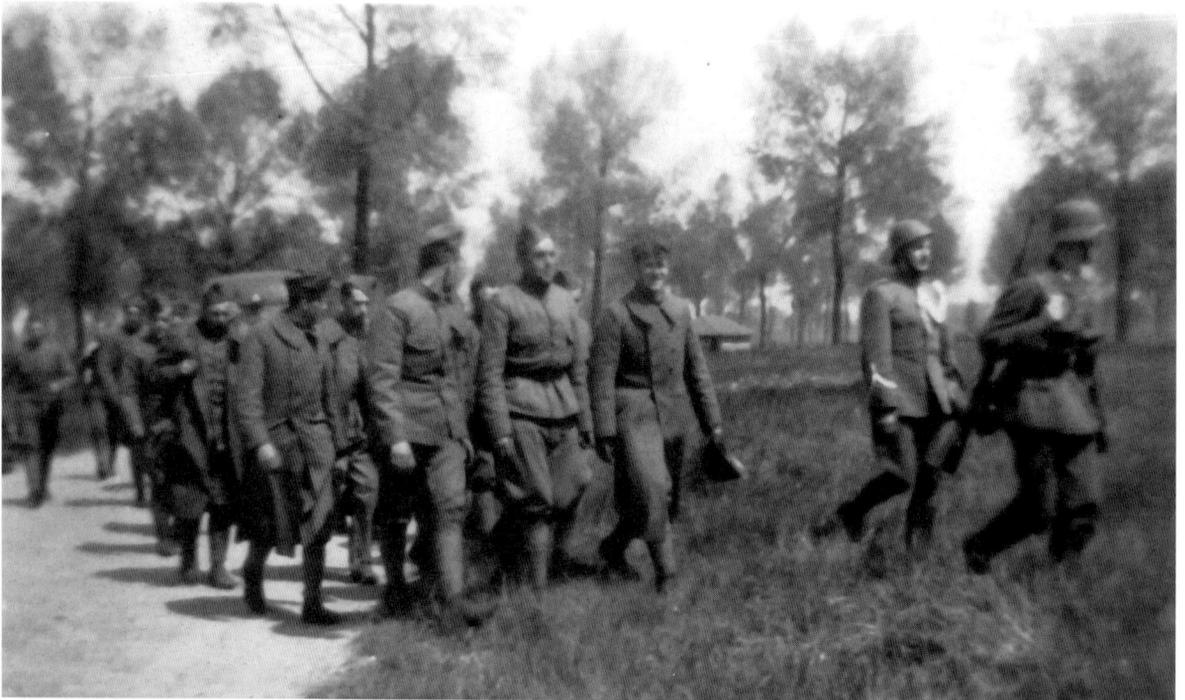

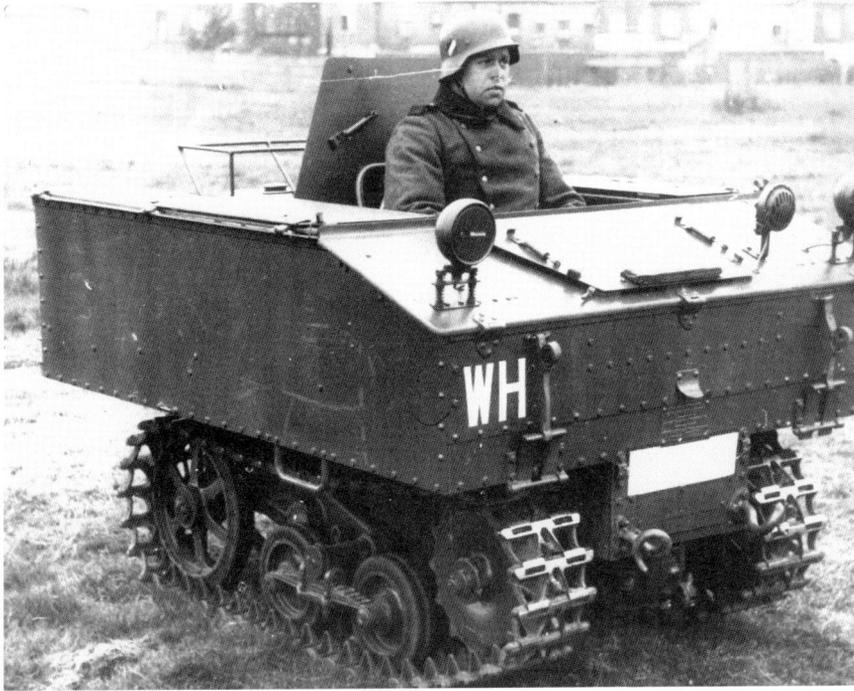

Under new ownership. The Belgians manufactured the Familleureux Utility B tracked light artillery tractor under licence drawing on a British Vickers-Armstrong design in the late 1930s. This tiny vehicle was only 2.4m long and came in an infantry and cavalry support variant designed to tow a 47mm anti-tank gun. Powered by a four-cylinder 52bhp engine (Ford B 3285-cc sv) mounted in the rear, over 300 were supplied by Britain or built in Belgium.

The Belgian Army relied on British and French equipment for their mechanised forces, and this included a number of British-built T13B2 tracked anti-tank gun carriers, armed with a 47mm (seen here), based on the Carden-Loyd Mark VI and T15 tankettes, also based on the British Vickers-Carden-Loyd designs.

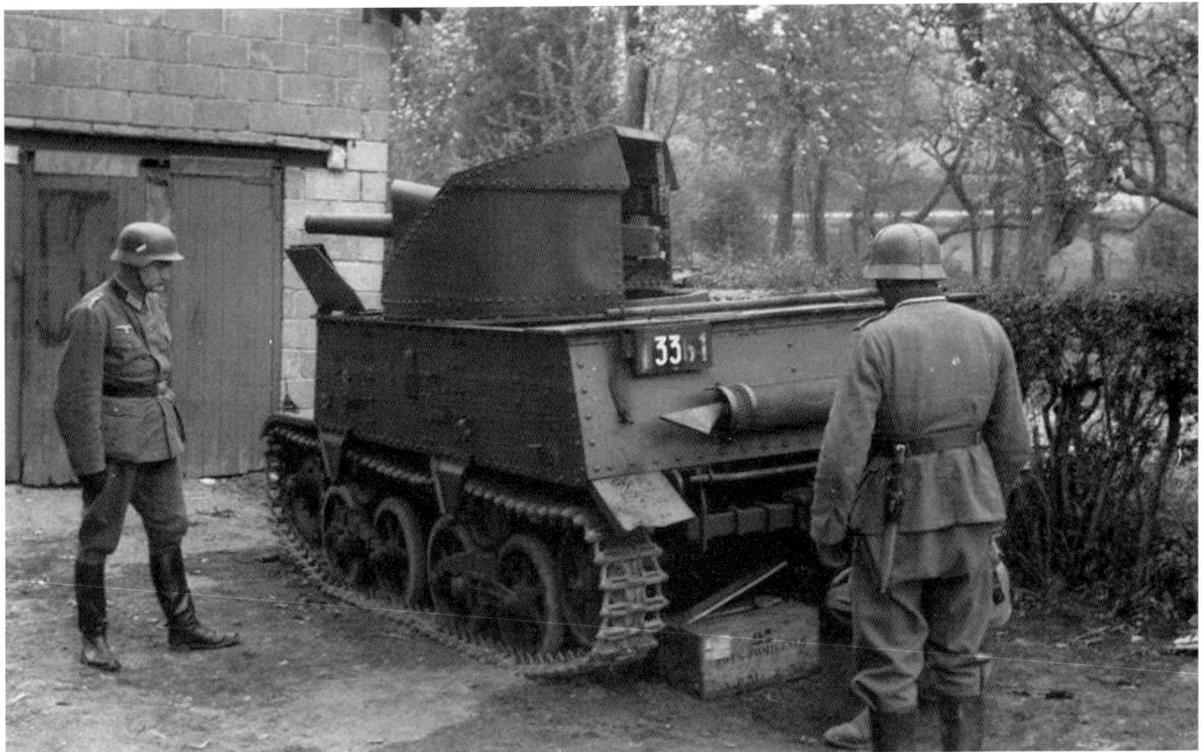

Belgian POWs, though they could easily be French. In 1940 the Belgian Army was dressed in almost the same khaki uniforms as in 1918. The soldiers' appearance was practically identical to the French, while the officers adopted a British-style service dress in 1935. These men were part of a regular army that numbered around 650,000 men in May 1940; they were among some 200,000 who were subsequently imprisoned.

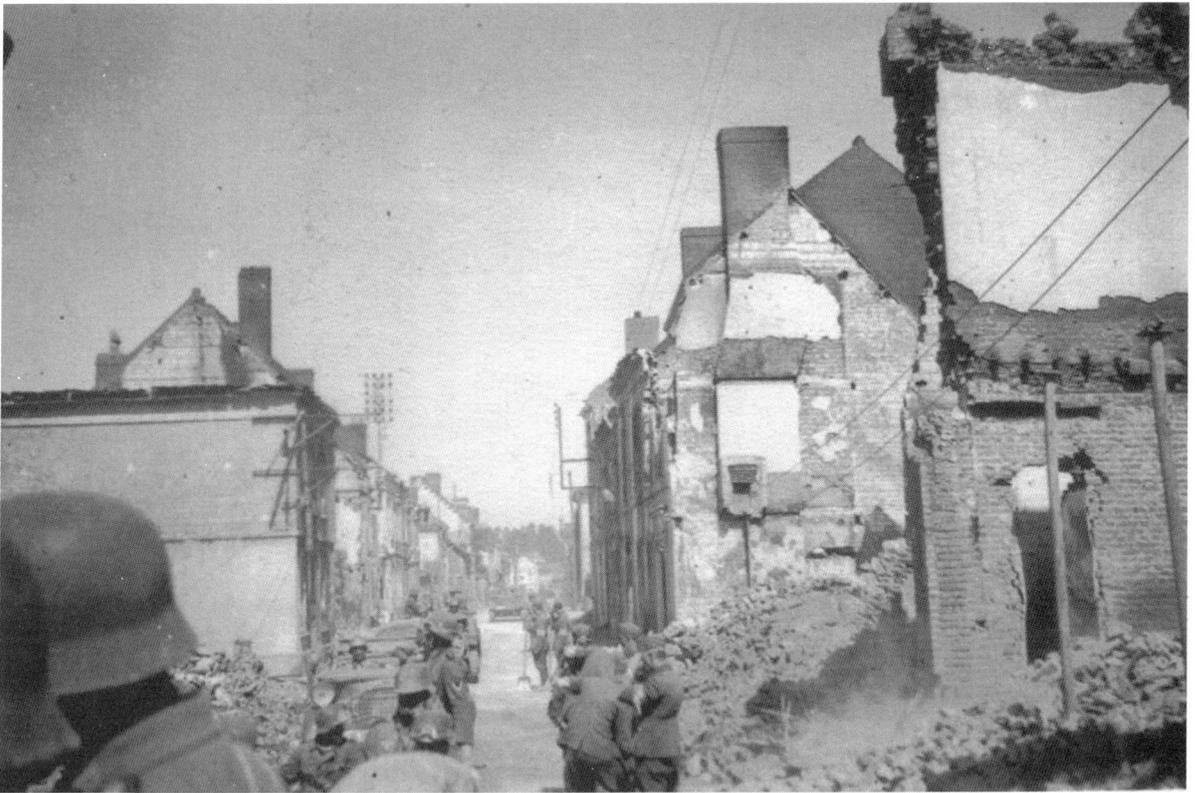

German columns, such as the one seen above, sped through the devastated streets of Belgian and Dutch towns with relative ease.

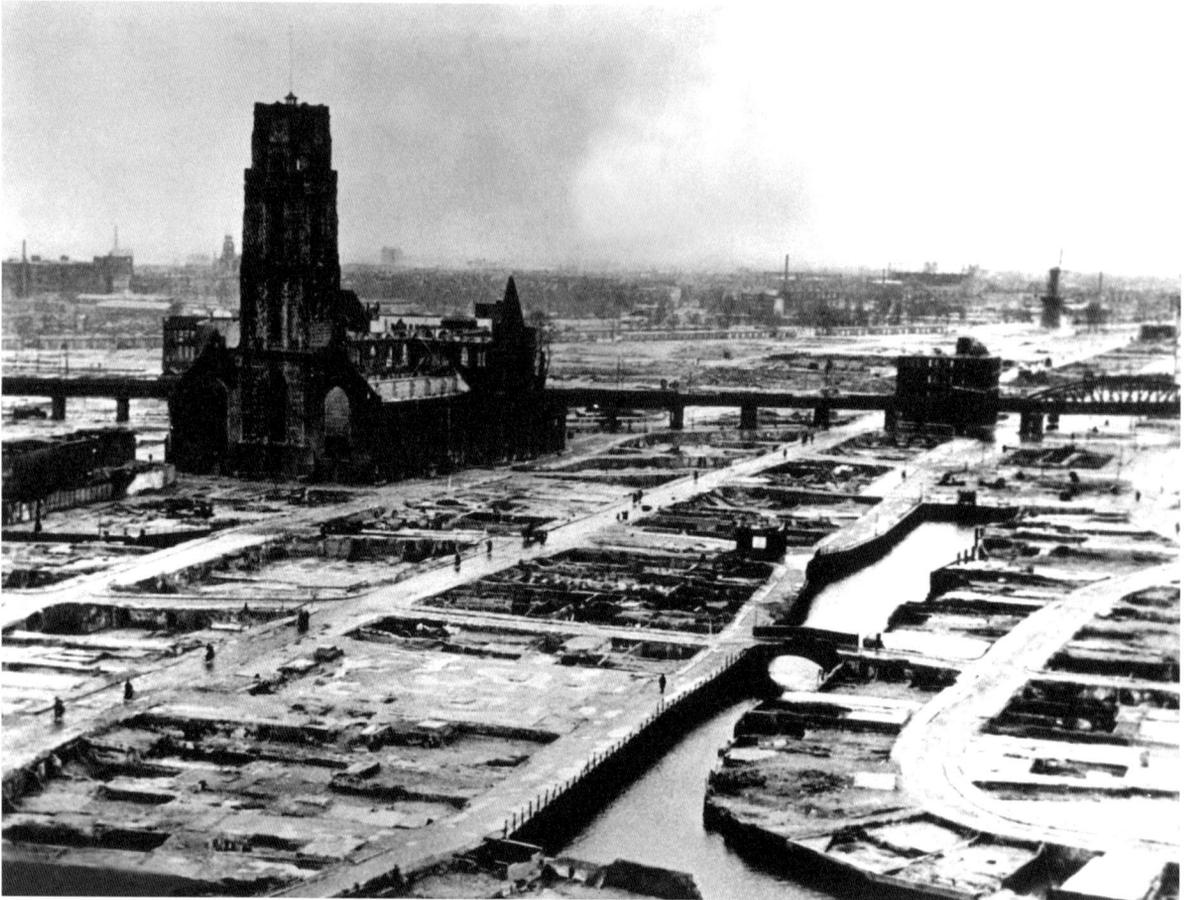

The reality of the Nazi Blitzkrieg – the smoking remains of Rotterdam. Bombing by the Luftwaffe to break Dutch resistance destroyed 25,000 homes and left some 78,000 civilians homeless. Belgium and the Netherlands lay prostrate before Hitler's forces and were forced to surrender.

Chapter Six

Blitzkrieg – Across the Meuse

The Luftwaffe conducted concerted surprise attacks on seventy airfields across France, Belgium and the Netherlands on 10 May – nine of these sites were used by the RAF. Luckily the latter suffered little damage but that was soon to change. In the air the Germans reigned supreme. Any Allied air attack was swamped by enemy fighters or halted by a hail of deadly flak. The British Advanced Air Striking Force had almost 140 bombers on the morning of 10 May – only half remained by dusk on the 12th. The RAF's wholly inadequate Battles and Blenheims suffered terrible losses as soon as they were committed to the battle.

The French thinking that the Belgian Ardennes region would shield them resulted in them placing their most ill-trained, ill-equipped troops who were unprepared to deal with the panzers at its exits. These forces were easily smashed and Corap's 9th Army scattered. Although half the French 7th Army was still protecting Sedan, Guderian moved to strike across the River Meuse while they were off balance.

Guderian stormed over on 13 May at Sedan brushing aside the French 55th Infantry Division. The latter was made up mostly of reserves lacking 75 per cent of their anti-tank guns, although they were well equipped with artillery. The division behind it, the 71st, had already lost almost half of its manpower due to leave and illness so could not help. Under sustained dive-bomber attack and artillery bombardment the 55th Infantry lost contact with the troops on its flanks and a gap opened up between the French 2nd and 9th Armies through which Guderian's panzers were pouring.

Although the French infantry were subjected to a terrifying air blitz on the morning of 13 May, they put up a stubborn resistance elsewhere along the Meuse. Three of the seven crossings attempted by the Germans failed completely and the others succeeded only after rather shaky starts. Luck was also a factor, and although two French armoured divisions were in a position to intervene, they were in a terrible state of chaos over their movement orders. They were never committed to the battle properly and became caught in the general chaos engulfing the French

Army. It was the lack of strategic reserves that meant the French swiftly ran out of options.

General de Lattre's regular 14th Infantry Division was ordered to move by road and rail to Rheims on 13 May, from where the advanced units were immediately sent to reinforce the threatened Sedan area. Combined with elements of another division plus the remnants of the French 9th Army, this force was ordered to plug the gap opened by the Germans between the French 9th and 2nd Armies. However, German dive-bombers constantly harassed the 14th Infantry's commander General de Lattre and his staff like so many others and it became impossible to coordinate his operations.

While the flanks of the German penetration were largely unprotected, with every hour the corridor grew wider and the forces in it more numerous. Rommel's 7th Panzer Division crossed the Meuse at Dinant in Belgium on 14 May and soon found itself under threat from the French 1st Armoured Division totalling 175 tanks, under General Bruneau. However, the next day the 7th and 5th Panzers launched a two-pronged attack on the partially refuelled French tanks. Lacking infantry, artillery and fighter support, the decimated 1st Armoured Division was flung back to the French frontier with just seventeen tanks. At Hirson the French 2nd Armoured Division suffered a similar fate when the 6th Panzer Division overran it.

The 6th Panzer Division and its Czech Skoda 35(t) tanks were highly efficient striking across the Meuse towards the Channel covering 217 miles in nine days. They had moved into the Wester Woods, east of the Rhine, at the beginning of March 1940 ready to take part in Operation Sickle Cut – the armoured thrust through the Ardennes into France. Skodas belonging to First Lieutenant Dr Franz Bake's 1st Company, 65th Panzer Battalion, spearheaded the attack on the Meuse. Unhindered by the French Air Force, the 37mm guns of Bake's Skodas, supported by assault guns armed with short 75mm guns, poured fire into the French defences across the river. They then forded on 13 May 1940, losing just one tank, which sank. Over the next three days Bake's Company accounted for seven French tanks, two of which Bake knocked out.

Every available Allied aircraft was then flung into the battle for the Sedan bridgehead on 14 May. The French Air Force tried first and was beaten off, and then seventy-one Battles and Blenheims were thrown into the attack losing forty of their number in the process. By nightfall both the French 2nd and 9th Armies were collapsing before the mounting German pressure.

Also on the 14th the subsequent anticipated French counterattacks failed to dislodge Guderian. The French threw in their only strategic reserve comprising the newly formed 3rd Armoured Division and 3rd Motorized Infantry Division, but over half the French tanks were knocked out. More French armour was on the way, but

along with the 71st Infantry Division they withdrew in the face of the advancing panzers. The following day, having suffered 5,000 casualties in 5 days of fighting, the Dutch Army surrendered.

On 16 May 6th Panzer Division's 35(t)s came up against a French armour counterattack, then four days later encountered the British 36th Brigade. Despite their mechanical shortcomings, 6th Panzer's Czech tanks gave a good account of themselves when they crossed swords with the formidable French heavy tank the Char B1-bis of the 2eme Division Cuirassée (2DCR), or 2nd Armoured Division. By the time of the attack on Guise Lieutenant Bake knew that their 37mm guns could not penetrate the frontal armour of the French tanks nor were they powerful enough to knock out an enemy tank with a single round. In one instance after a close engagement Bake and his crew took three shots to destroy the tank they were engaging.

Meanwhile General de Lattre wanted to remain north of the Aisne near Rethel to impede what he rightly deduced was the main German thrust. However by 17 May the 14th Infantry Division was holding a 13-mile front on the south banks of the Aisne and the Aisne Canal. For four days de Lattre's men contained the German attacks. The General himself understood that linear defence was simply a waste of time and operated an all-round concept based on mutually supporting defence zones usually anchored on villages and hamlets.

On 11 May 1940 Charles de Gaulle, at 49 the youngest general in the French Army, was appointed commander of the virtually non-existent 4th Armoured Division. Instead this was dubbed the 'de Gaulle Force', or 'groupement de Gaulle'. He was despatched to Loan with instructions to delay the enemy so that a front could be established on the Aisene and the Ailette to bar the approaches to Paris. Gathering a battalion of heavy tanks and two of light tanks but lacking infantry and artillery, on 18 May these forces counterattacked with the aim of capturing Sissonne and Montcornet. They straddled the roads to Saint-Quentin, Loan and Rheims and would bar the enemy's way west and to the front held by the French 6th Army.

General de Gaulle's light tanks reached Montcornet while the heavies arrived on the outskirts of Saint-Pierremont. German artillery soon began to take a toll on his light tanks. After the arrival of reinforcements de Gaulle's men overran a German column near Chivres. Retribution against 'groupement de Gaulle' swiftly came in the form of stuka and artillery bombardment. With the units on his flanks refusing to join his attack de Gaulle found himself in an exposed salient and had to withdraw. On the night of 26/27 May he was ordered back to Abbeville. Again he counterattacked with two battalions of tanks and a regiment of tracked carriers and this time drove the Germans back 14km.

Once the Germans were beyond the Meuse between Sedan and Namur, the British, French and Belgian position on the Dyle, Gembloux Gap and at Dinant was untenable. General Gamelin ordered a staggered withdrawal 45 miles west back to the Escaut River. With the Germans slicing through the Ardennes, British forces in Belgium were in danger of being cut off. While the BEF fended off heavy German infantry attacks, General Gaston Billotte, Commander of the First Group of Armies, which included the British, ordered a withdrawal to the Escaut or Scheldt Rivers on 16 May. This was done in an orderly manner, but ten days after the withdrawal the Belgians sued for peace. Seven British divisions were now committed to this new defensive line.

A German shell impacts in a French field sending up a huge shower of clods of earth. German artillery and air strikes heralded Hitler's assault on France and the Low Countries on 10 May 1940. The Luftwaffe conducted surprise attacks on seventy airfields. For the French and British forces this finally brought to an end the period known as the Phoney War.

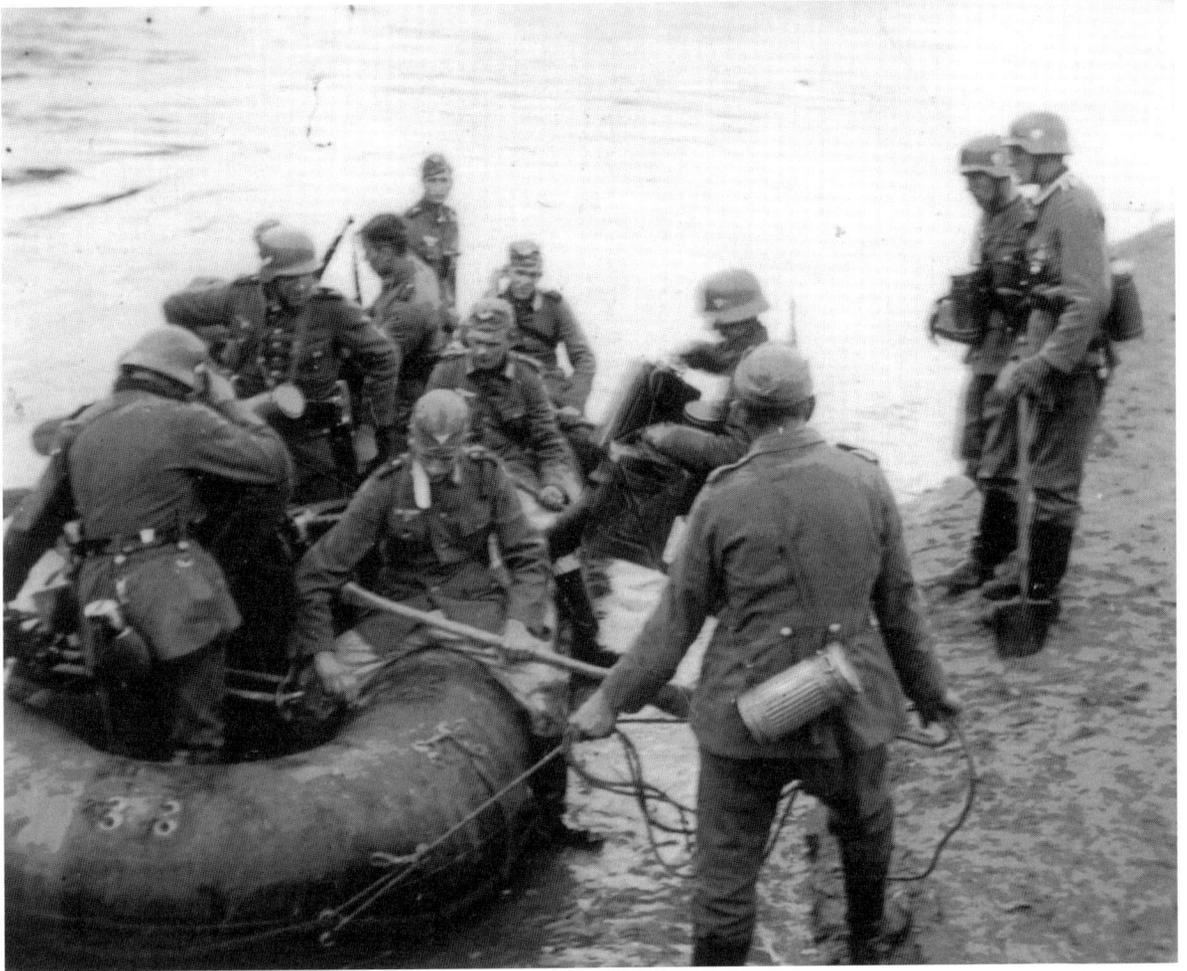

German infantry disembarking from a dinghy. On 13 May 1940 Guderian attacked across the Meuse at Sedan and the two French infantry divisions facing him soon collapsed.

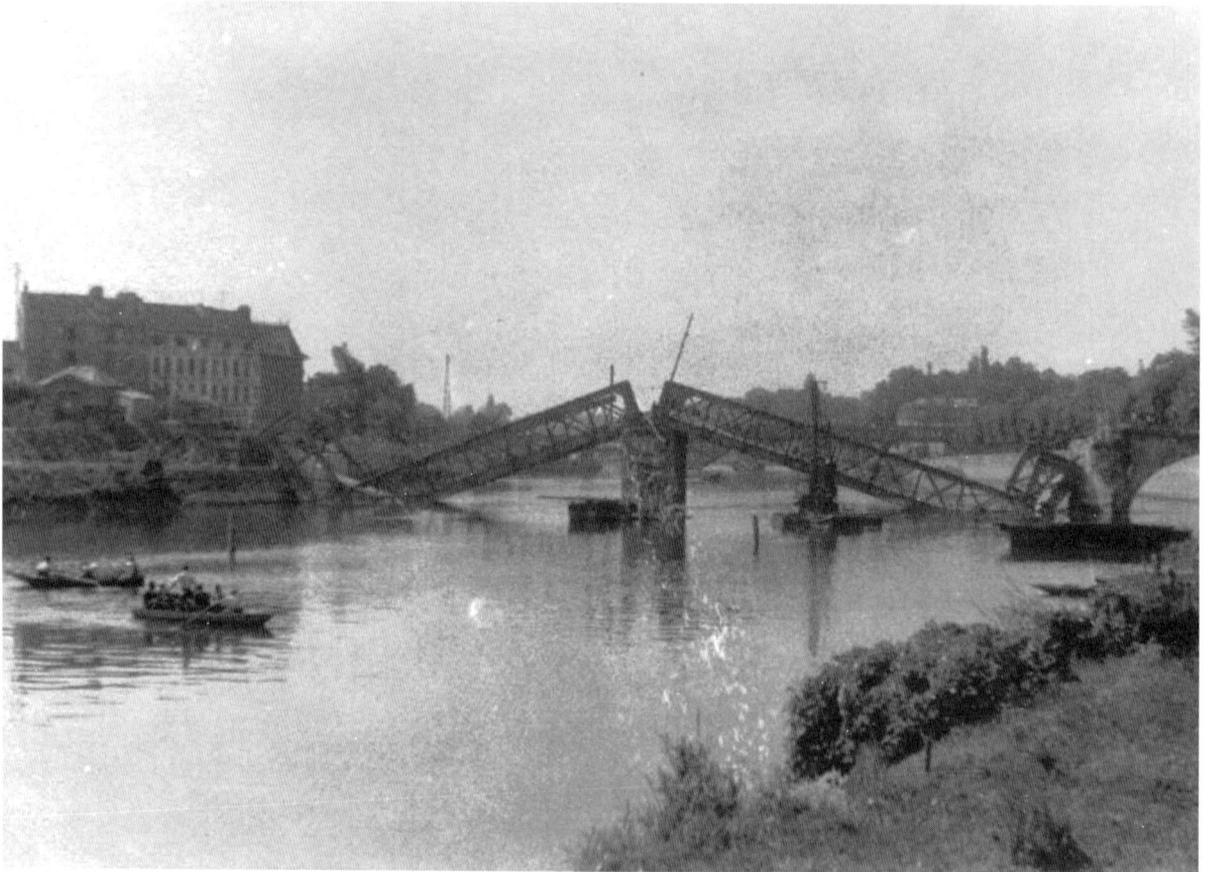

Above and opposite: Ultimately French efforts to stop the Germans getting over the Meuse were a failure. Although three of the seven crossings were halted, the others succeeded. Allied air attacks on the German crossing points were swiftly beaten off and the panzers swarmed over the river.

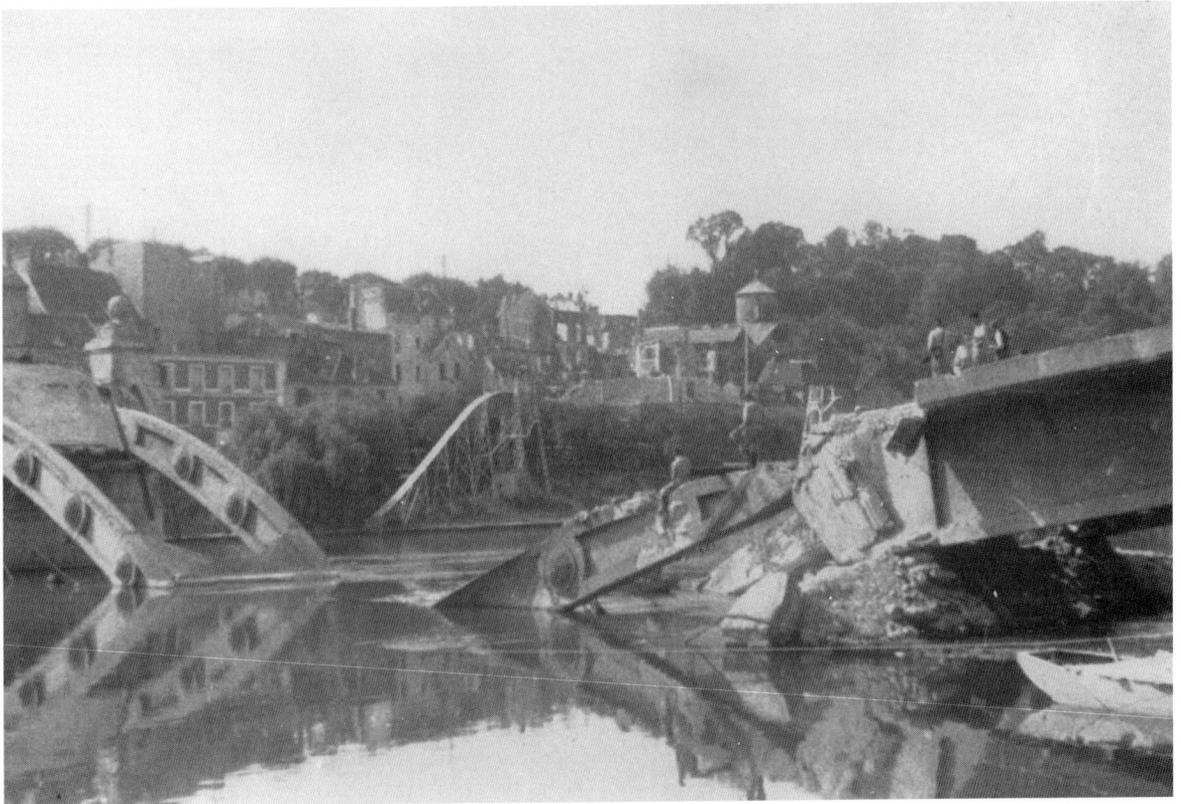

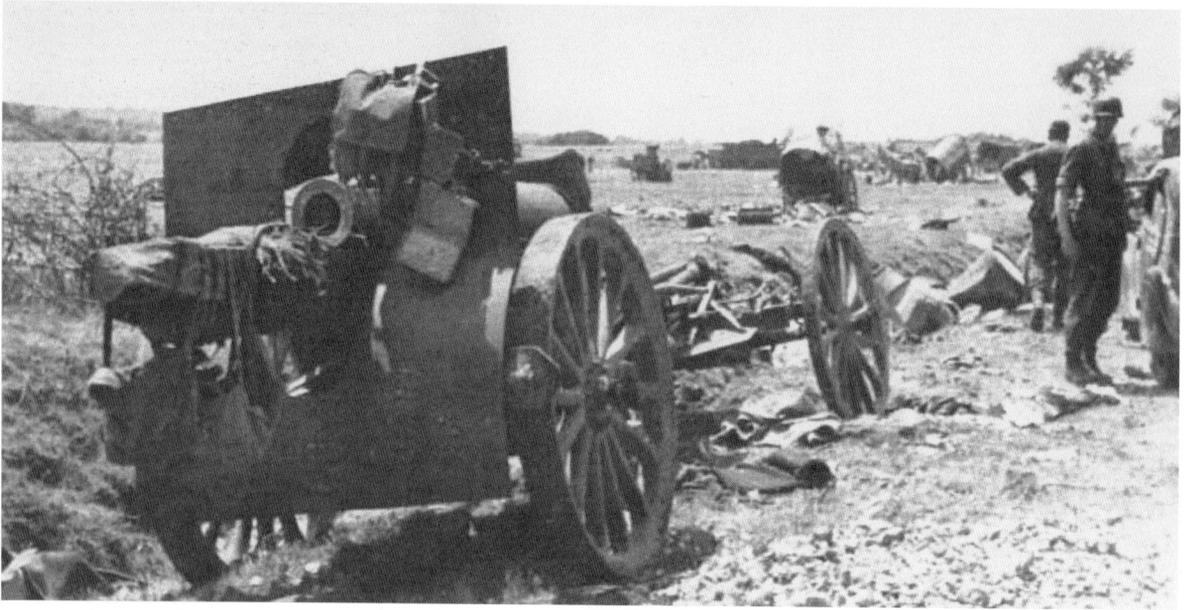

German troops examining an abandoned French howitzer. Judging from the debris, the crews were caught by enemy dive-bombers. The French 55th Infantry Division which bore the brunt of the German attack at Sedan was well equipped with artillery, but crucially lacked anti-tank guns.

In a highly touched up photograph a Panzer Mk I or II negotiates a pontoon bridge. Rommel's 7th Panzer Division crossed the Meuse at Dinant in Belgium on 14 May and soon found itself under threat from the French 1st Armoured Division totalling 175 tanks, under General Bruneau.

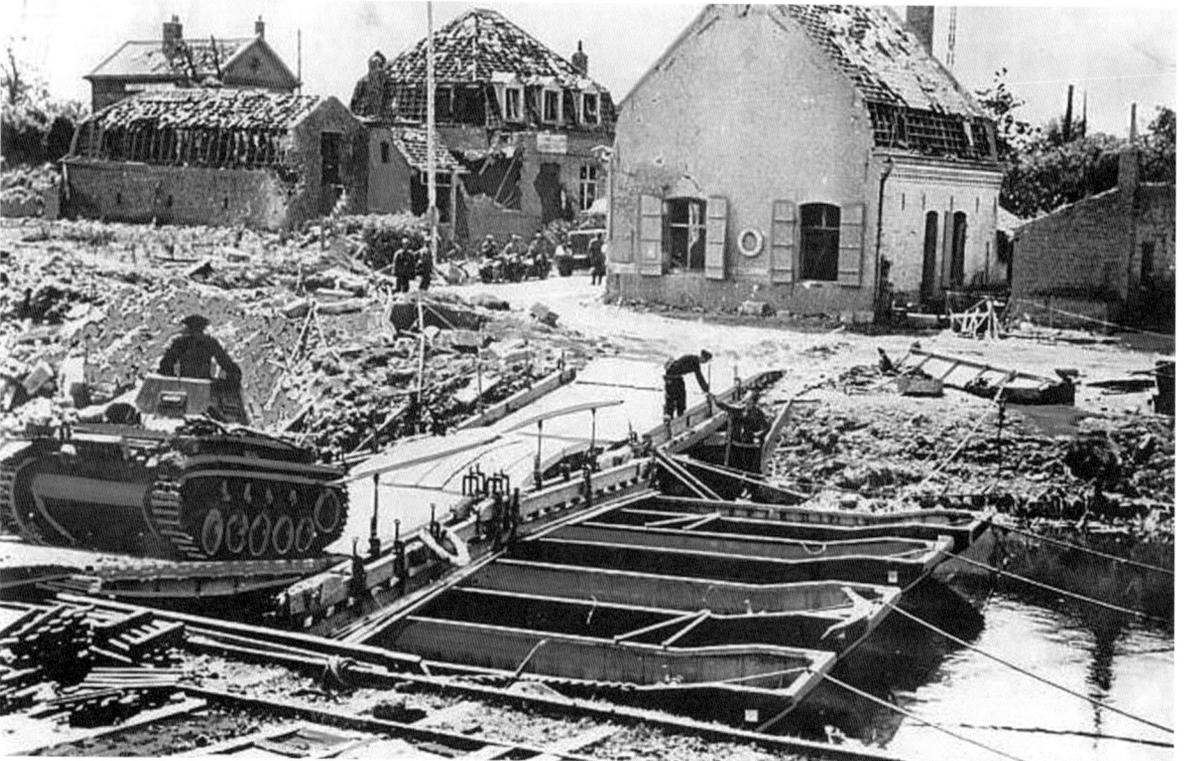

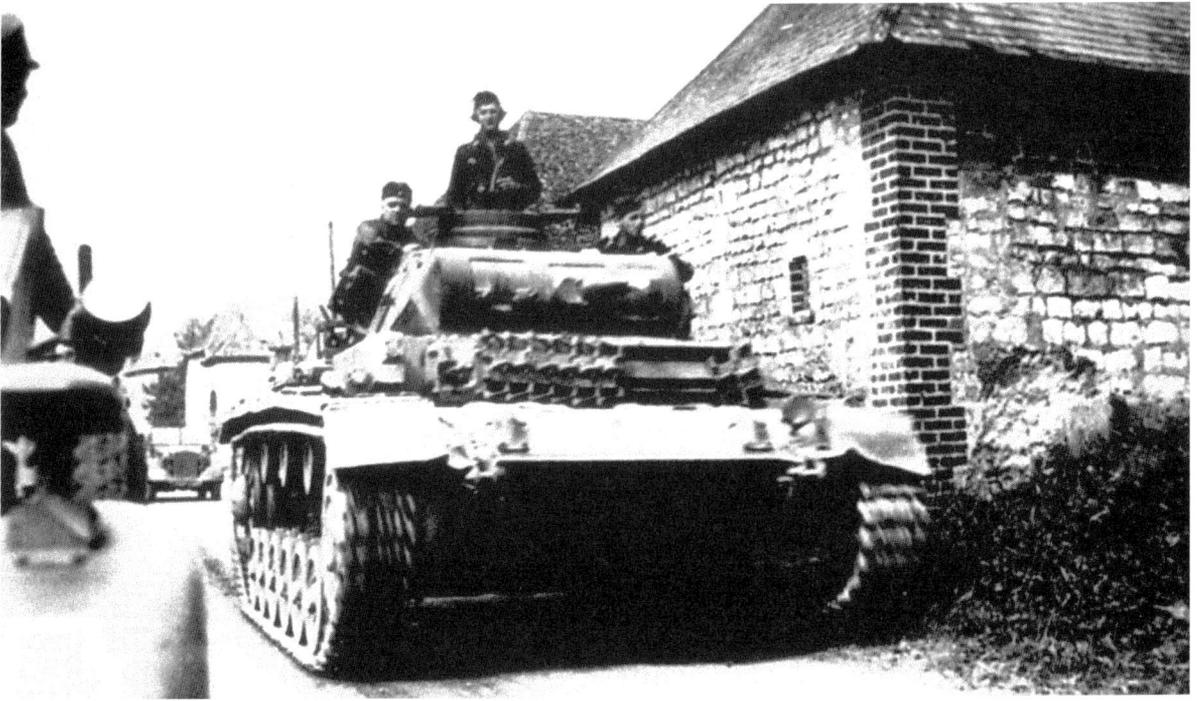

A Panzer Mk III is seen pushing into France. Three panzer divisions with support from the Luftwaffe soon made short work of the French 1st and 2nd armoured divisions, which struggled to stage coordinated counterattacks.

A horse-drawn German 105mm field gun crosses the Meuse – note the gun crew have stacked their helmets on the ammunition carriage. This is the leichte Feld Haubtize or LeFH 18 light field howitzer, which fired a 14.8kg shell with a range of 10,675m – over 5,000 of these were in service with the German Army by September 1939. It was either towed by horse or the Sdkfz halftrack.

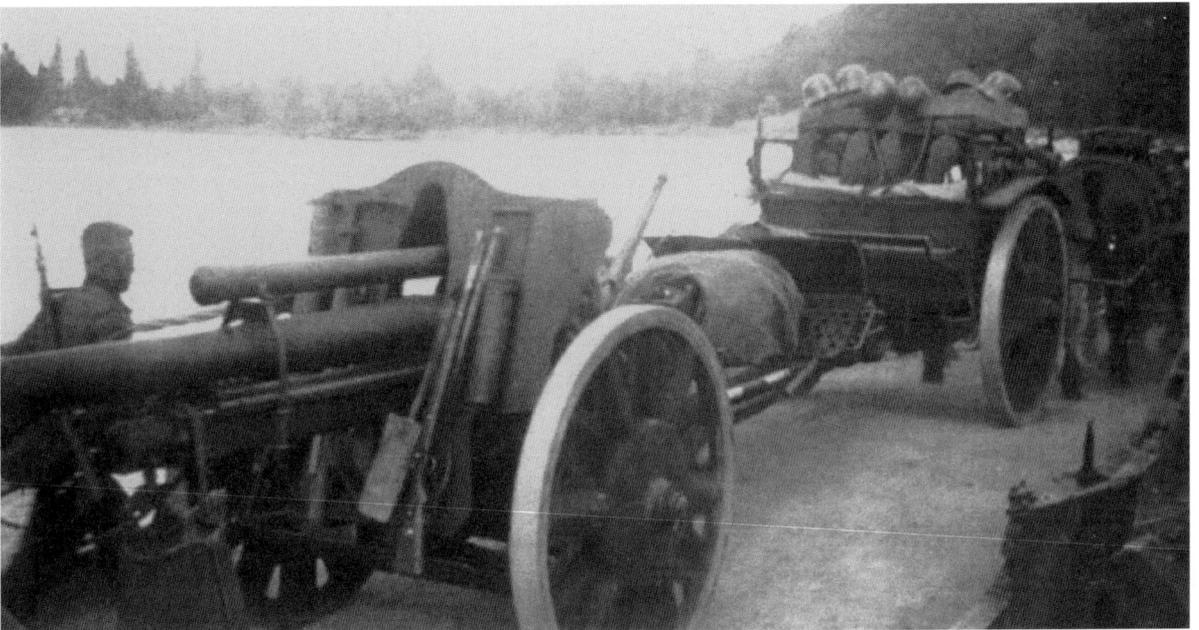

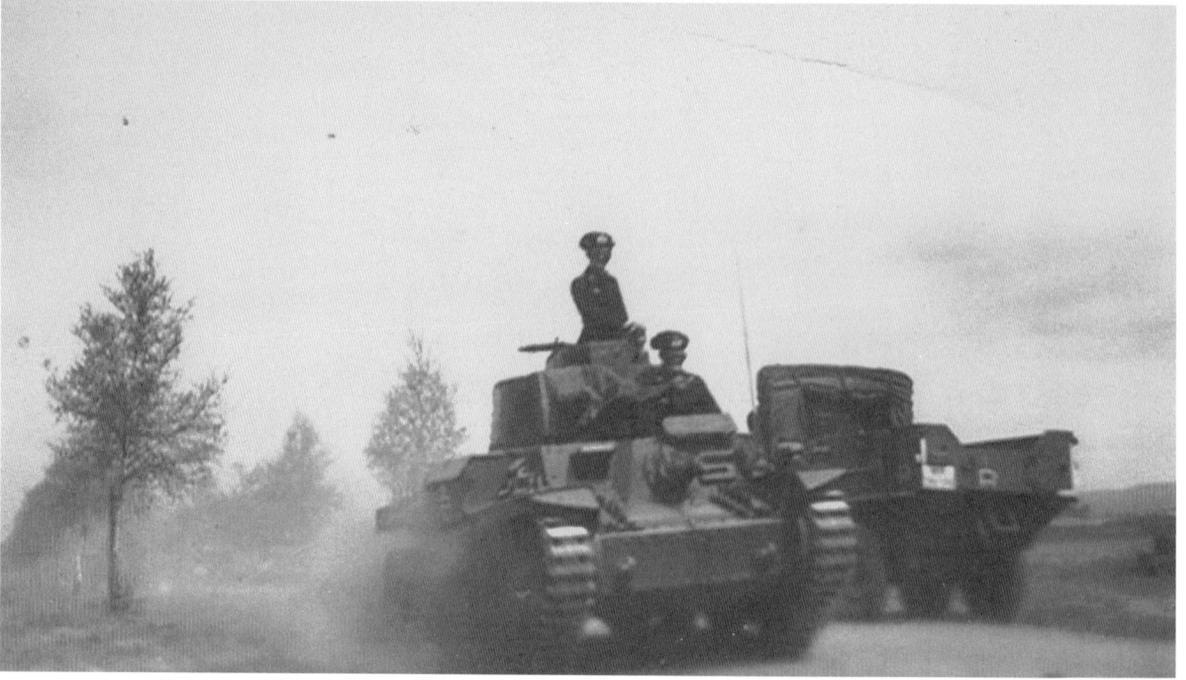

The Skodas of the 6th Panzer Division unhindered by the French Air Force forded the Meuse on 13 May losing just a single tank.

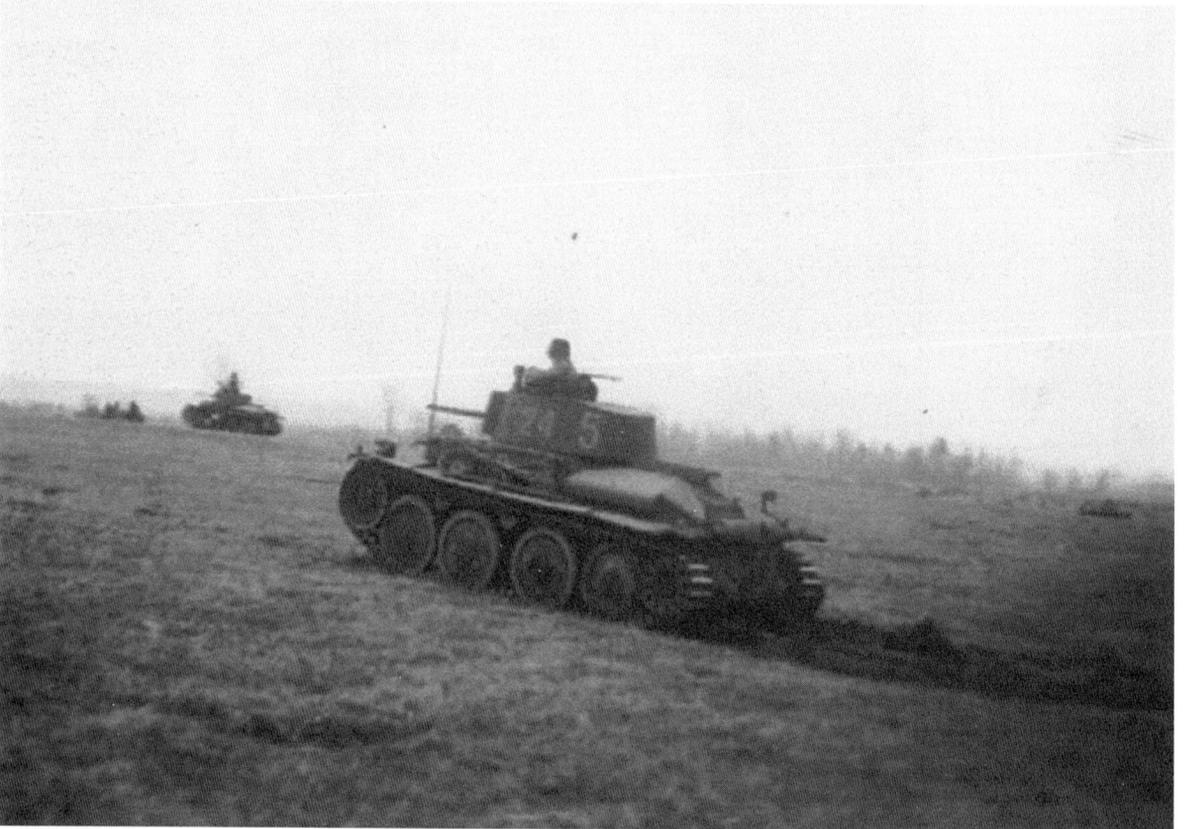

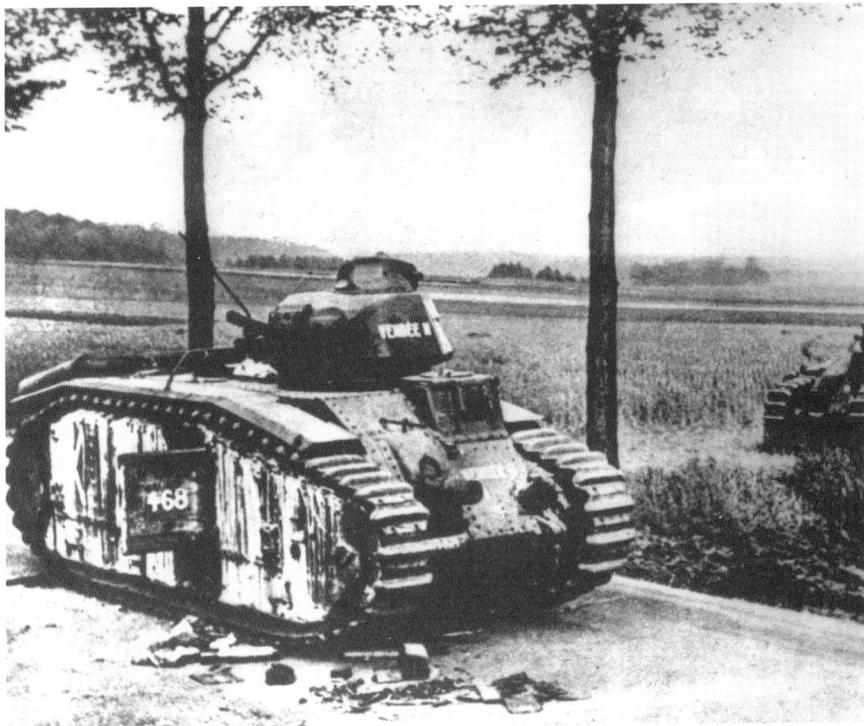

Two knocked out French Char B1-bis. On 18 May 1940 General de Gaulle's 4th Armoured Division counterattacked at Montcornet with heavy tanks and reached the outskirts of Saint-Pierremont. Although partially successful, the tanks found themselves at the mercy of German artillery and dive-bombers.

The panzers did not have it all their own way as this disabled LT-35 shows. The French 47mm anti-tank gun easily outgunned the German light tanks.

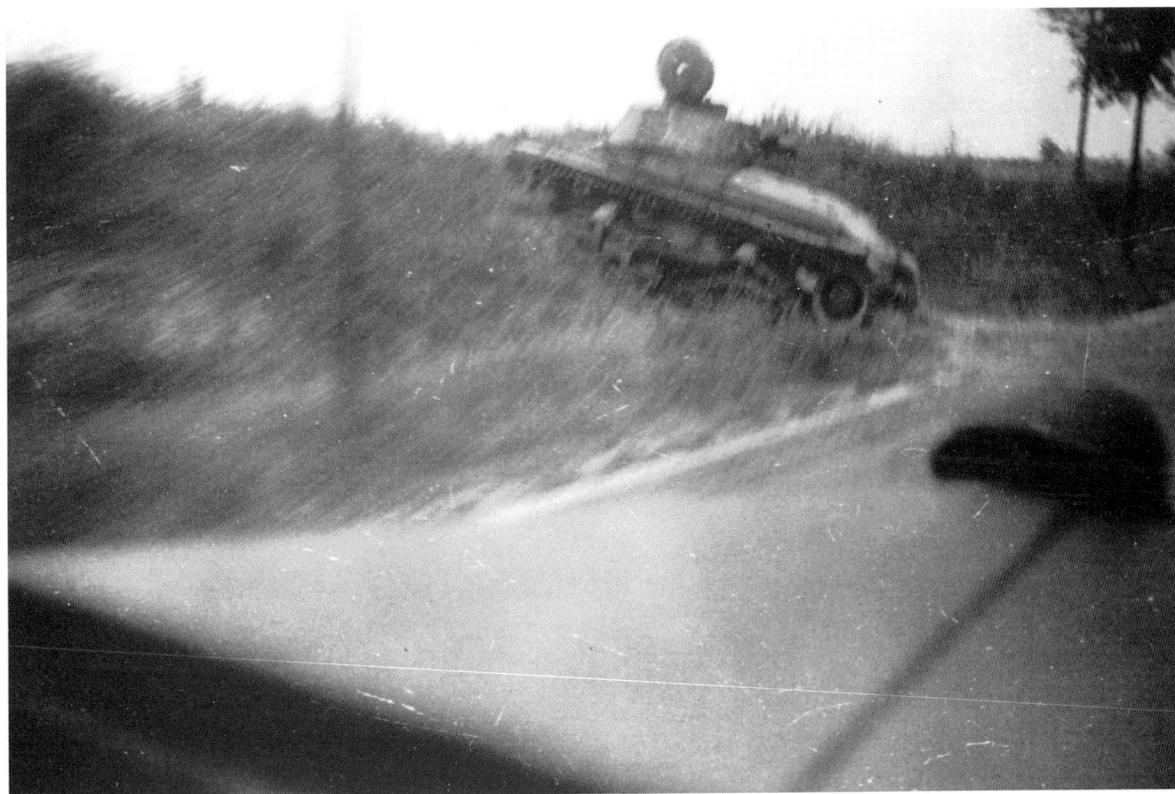

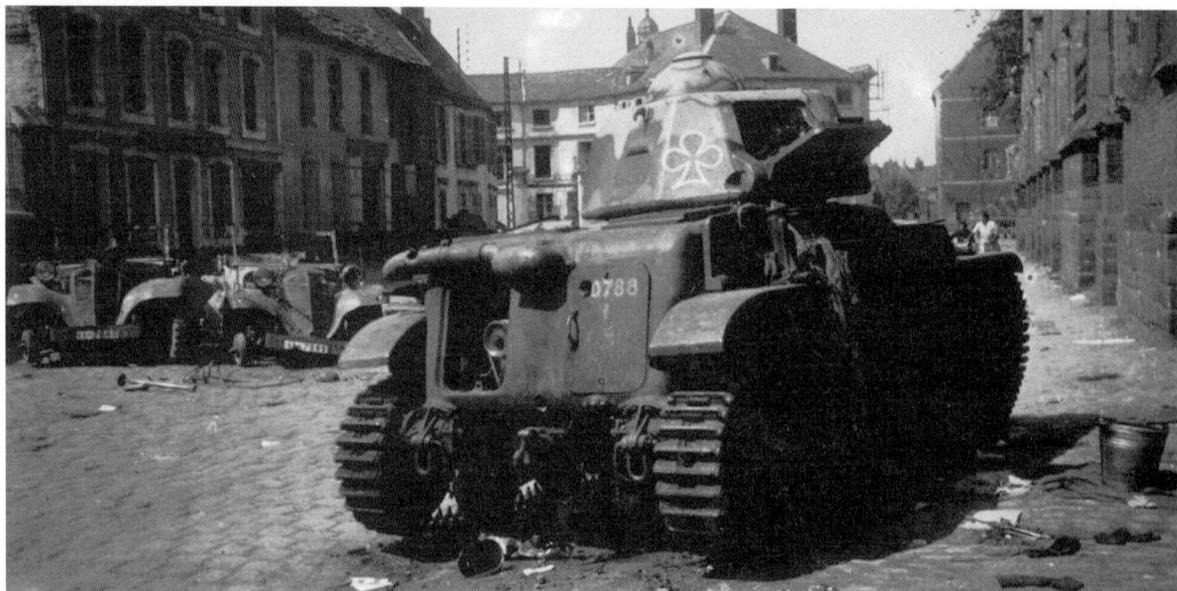

An abandoned French R-35 light tank – note the playing card insignia which were often painted on the turret for identification of sub units. The open turret hatch acted as a seat for the tank commander who had to aim, load and fire the 37mm SA 18 gun and the coaxial machine gun. Production amounted to upwards of 2,000 and when war was declared it was the most numerous of all the French tank types. Reportedly at the time of the invasion there were some 945 R-35/40s in front-line use, of which 135 were assigned to de Gaulle's 4th Armoured Division.

A German Opel Blitz lorry (note the French helmet trophy hung from the bonnet) passes two abandoned tracked French carriers.

This French town suffered at the hands of the Luftwaffe. The roofs and windows of the local shops have been smashed and the high street is strewn with debris. On the left a French woman trudges forlornly toward the wreckage.

German soldiers inspect their prize – a French FT-17 light tank.

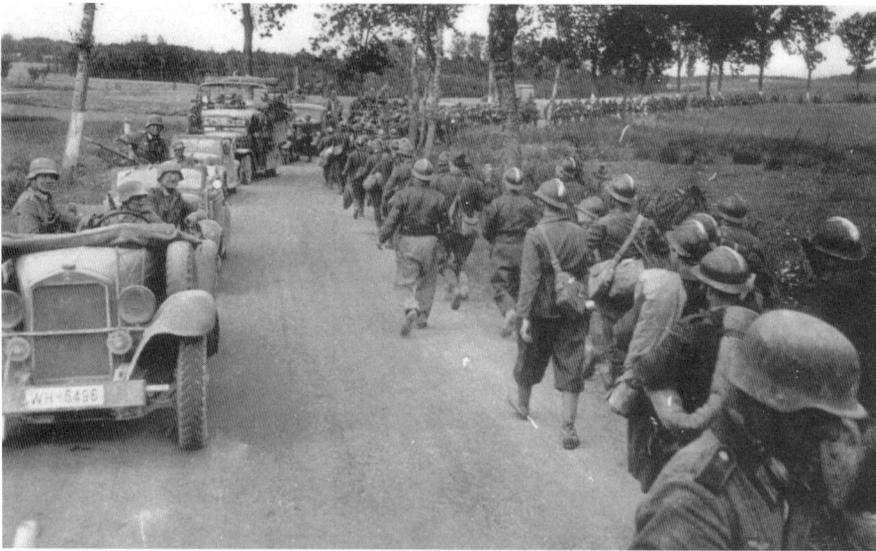

Left and middle:
French POWs are led to the rear. In the first shot a German motor vehicle column has stopped to gloat; most of the French are wearing the old Adrian type helmet.

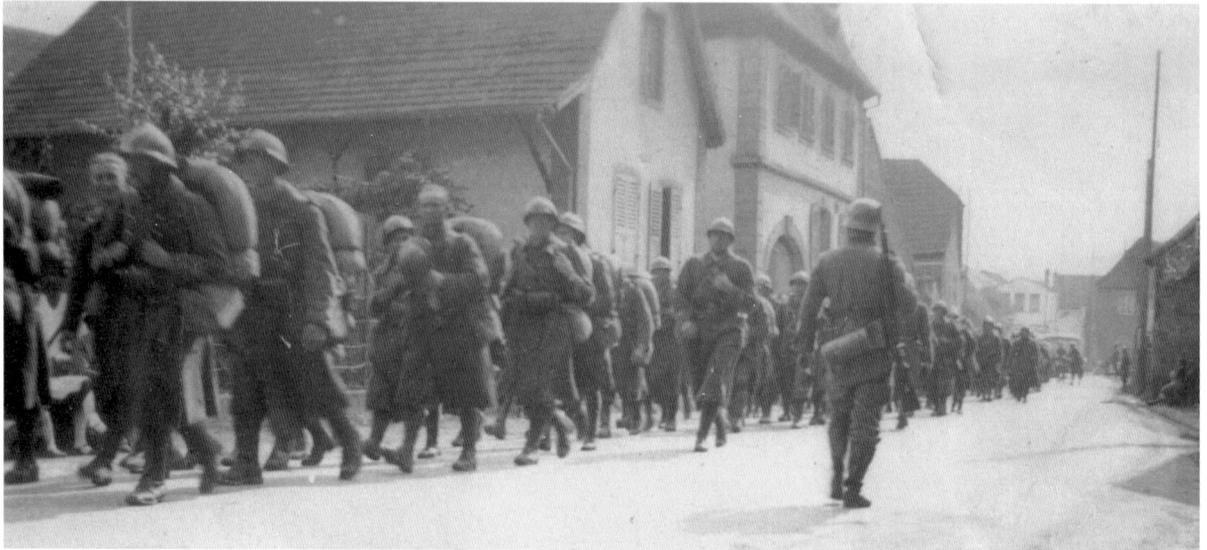

All too soon the RAF's Fairey Battle bomber squadrons were to face the grim reality of confronting the Luftwaffe in France.

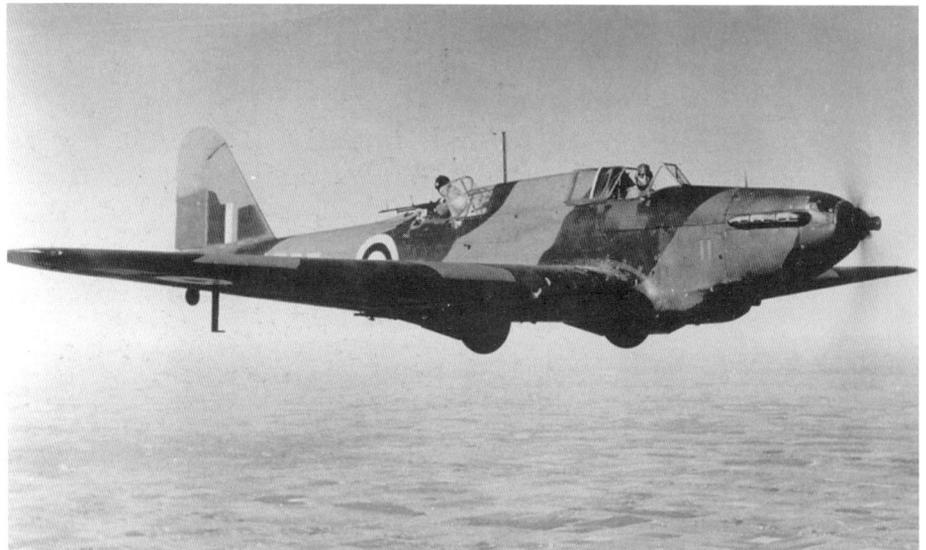

Chapter Seven

Desperate Situation – Counterattack!

The British 1st Tank Brigade was directed to Tournai, but arriving at Enghein Brigadier Pratt's tanks found that the railway station had been bombed by the Luftwaffe and that all the engines had dispersed. There was no choice but to take to the road. The Brigade gathered at Ath on 17 May, only to be sent on a fool's errand in response to reports of a German breakthrough. Eventually reaching Orchies, 16 miles south-east of Lille, Brigadier Pratt joined a scratch force under Major General Frank Mason Macfarlane, Director of Military Intelligence at GHQ, dubbed 'Macforce'. British tanks were designed to cover just 10 miles a day before maintenance; by the time they arrived back in Arras on 18 May they had travelled 120 miles.

Alarmingly by the 17th the French had exhausted all their reserves trying to stem the German tide and were not in a position to defend Paris. In a desperate all or nothing attempt to slice through the German spearhead General de Gaulle had launched his unsuccessful counterattack at Montcornet. Assuming the Germans would now turn on the French capital, General Alphonse Georges wanted to throw six divisions against the Germans' southern and north-western flanks. In reality his scattered and harassed forces were unable to concentrate for such a counterattack. On 19 May Gamelin was sacked by French Premier Reynaud and replaced by the 72-year-old General Maxime Weygand. That day General Erwin Rommel's 7th Panzer Division reached Cambrai, just 24 miles south of Orchies.

Within a week of getting over the Meuse seven German panzer divisions had pierced the French defences and on 20 May General Heinz Guderian's 19th Panzer Corps reached the Channel west of Abbeville. It should be pointed out that the panzers did not have it all their own way. The bulk of the panzer divisions comprised Mk Is and Mk IIs and by the time the forward units were gazing out over the English Channel at Abbeville many vehicles had suffered mechanical failure. At this stage the panzers had lost 40 per cent of their strength and could have suffered a defeat if the Allies had any strategic reserves. Nonetheless they had conducted one of the greatest flanking movements in history – the encirclement of the Allies in Belgium.

Now the French generals were in a state of despair and the British ones were alarmed at the prospect of being cut off from Cherbourg and Le Harve and home.

Guderian swept northward toward the ports of Boulogne, Calais and Dunkirk in an effort to cut off those British and French forces north of the River Somme. In the meantime early on the 20th the British 1st Tank Brigade and the 5th Division were ordered to the Vimy area north of Arras to reinforce the 50th Northumbrian Division. Placed under Major General Harold E. Franklyn, General Officer Commanding 5th Division, this force was known at 'Frankforce'.

After reaching Cambrai Rommel halted to allow his troops to catch their breath. He planned to resume his advance on the 19th, his destination the high ground south-east of Arras where the British Rear GHQ was located. General Hoth arrived and ordered Rommel to stay his hand. 'The troops have been twenty hours in the same place,' argued an exasperated Rommel, 'and a night attack during moonlight will result in fewer losses.' Hoth acquiesced. On the 20th Rommel's tank spearhead reached Beaurains just 2½ miles south of Arras at 0600hr. Unfortunately the motorised infantry were lagging behind so Rommel sped off to hurry them up. French troops caused him a few headaches for the next few hours until the infantry and artillery arrived.

Although Lord Gort had dismissed the Allied High Command's call for a joint Anglo-French counterattack, he could not ignore the wishes of Prime Minister Winston Churchill. Aware of the deteriorating situation in France, General Sir Edmund Ironside, Chief of the Imperial General Staff and the most senior British Army officer, was sent to France to see Gort in person. Ironside wanted Gort to commit the whole of the BEF to an attack, but Gort could not withdraw those troops fighting on the Scheldt without opening up a gap in the defence between the BEF and the Belgian Army. To make matters worse the Germans were moving around the British right flank between Arras and the Somme.

The situation for the British was very desperate; the BEF had just four days worth of supplies remaining and barely sufficient ammunition for another grapple with the Germans. Although Gort's options were limited and diminishing by the day, he still had the 5th and 50th Divisions that could strike toward the Somme. It was hoped that the new French Commander in Chief General Weygand might marshal his forces and attack the gap from the south.

General Ironside seeking out General Billotte found him at Lens with the commander of the French 1st Army, General Georges Blanchard. Ironside was appalled at the state of apathy exhibited by the French generals and shaking Billotte in a fit of rage declared, 'You must make a plan. Attack at once to the south with all your forces on Amiens.' The French 1st Army informed General Franklyn that it could not mount an attack towards Cambrai for two days.

General Franklyn tried to coordinate his efforts with two senior French officers, Generals Prioux, of the Cavalry Corps, and Altmayer, of the French 5th Corps, on 20 May. Also present was General Billotte, in theory Lord Gort's superior, but Franklyn had no idea who he was. Altmayer announced he planned to launch the 250 tanks of the French 3rd Light Mechanised Division south the following day. However, the French were unable to get into position until the 22nd due to fuel shortages and the exhaustion of the crews. In reality all the 3rd Light Mechanised could muster were about 60 Somua tanks having already lost its H-35 tanks.

Altmayer though was a broken man. Liaison officer Major Vautrin was sent to the general's HQ to get him to commit to the venture. Vautrin reported back to the High Command, 'General Altmayer, who seemed tired out and thoroughly disheartened, wept silently on his bed. He told me his troops had buggered off. He was ready to accept all the consequences of his refusal (to go to Arras) . . . but he could no longer continue to sacrifice the Army Corps of which he had already lost half.' In contrast GHQ was considering 'Frankforce' as a major element of the forthcoming British and French counterattack.

Franklyn, intent on supporting the Arras garrison, deployed 5th Division's 13th Brigade to the east on the Scarpe facing Pelves, while its 17th Brigade was held in reserve north of Arras. The 150th Brigade from 50th Division took up position east of the town on the 13th's right flank. To the west the 151st Brigade joined 4RTR and 7RTR of the 1st Tank Brigade.

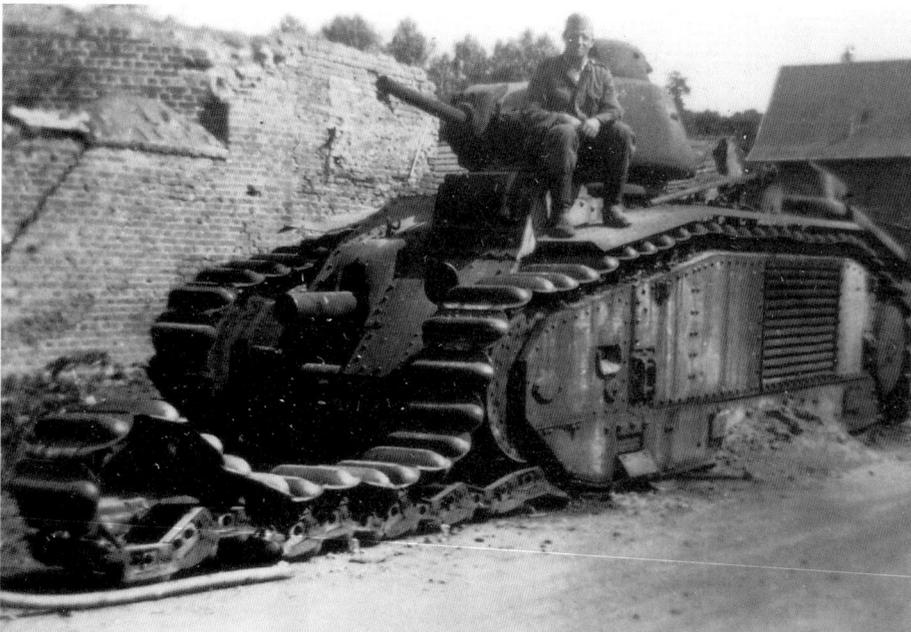

At 30 tonnes, with 60mm of armour plus a 75mm gun in the hull and 47mm anti-tank gun in the turret, the B1-bis was the most powerful tank in Western Europe in 1939–40. The initial B1 had a 25mm turret gun.

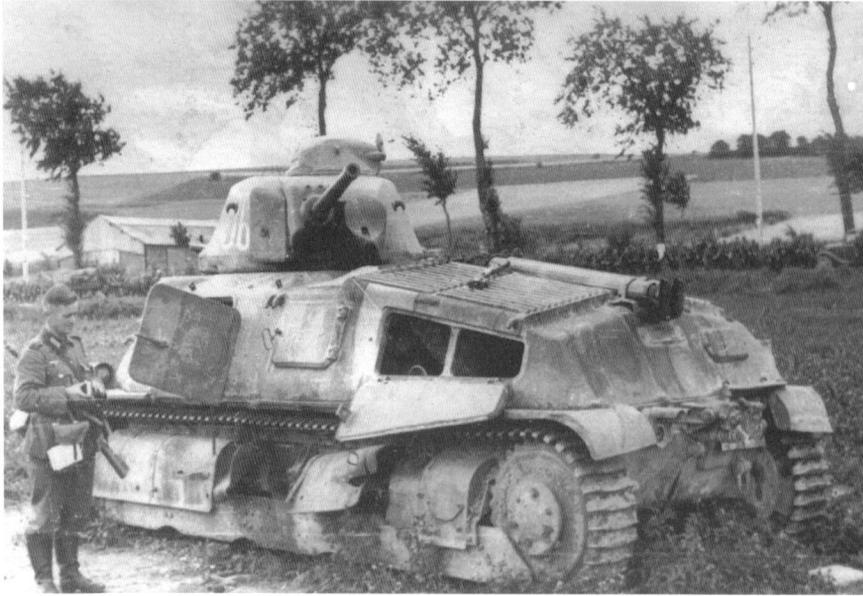

The heavily armoured 20-tonne French Somua S-35 was the backbone of the French cavalry and mechanised divisions. While French armour was organised into regiments, consisting of two battalions, these were only peacetime formations, which on mobilisation were supposed to fight in tank battalion groupings. In reality the tank battalions fought singularly and often at just company or just platoon strength with inevitable results.

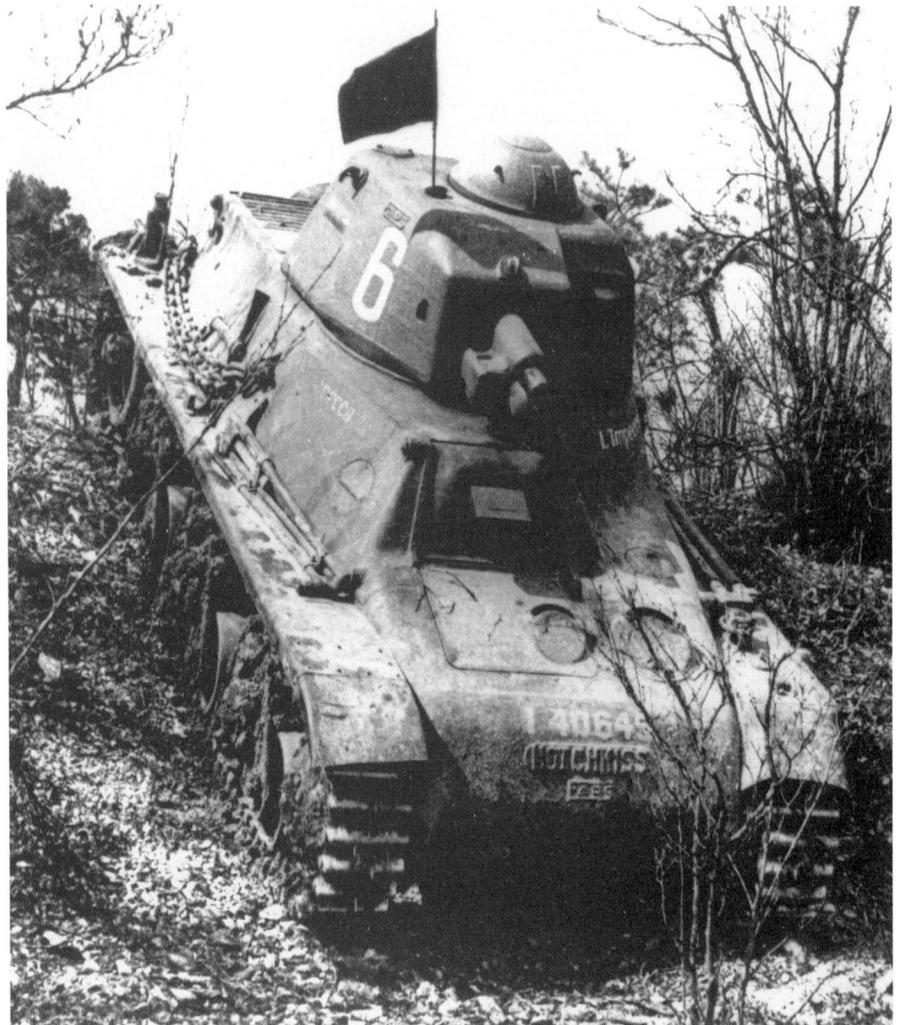

Judging by the near horizontal rear engine deck (as compared to the sloping deck of the H-35) this Hotchkiss light tank is either the interim H-38 or an early production H-39 armed with the short-barrelled SA 18 37mm gun. Generally the later H-39 was equipped with the long-barrelled SA 38 37mm gun which had double the muzzle velocity.

More knocked out French B1-bis. The photograph to the left shows that this tank's rear armour took eleven hits, while the tank in the photograph below has had its turret blown clean off and the fighting compartment ripped open.

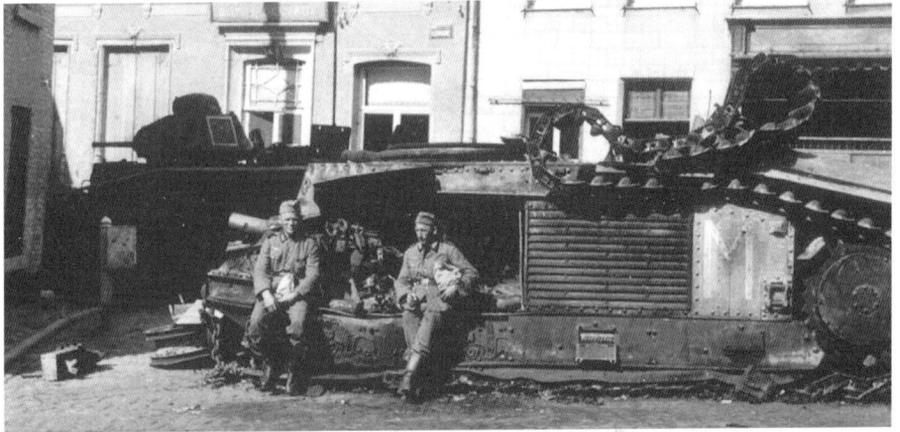

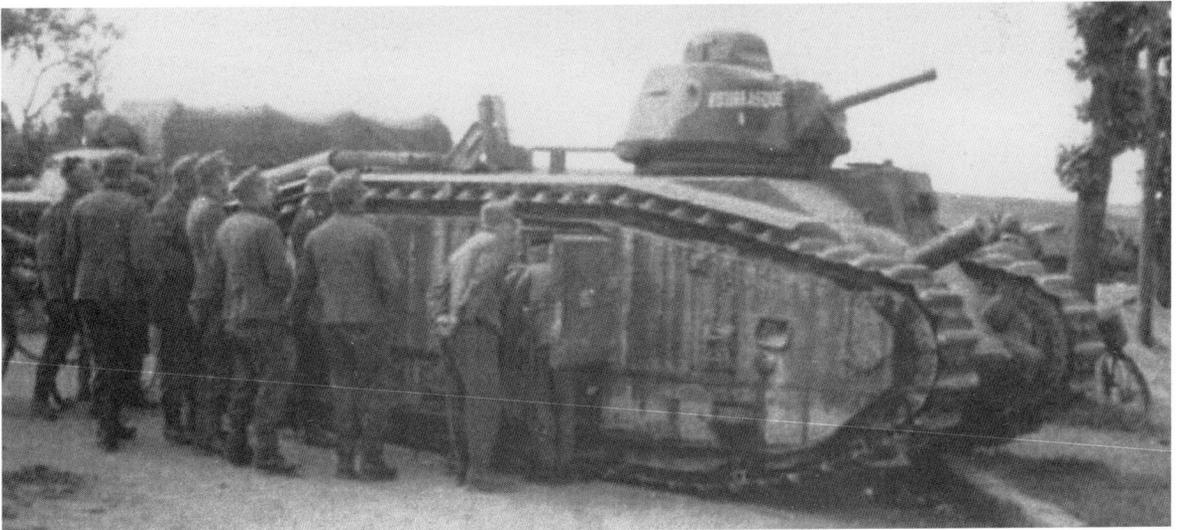

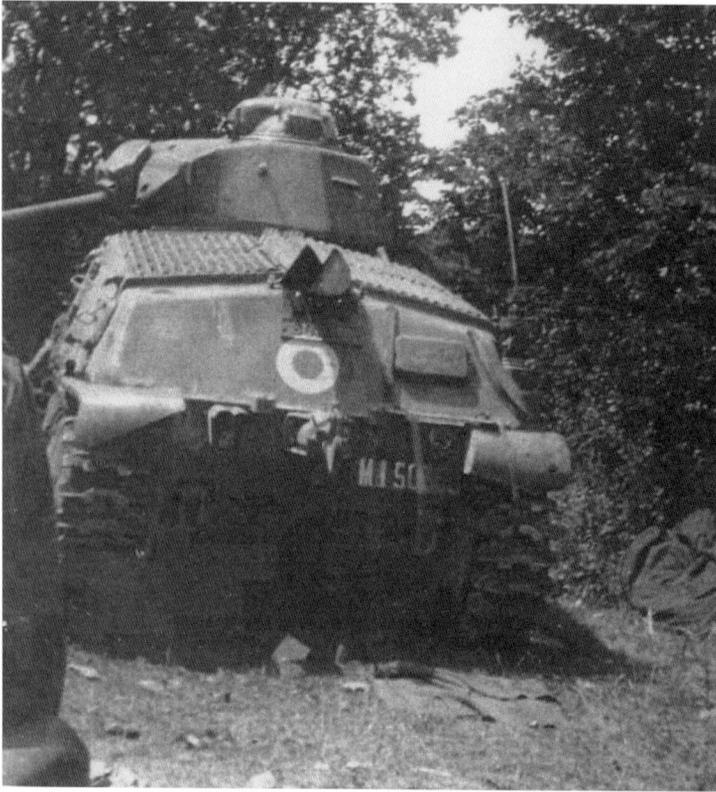

More knocked out French tanks, this time the S-35; the turret is derived from that of the B1-bis and D-2 tanks. Note the relatively compact silhouette, it was built from cast armour. Originally this was classified as an Automitrailleuse de Combat (AMC) but was later re-designated Char de Cavalrie and became one of the principal tanks of the Division Légère Mécanique. Each of these mechanised cavalry divisions had one regiment (two squadrons) of S-35s in its tank brigade along with a regiment of Hotchkiss H-39s.

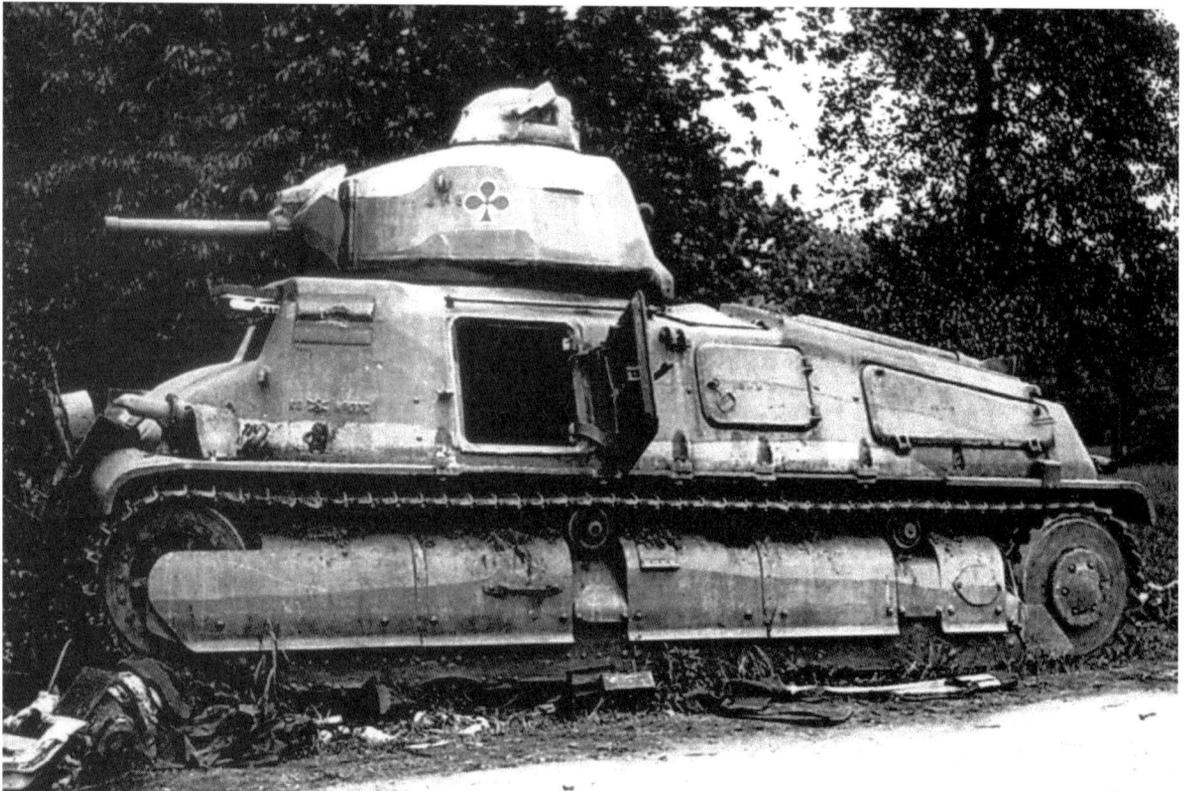

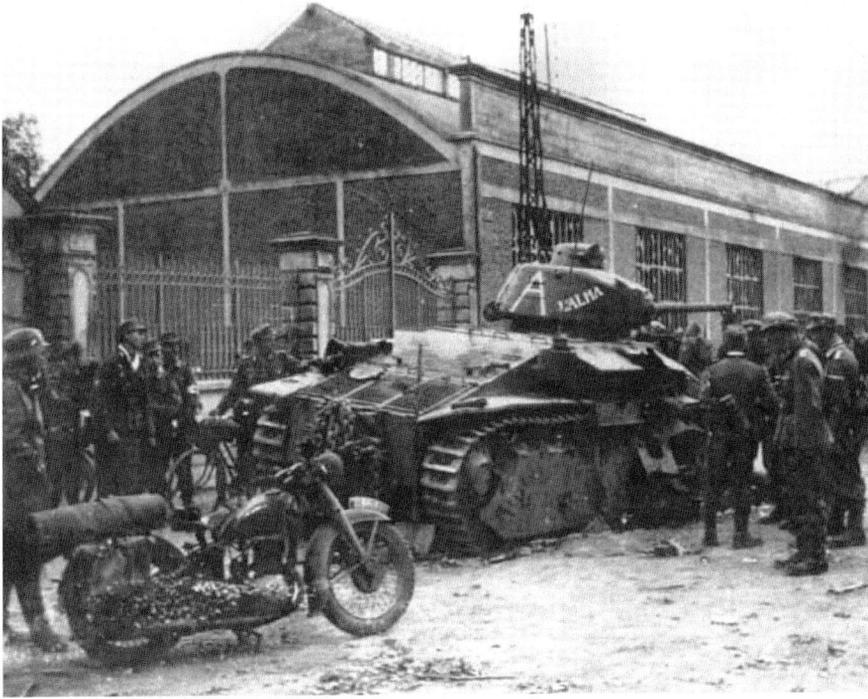

These German troops are examining a Char Moyen Renault D-2. This was one of the first modern types of infantry medium tank to be supplied to the French Army after the First World War. The Char D-2 appeared in 1933 but had been largely superseded by the Char B series by 1940. However, it still remained in front-line service and notably was issued to de Gaulle's 4th Armoured Division.

This burning tank appears to be a Panzer Mk I. The French 47mm anti-tank gun was more than capable of tackling this model of panzer.

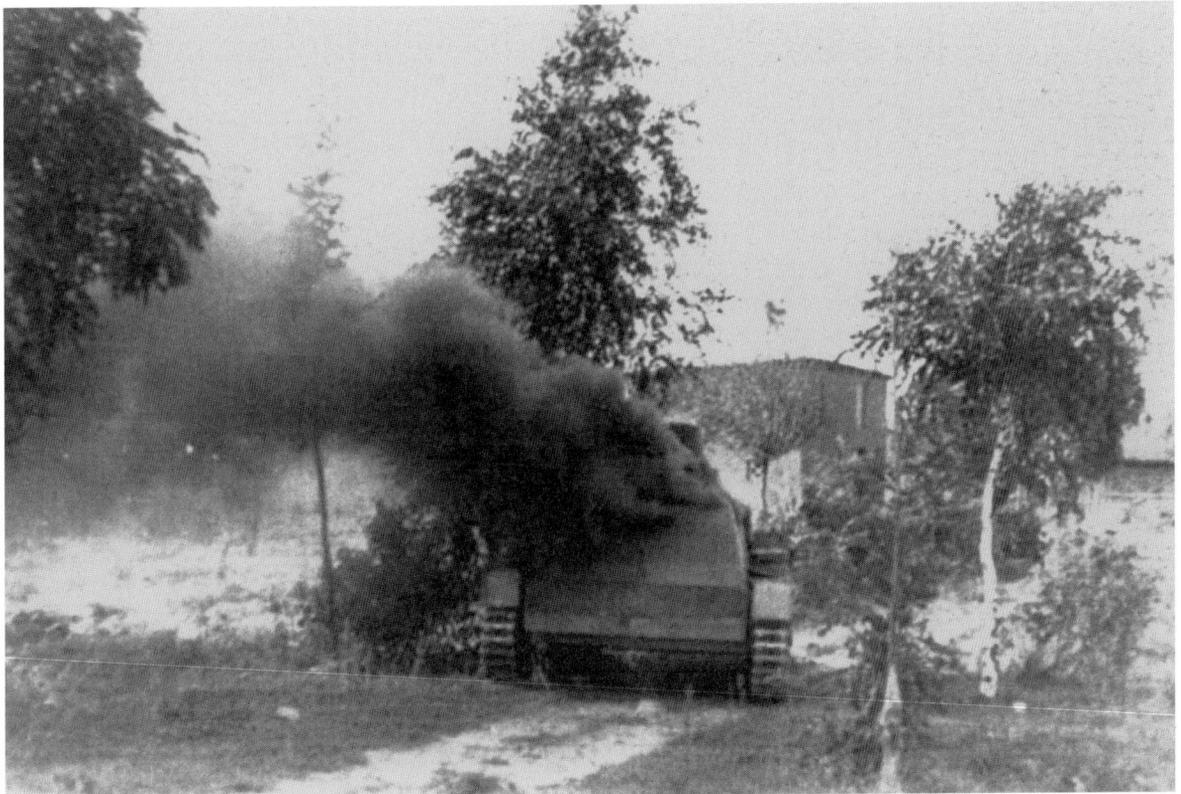

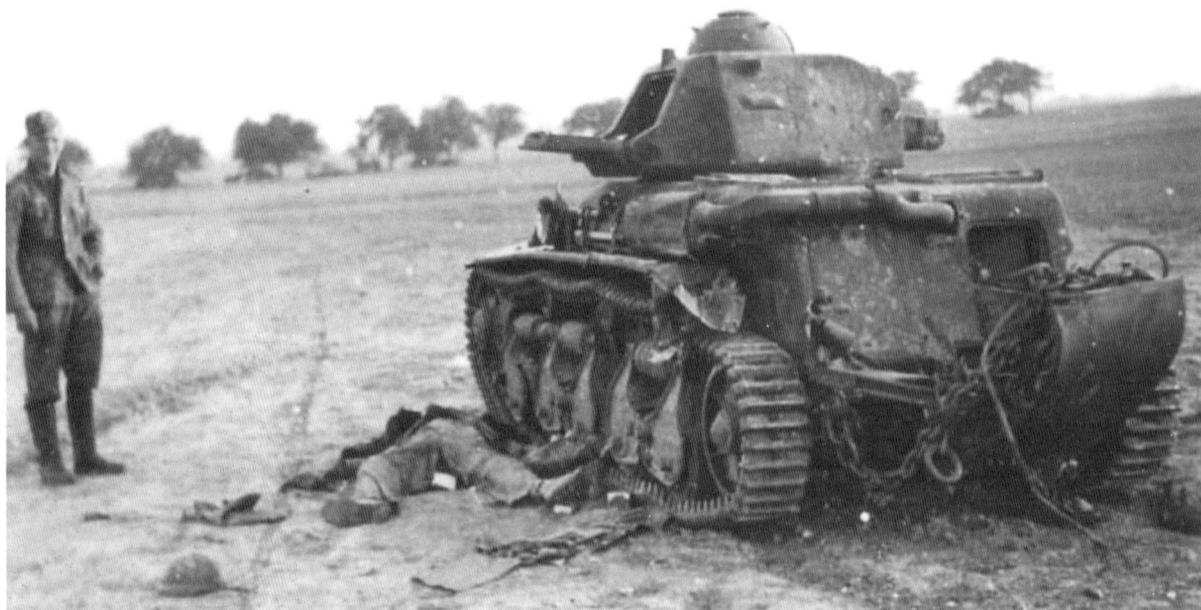

On 14 May General Brocard's 3rd Armoured Division and General Bertin-Boussu's 3rd Motorised Infantry Division were launched into a counterattack. They lost half their tanks for their trouble. In the photograph above the French crewman lying on the ground was unable to escape his stricken R-35. In the image below the S-35 in the foreground appears to have been abandoned after its crew tried unsuccessfully to get it off a cobbled road. Behind it is a Char Léger Hotchkiss H-35, which also seems to have been abandoned. The raised engine cover indicates that it may have broken down.

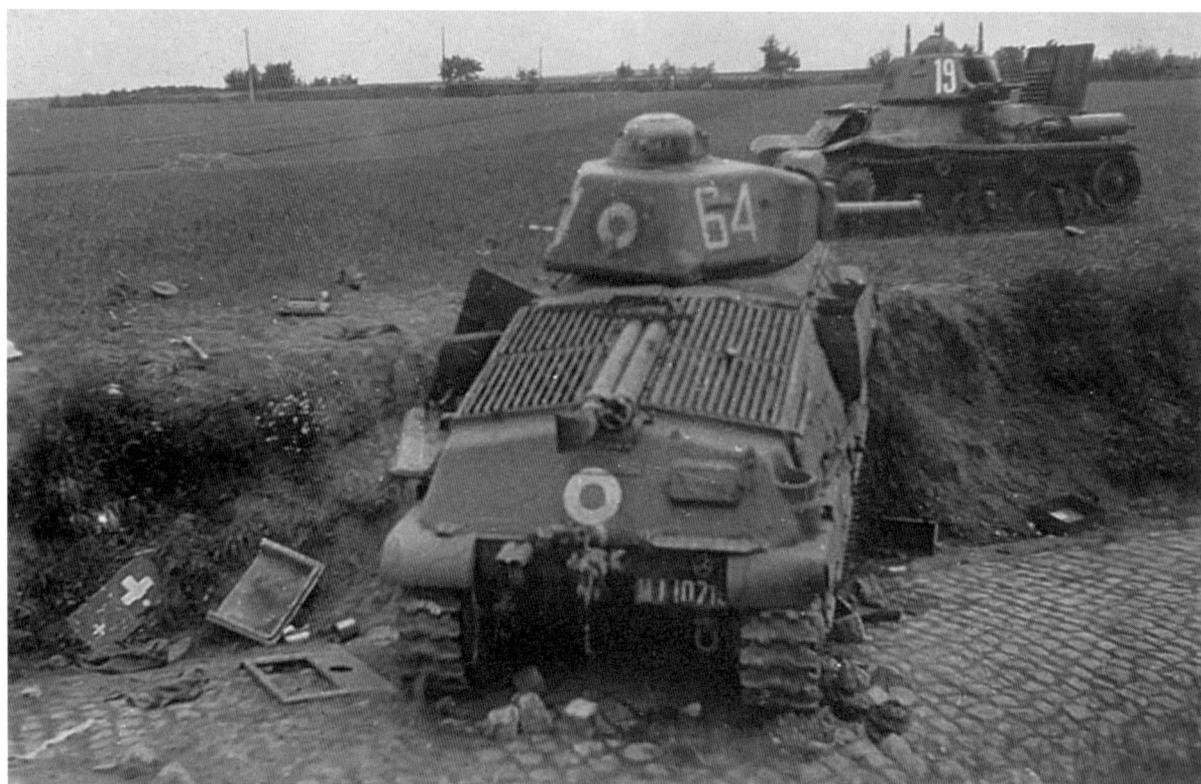

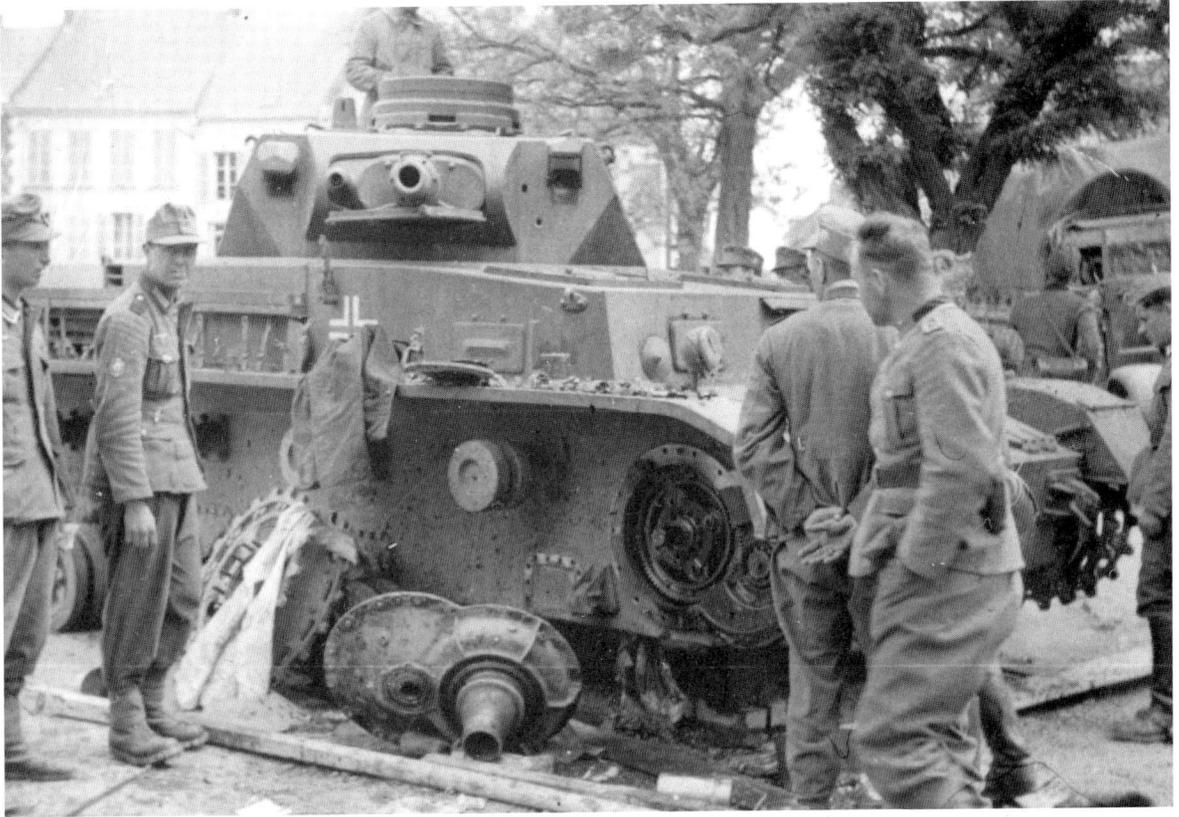

These Germans are looking at what appears to be a Panzer Mk IV Ausf C or D armed with a short 75mm anti-tank gun. By May 1940 every tank detachment had a medium tank company of six to eleven Panzer IVs. At the start of the campaign against France there were 280 Ausf A, B, C and D Mk IVs in the panzer divisions.

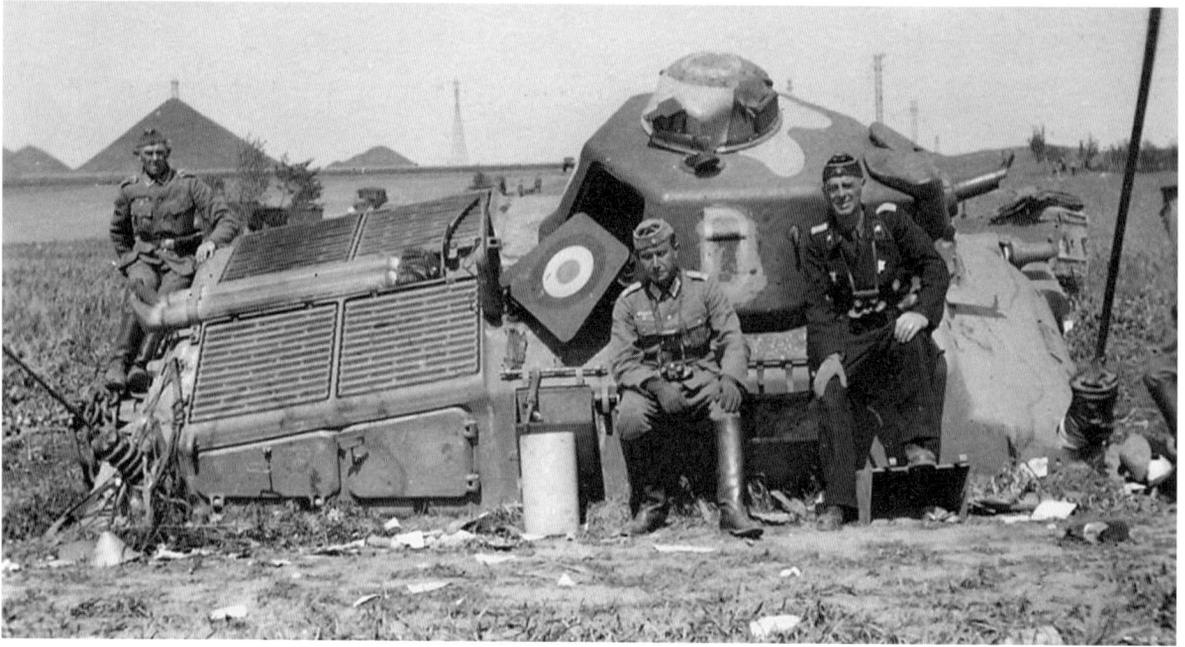

German troops including a panzertruppen on the right pose with another knocked out S-35. On 16 May General Bruche's French 2nd Armoured Division came up against the 6th Panzer Division and was driven back. Two days later de Gaulle's 4th Armoured Division struck toward Montcornet but after some initial success was also driven back.

This French anti-tank gunner died trying to fend off the panzers. The weapon is either the French 25mm or 47mm anti-tank gun.

Chapter Eight

Arras – Rommel's Bloody Nose

British tanks struggled along choked roads through Carvin and Lens to cover the 30 miles between Orchies and Vimy. The last of the 1st Tank Brigade reached Vimy at 0500hr on 21 May thereby delaying Franklyn's plans. The lack of trains meant the tanks had covered 120 miles in 5 days and this took its toll in wear and tear; of the 77 Matilda Mk Is 19 had been lost and of the 23 Mk IIs 7 of these were unserviceable. While more numerous, the Matilda I's armour was almost impervious to the Germans' standard 37mm anti-tank gun, but its Vickers machine gun lacked real bite. Without an anti-tank gun it simply was not in a position to take on the panzers.

Major General Martel, 50th Division's commander, was instructed to clear the south of Arras as far as the Cojeul River, a distance of just 10 miles. Following this the 5th Division's 13th Brigade was to advance south to link up with the 151st Brigade from 50th Division. These combined forces were then to push on to a line on the River Sensee to the south-east. In total Martel's attack force numbered some 3,500 troops supported by 74 tanks. He organised them into two mobile battle groups each consisting of a tank and infantry battalion supported by field artillery and anti-tank batteries. For the opening of the Arras attack the French 3rd Light Mechanised Division's S-35 tanks were supposedly to screen the British right flank.

The two British columns were to sweep south-east of Arras. The right-hand column spearheaded by the 7RTR with twenty-three Matilda Is and nine Matilda IIs was to push through Duisans, Walrus and Berneville to the Beaumetz–Arras highway, from where it was to attack toward Wailly, Ficheux and onto the Cojeul River. The left-hand column lead by the 4RTR with thirty-five Matilda Is and seven Matilda IIs was to drive through Dainville, Achicourt, then split clearing Agny to the south to Mercatel and the Cojeul; while just to the north the rest would attack through Beaurains, Neuville and then onto Wancourt on the Cojeul.

The infantry units supporting the tanks were from 6th and 8th Bttalions of the Durham Light Infantry (DLI) assigned to the 4RTR and 7RTR respectively. These were Territorial Army units from north-east England and had only half their number

of Bren light machine guns, no radios and little artillery. Each column was supported by a battery of just twelve field guns and twelve 2-pounder anti-tank guns. The lack of radios hampered communication with the tanks. The DLIs also lacked adequate transport and were suffering with their feet. They spent the night in the shadow of a much earlier battlefield near the Canadian memorial at Vimy Ridge.

Facing them was Rommel's 7th Panzer Division consisting of the 25th Panzer Regiment with about 180 tanks and the 7th Rifle Brigade numbering about 4,000 men. They were well supported with thirty-six 105mm field guns and howitzers and thirty-six 37mm anti-tank guns; crucially the 23rd Flak Regiment included a battery of 88mm anti-aircraft guns, which could be used in a dual anti-tank role. Even without the assistance of the nearby 5th Panzer Division Rommel outgunned and outnumbered Martel's attacking force from the start.

Rommel was aware of the concentrating British and French forces north of Arras and intended to strike west of Arras with the SS Totenkopf Division screening his left flank toward Beaumetz, while the 5th Panzer Division would strike east on his right. To guard his right flank south-east of Arras Rommel established a defensive line extending from Wailly to the west to Neuville in the east.

At 1315hr on 21 May 1941 the British tanks began moving the 8 miles to their Arras–Doullens road start line without the DLI, which had been delayed. They did not catch up with the tanks until 1600hr. Martel found that Maroeuil was already under shellfire at 1430hr and that German troops were in Duisans to the south. The day did not start off well when British tanks accidentally engaged some French ones near the village. Luckily there were no losses before the error was realised.

Rommel takes up the story: 'At about 15.00 hours I gave the Panzer Regiment orders to attack. Although the armour had by this time been seriously reduced in numbers due to breakdowns and casualties.' He must have been wrong about the timing, because the French reported seeing panzers on the right flank as the British attack got underway. Discovering the panzers also had no infantry support, Rommel sped off toward Ficheux, finding part of the 6th Rifle Regiment he headed toward Wailly. 'One of our howitzer batteries was already in position at the northern exit from the village,' recalled Rommel, 'firing rapid on enemy tanks attacking southward from Arras.'

After capturing Duisans two companies of the 8th DLI and two troops of the 260th Anti-Tank Battery were left to defend the village. The 8th DLI's anti-tank guns and support platoon soon went into action against some French tanks! The latter then supported the DLI's attack on the cemetery near Duisans. The number of German prisoners taken there varies, the implication being that some were shot out of hand. The SS were later to cite the DLI's behaviour at Arras as the excuse for murdering British POWs at Le Cornet and Wormhoudt.

Certainly heavy casualties among the DLI's officers meant that POWs received little sympathy from their captors. An officer of 7RTR escorting a German non-commissioned officer was appalled at the treatment the man received. 'I continued into Dainville and handed over the prisoner to a Captain of the DLI for conveyance to Provost Personnel. The troops displayed great animosity towards the prisoner, and I was compelled to draw my revolver and order them off before I could reach their officer.'

By mid-afternoon with Warlus and Berneville in British possession the 8th DLI finally found themselves on the Arras–Doullens road/railway start line. German defences around Berneville inflicted heavy casualties on the DLI and a Stuka dive-bomber attack showed the glaring lack of air support available to the British. However, the 7RTR's tanks pressed on reaching Wailly.

At Wailly Rommel found, 'The enemy tank fire had created chaos and confusion among our troops in the village and they were jamming up the roads and yards with their vehicles, instead of going into action with every available weapon to fight off the oncoming enemy.' Moving west of Wailly with Lieutenant Most at his side, Rommel saw that the advancing British tanks, spearheaded by a Matilda II, had already crossed the Arras–Beaumetz railway and set about a Panzer III. British tanks were also pressing in from the north from Bac du Nord, which lay north-west of Wailly. Some of his infantry took flight taking the crew of a howitzer battery with them.

At this point the British were suddenly taken by surprise by Rommel's well-concealed anti-tank guns and anti-aircraft troop who were hiding in the hollows and small wood. Rommel and Most crept among the guns and personally assigned each its targets. Some of his officers pointed out that the range was too great but Rommel knew they could not wait or they would be overrun. He then ordered a furious and rapid fire in an attempt to halt the oncoming tanks. Despite being under fire themselves Rommel's gun crews kept their nerve and opened up.

'It did not look as though the battery would have much difficulty in dealing with the enemy tanks,' recalls Rommel, 'for the gunners were calmly hurling round after round into them in complete disregard of the return fire.' The leading vehicles soon lurched to a halt. Just 150yd west of the small wood a Matilda II was stopped after its driver was killed, and in a daze a British captain emerged from the tank and staggered hands in the air toward the German lines. At a range of up to 1,500yd beyond the abandoned howitzer battery the reception was so hot that the British veered away. 'One tank [Mk II] showed as many as 14 direct hits,' a British tank officer recalled, 'and the only indication the crew had of being hit was a red glow for a few seconds on the inside of the armour plate.'

One of Rommel's field guns claimed Lieutenant Colonel Fitzmaurice, commanding 4 RTR, when his Mk VI light tank was hit. The 7RTR commander

Lieutenant Colonel Heyland was also killed by machine-gun fire after dismounting from his vehicle. Rommel now turned his attention on those tanks approaching from Bac du Nord. Some caught fire, others were halted while the rest turned tail.

In Rommel's moment of triumph personal tragedy struck. He recalled:

> The worst seemed to be over and the attack beaten off, when suddenly Most sank to the ground behind a 20mm anti-aircraft gun close beside me. He was mortally wounded and blood gushed from his mouth. I had no idea that there was any firing in our vicinity at that moment apart from that of the 20mm gun. Now, however, the enemy suddenly started dropping heavy gunfire into our position in the wood. Poor Most was beyond help and died before he could be carried into cover beside the gun position. The death of this brave man, a magnificent soldier, touched me deeply.

The British left-hand column got as far as Neuville and Wancourt but ran into Rommel's screening defences consisting of 20mm and 88mm anti-aircraft guns and 105mm howitzers. In the area of Tilloy-Beaurains-Agny the British overran the German's light anti-tank guns and the SS were put to flight. The British triumph was shortlived as Rommel recalls, 'Finally, the divisional artillery and 88mm anti-aircraft batteries succeeded in bringing the enemy armour to a halt south of the line Beaurains-Agny.' The carnage among the British armour was considerable, according to Rommel, 'Twenty-eight enemy tanks were destroyed by the artillery alone, while the anti-aircraft guns accounted for one heavy and seven light [tanks].'

At 1900hr Rommel ordered the 25th Panzer Regiment to strike south-eastwards in order to take the British in the rear. South of Agnez, which lay west of Arras and Duisans respectively, the panzers ran into a superior force of British tanks. In the following tank battle the Germans lost ten panzers but knocked out seven Matilda IIs and six anti-tank guns. The panzers broke through and the defeated British headed back toward Arras.

By 2215hr the British left-hand column was withdrawing on Achicourt, south of Arras, where the 6th DLI conducted a hotly contested rearguard action. On the right, six French tanks and two armoured personnel carriers got through to Warlus past midnight and covered the retreat. Ten Bren gun carriers from the 9th DLI covered the withdrawal of those men still at Duisans. Although Rommel had received a bloody nose, he had kept his nerve and thrown back the brave but futile British counterattack.

Where are we? The early production Matilda II deployed to France is recognisable by the Vickers machine gun on the left-hand side of the turret, rather than the smaller Besa 7.92mm fitted in the Mk IIA. While the British Prime Minister was insistent that the British and French armies should counterattack, General Blanchard's French 1st Army was in no position to help the BEF.

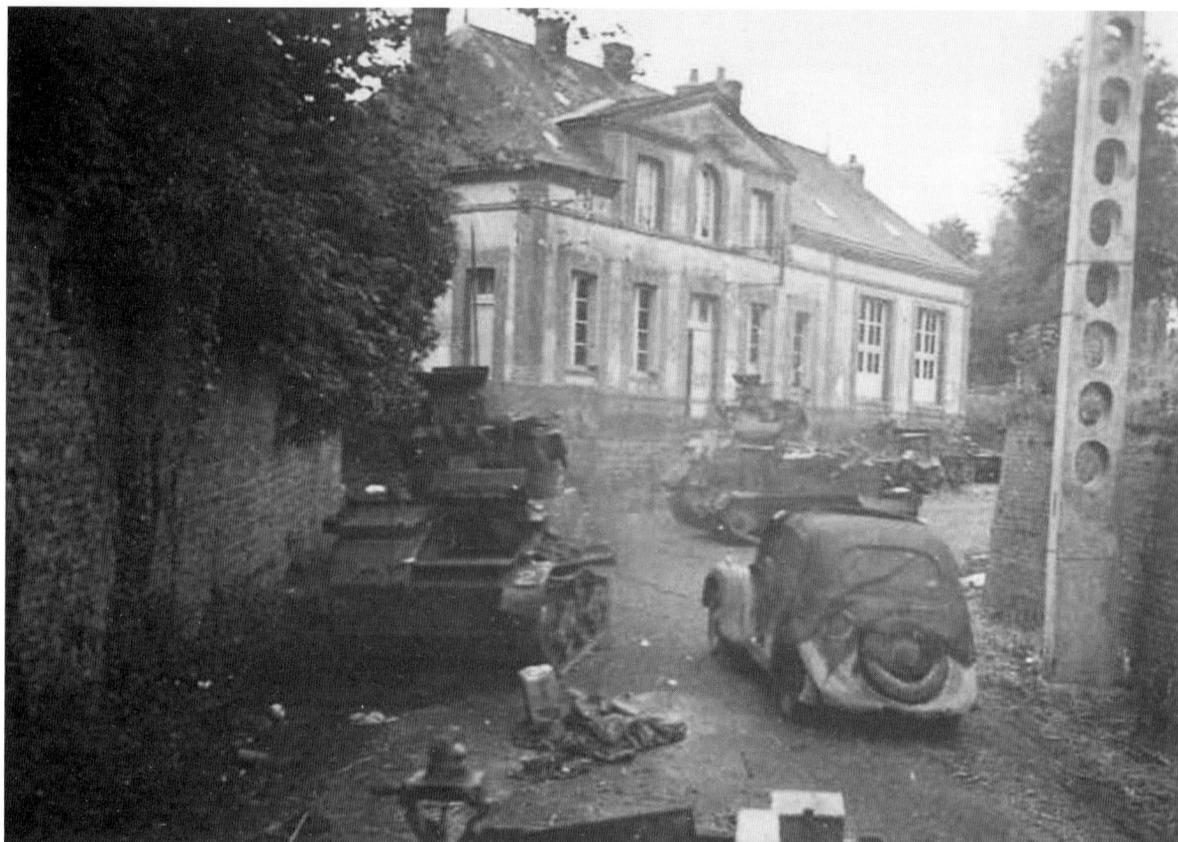

Most of the BEF's tank strength was made up of the Mk VIB light tank armed with two Vickers machine guns. The 4RTR and 7RTR shipped to France with seven MK VI light tanks each.

The Panzer Mk I seen here, comparable to the British Mk VIB, was not able to withstand the Matilda II. The British 1st Tank Brigade supported by elements of two infantry divisions confronted Rommel's 7th Panzer Division, which was equipped with 180 panzers including the Mk I, at Arras.

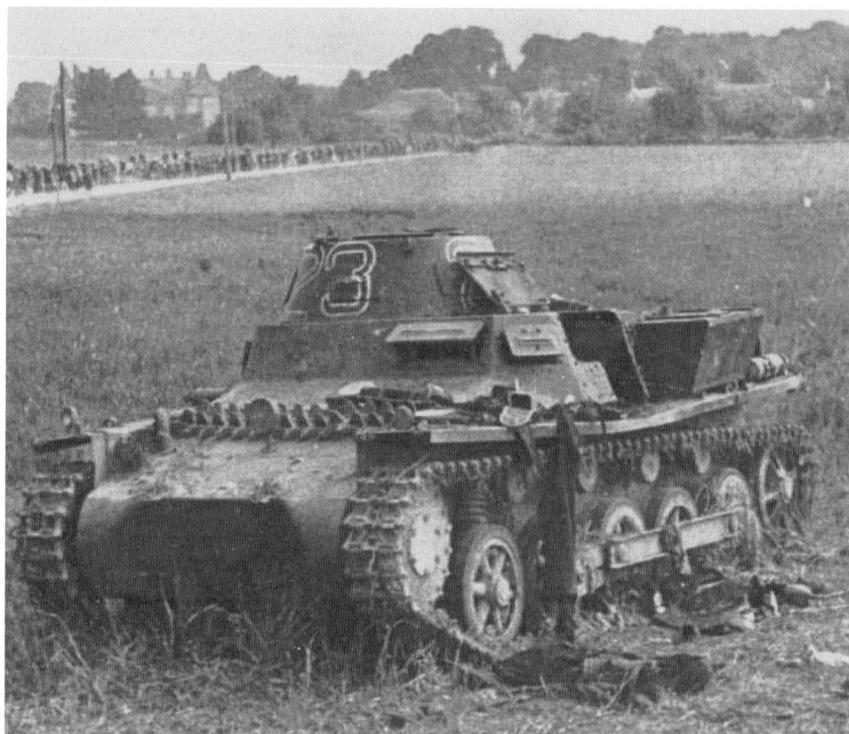

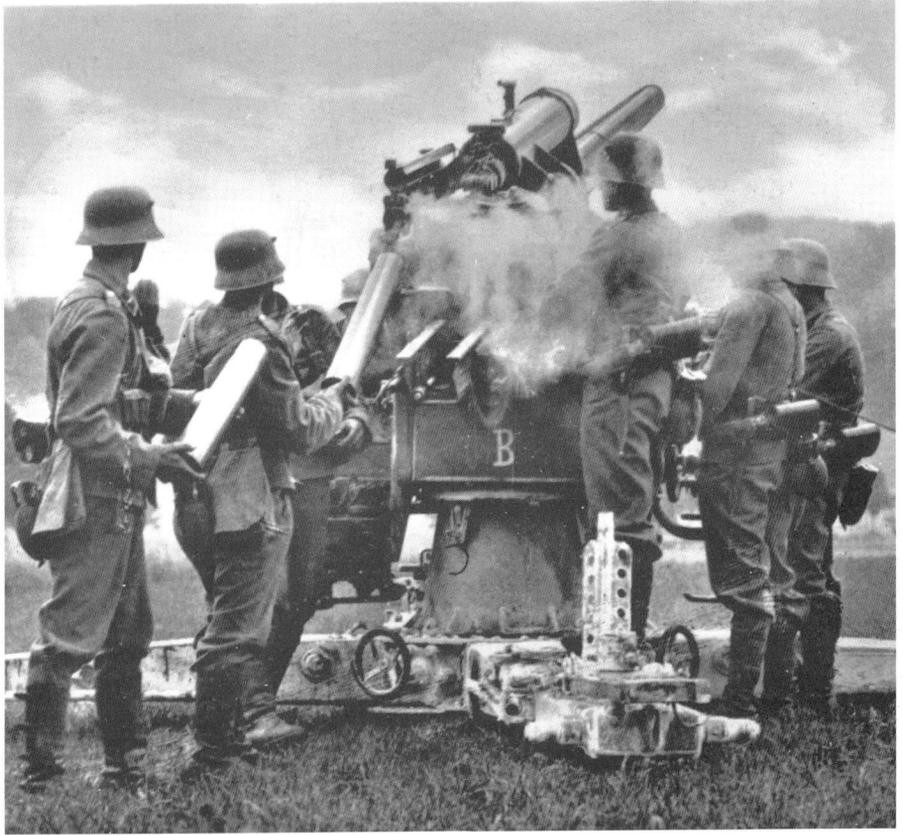

The concentrated firepower of Rommel's artillery was instrumental in thwarting the British attack accounting for twenty-eight tank kills. According to Rommel, his flak guns, including the 88mm, used in an anti-tank role claimed one heavy and seven light tanks.

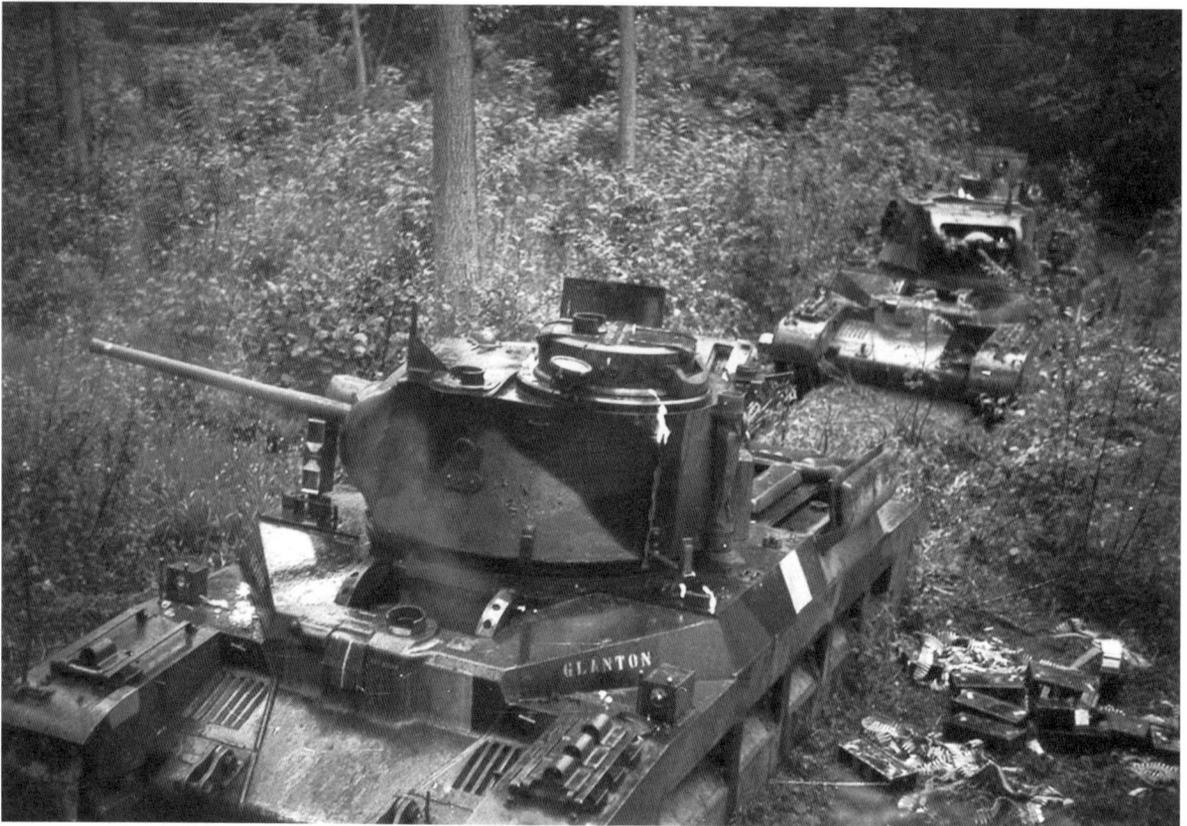

Knocked out British Matilda tanks lost during the fighting in the Arras area. In 1940 the Matilda Mk II Infantry Tank was the heaviest in British service, but was not available in sufficient numbers and those used against Rommel were simply brought to a halt by his superior firepower.

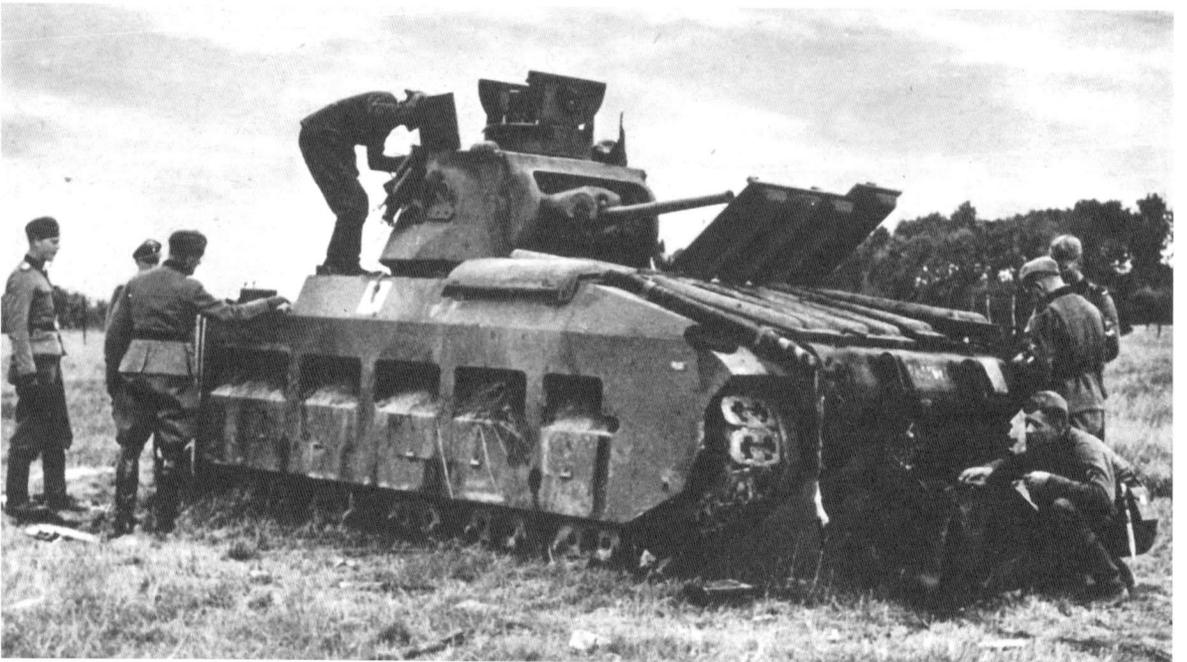

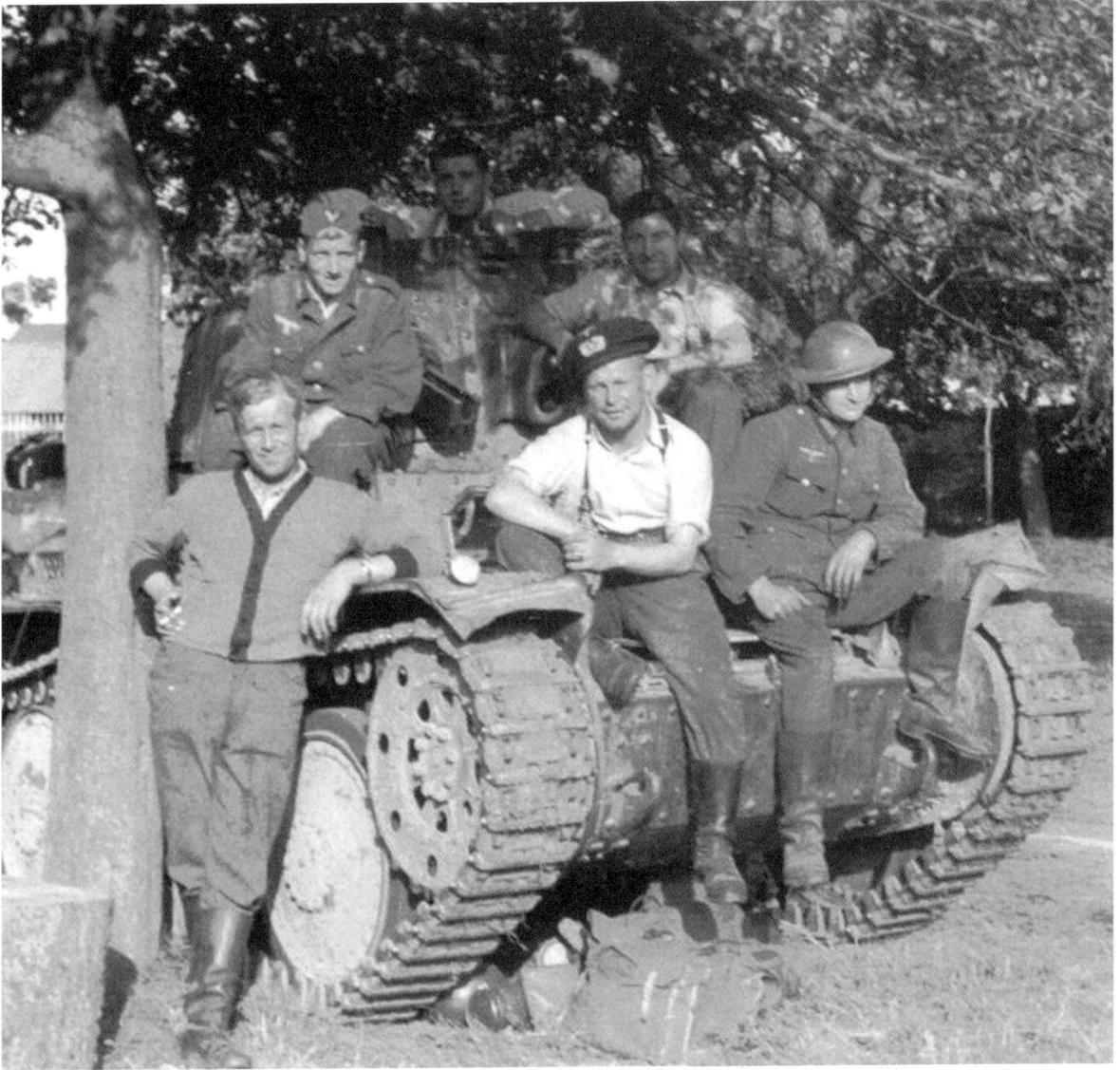

Triumphant panzertruppen seated on their Czech-built PzKpfw 38(t) — note the man on the right at the front sporting a captured British helmet.

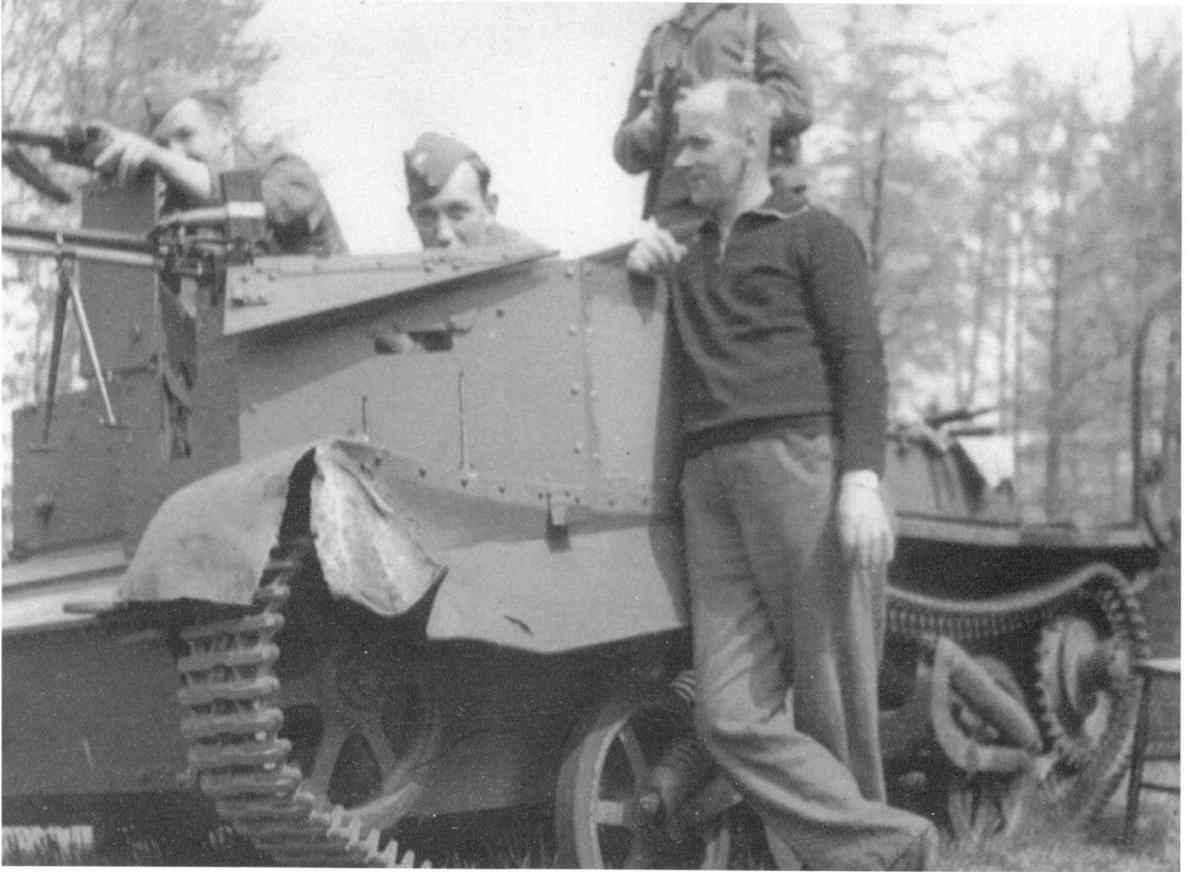

More war trophies – this time a captured British Bren gun carrier.

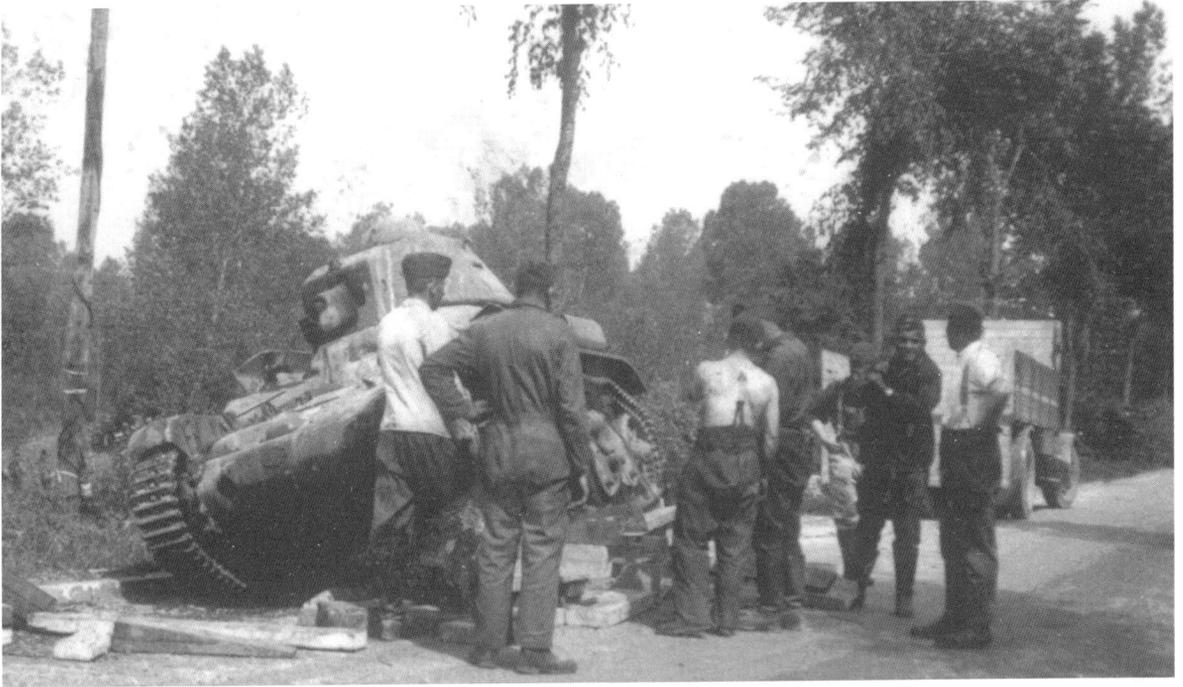

At Arras the British sought the help of the French Cavalry Corps and the French 5th Corps, but between them all they could muster was the 3rd Light Mechanised Division. German troops are seen with knocked out French R-35s.

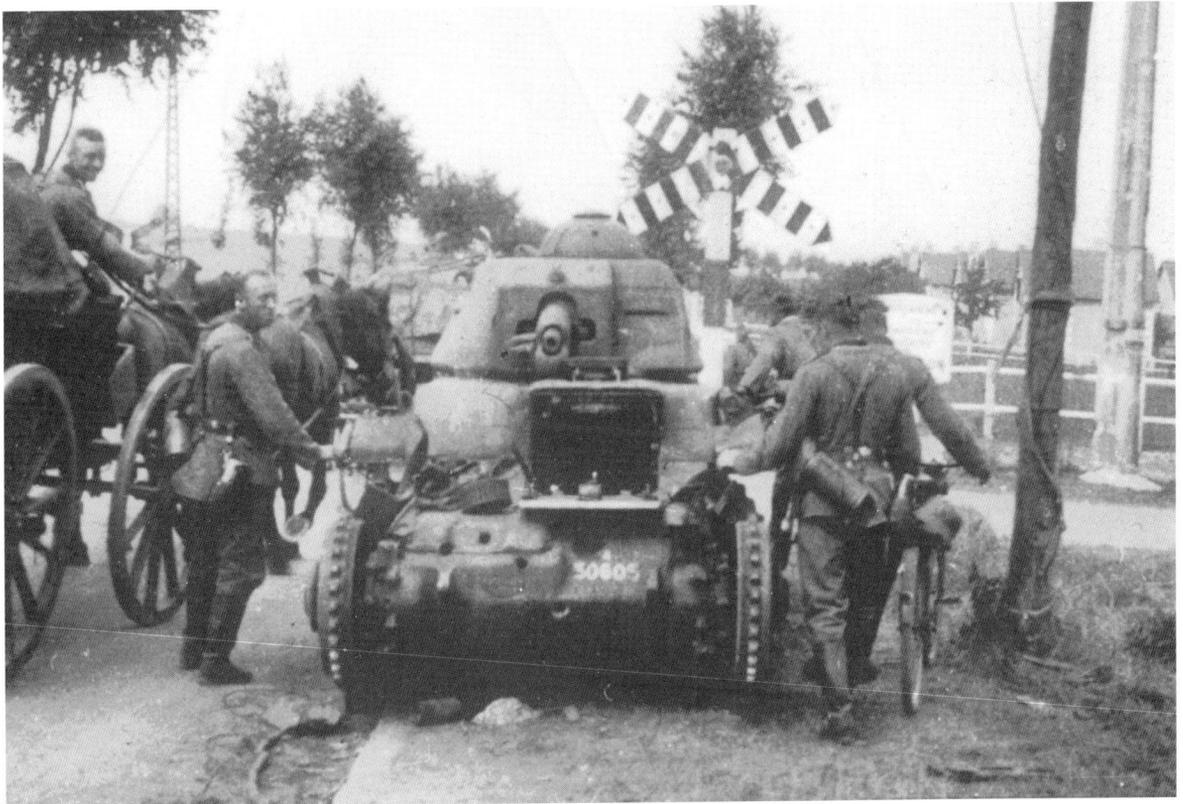

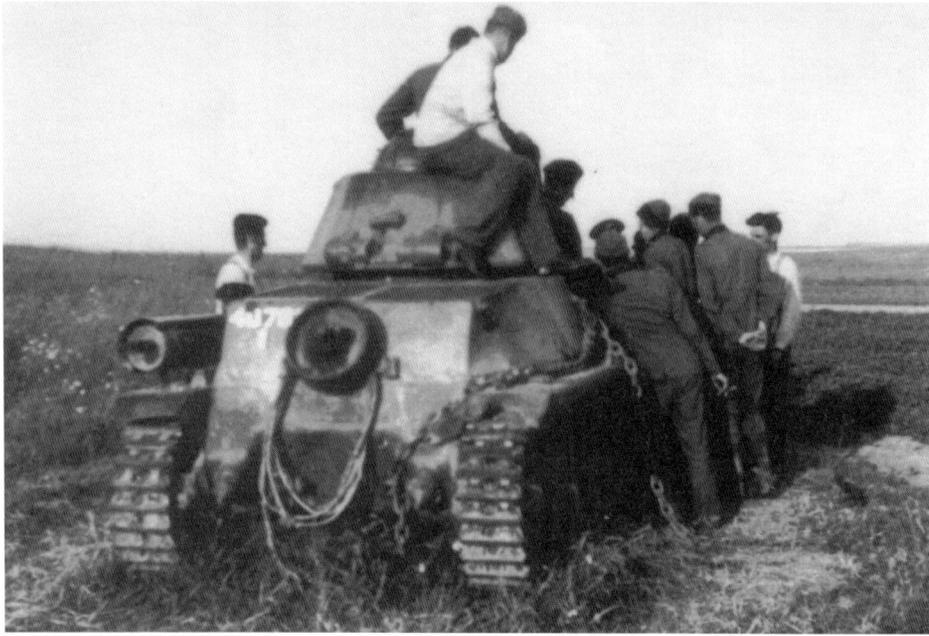

German troops with an H-35 at Arras. By the time of the counterattack here the 3rd Light Mechanised Division had already lost all its H-35s.

This German officer is highlighting all the anti-tank gun penetration marks on this unfortunate S-35. General Langlois's 3rd Light Mechanised Division with some sixty such tanks was supposed to have supported the British counterattack at Arras but was two days late. When the French did commence their attack they were pounded to a halt by dive-bombers and artillery and the tank crews fled.

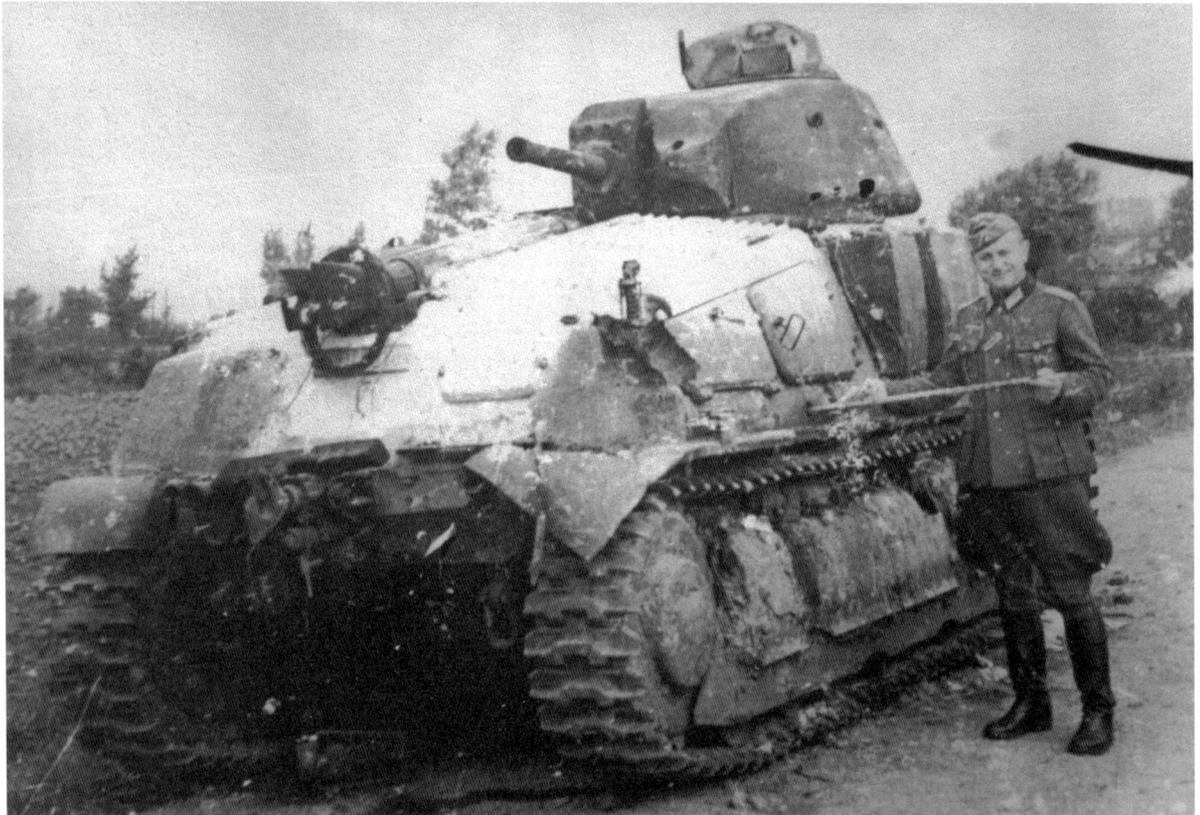

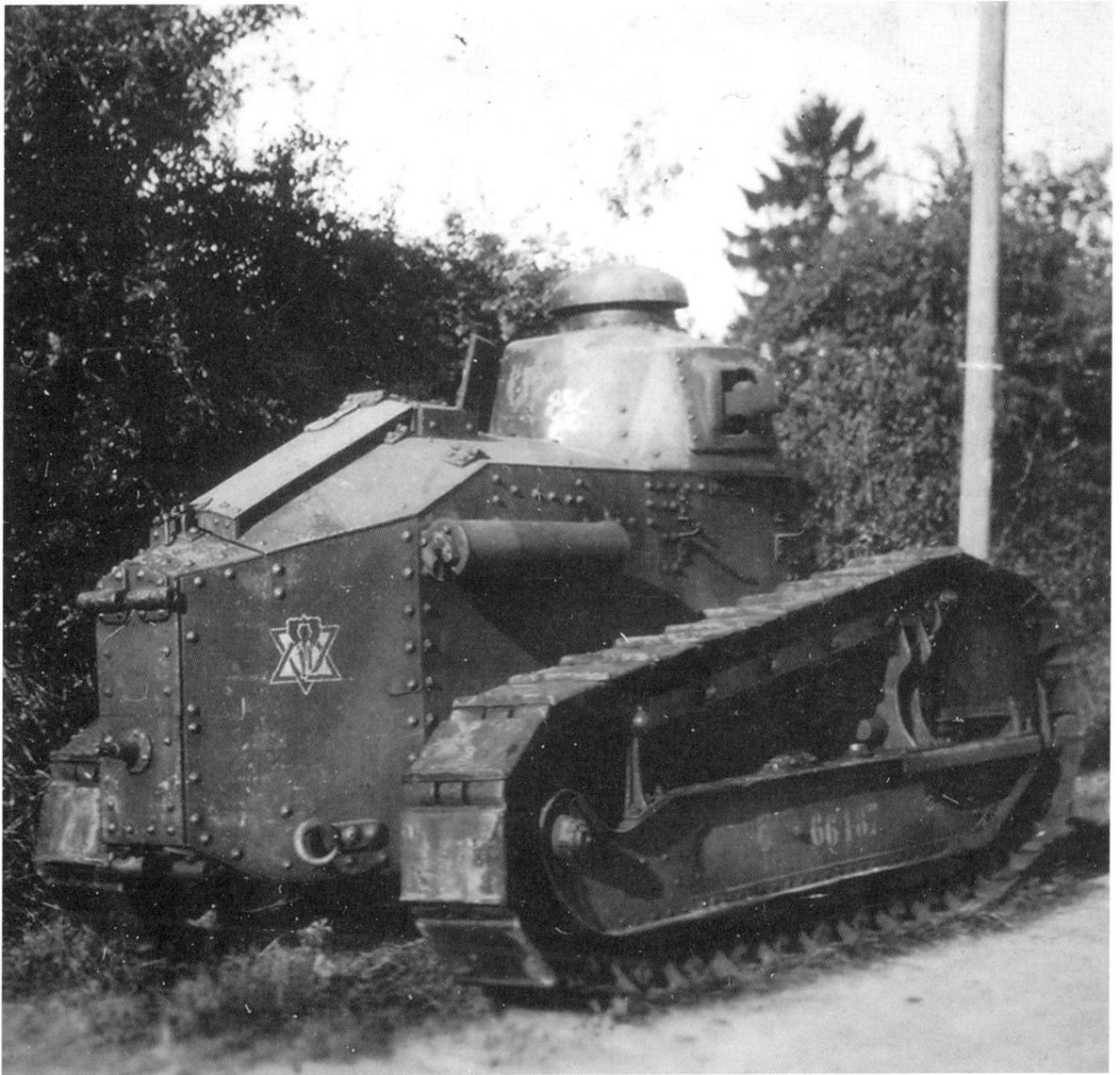

A French FT-17 light tank lays abandoned at the roadside. This type of tank was woefully obsolete and even in an infantry support role was simply too slow.

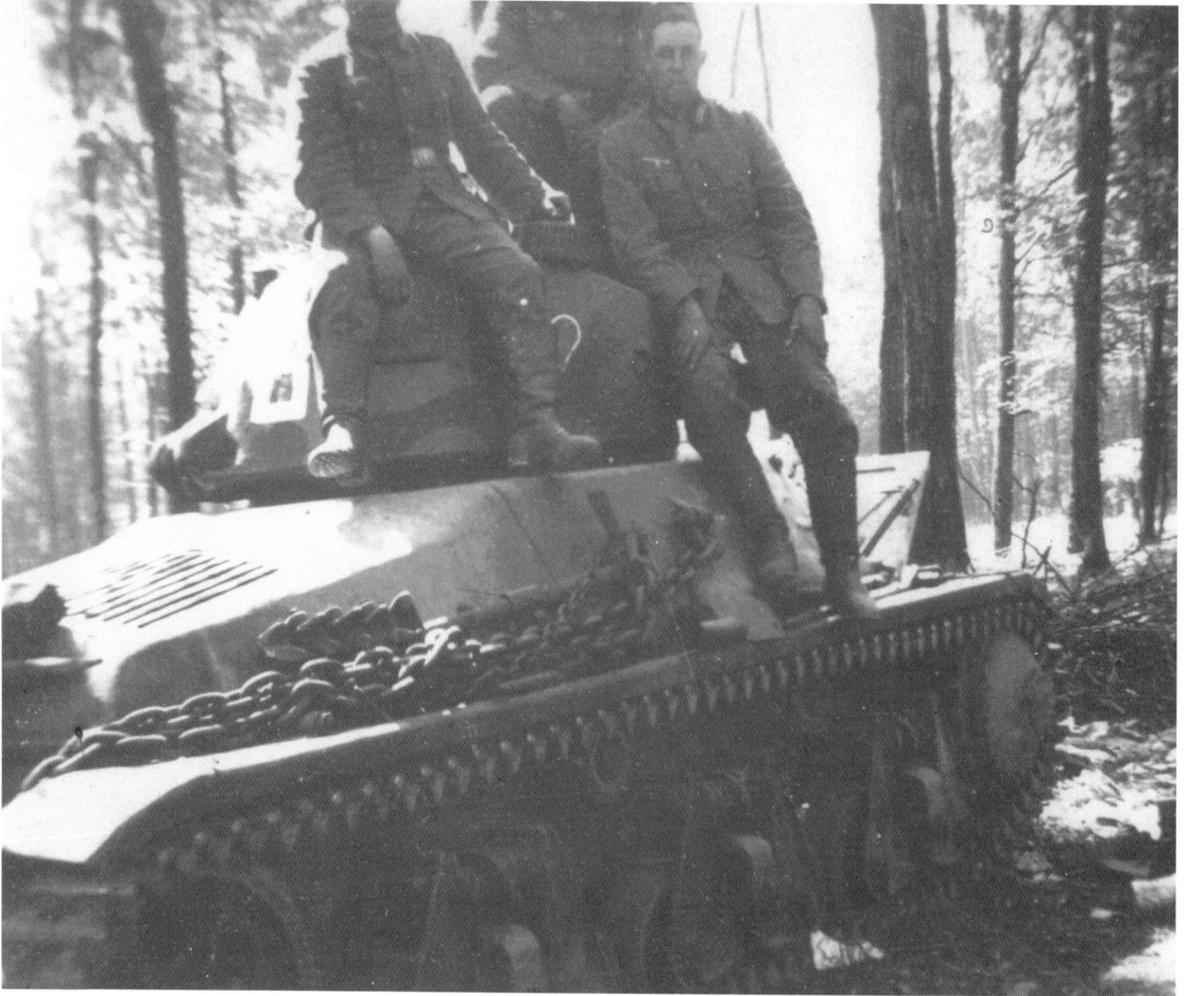

These German soldiers are posing on a Hotchkiss H-39, which is easily identifiable from the earlier H-35 by the slopping rear engine cover. This particular tank seems to have been abandoned in some woods somewhere in northern France.

Chapter Nine

Dunkirk – Churchill's Miracle

Belatedly the French 3rd Light Mechanised Division went into action on 23 May only to be pounded to a halt by German dive-bombers and artillery fire. The French crews abandoned their stricken vehicles and fled. That evening the British left Arras, withdrawing 18 miles north to the canal line running through La Bassée and Bethune, to Gravelines on the coast south-west of Dunkirk. Despite this the fighting at Arras enabled four British divisions and most of the French 1st Army to withdraw toward the coast in reasonably good order.

The lumbering British Matilda II had proved a nasty shock for the Germans. Despite being unavailable in sufficient numbers, lacking adequate infantry and artillery support and no air cover, their measure of success had been due to the tough 78mm armour, which proved invulnerable to the standard German 37mm anti-tank gun.

Remarkably during the fighting around Arras against the British the Germans lost 4 times the number of casualties they had suffered during the actual breakthrough into France, consisting of 89 dead, 116 wounded and 173 missing. On 27 May Rommel gained the distinction of becoming the first German divisional commander in France to receive the Knight's Cross.

In some quarters the British attack at Arras was seen as a waste of dwindling resources, ill conceived, poorly executed and achieving little result. This was not the case, as the Germans were alarmed at the prospect of their panzer divisions being cut off before their infantry could reach them. While the Germans dismissed all the French counterattacks, the British effort at Arras caused Generals Kluge and Kleist to pause. Guderian's drive on Boulogne, Calais and Dunkirk was slowed. This ripple of unease passed up the chain of command to Hitler who halted his forces for two crucial days allowing the British time to prepare their desperate rearguard defences at Dunkirk.

Afterwards General von Rundstedt paid British achievements at Arras the highest compliment saying, 'A critical moment in the drive came just as my forces had

reached the Channel. It was caused by a British counter-strike southwards from Arras on May 21st. For a short time it was feared that our armoured divisions would be cut off before the infantry divisions could come up and support them. None of the French counterattacks carried any threat such as this one did.' This was praise indeed for the brave British efforts.

Although by 24 May the 6th Panzer Division was poised to attack Cassel, HQ of the BEF, Hitler ordered a halt thereby saving the BEF from total destruction. When the attack did come the British 145th Infantry Brigade was as prepared as it could be, and only when they attempted to retreat was the garrison lost. First Lieutenant Bake and his Czech tanks were involved in stopping the British tanks breaking out from Cassel in the direction of Waten.

Circling south, Bake caught them in the flank and his sixteen tanks opened fire at once. The first two British tanks were blown to pieces followed by six others. The Germans then pressed home their attack and soon Bake's tank had accounted for another three British tanks. When the fighting came to a stop 50 tanks had been destroyed, several hundred British soldiers killed and 2,000 captured. In total Bake's division took 60 tanks, 5 armoured cars, 10 artillery pieces and 11 anti-tank guns, 30 motor cars and 233 trucks. The 6th Panzer Division then pursued the retreating French. Under attack by the 10th Panzer Division and the Luftwaffe's Stukas the port of Calais surrendered on 26 May and the Germans took 20,000 prisoners, 3,500 of them British.

It was Hitler's 'Halt Order' at Dunkirk that marred his incredibly successful Blitzkrieg against France and prevented the BEF from being annihilated. Operation Dynamo between 27 May and 4 June 1940 scooped 224,685 British soldiers and another 141,445 Allied troops from the German net. France had yet to surrender on the 21st, so for most evacuated French troops there seemed little point in remaining in Britain.

Indeed many were given no choice in the matter and were ferried home via Normandy or Morocco to help stabilise the situation on the Seine, Lower Normandy and the Marne. Not all were keen to go, as it was apparent that France could not hold out much longer, but by the end of June 1940 of those rescued only 45,000 remained in Britain.

However there were sound strategic reasons for Hitler's actions. He was worried about protecting his southern flank and seizing Paris, after all his main purpose was the defeat of France. With her armies scattered France signed an armistice on 22 June and Hitler told General von Kleist that, 'They [Britain] will not come back in this war.'

In terms of saving manpower the evacuation of the BEF from Dunkirk was a miracle; in terms of equipment losses it was a disaster of the first magnitude. Hitler

captured almost every tank the British Army possessed and most of its motor transport. His haul included 600 tanks, 75,000 motor vehicles, 1,200 field and heavy guns, 1,350 anti-aircraft and anti-tank guns, 6,400 anti-tank rifles, 11,000 machine guns, 90,000 rifles and 7,000 tons of ammunition. By the summer of 1940, Britain's armoured units possessed just 240 medium tanks, 108 cruiser tanks and 514 largely useless light tanks.

The British Army also found itself bereft of transport. When the war started the British Army had approximately 85,000 motor vehicles. The bulk of these had been shipped to France with the BEF but just over 5,000 were retrieved during the evacuation and the rest were left behind. More could have been saved but most were often abandoned prematurely, for example the Army had over 10,000 light lorries but over half were abandoned.

Many British officers were dismayed at having to abandon their equipment. Lieutenant Colonel Brian Horrocks recalled,

> It was impossible to evacuate our heavy weapons and transport, so as soon as we got inside the [Dunkirk] bridgehead we were ordered to immobilise our vehicles and move on foot. The drivers hated doing this because in war each driver develops a feeling of affection for his own lorry or truck. It was a horrible sight – thousands of abandoned vehicles, carriers, guns and pieces of military equipment of all sorts. It was a graveyard of gear.

During the Dunkirk evacuation the RAF flew 3,561 sorties, of which 2,739 were by Fighter Command. Documents captured after the war indicate that the Luftwaffe lost 132 aircraft despite the RAF's grandiose claims of 3 times this number. During the Battle for France no Spitfires had been deployed across the Channel and during the evacuation Spitfire pilots were ordered not to over fly the French coast for fear of the aircraft falling into enemy hands.

The Dunkirk evacuation cost the RAF 100 fighters and about 80 pilots, which left Fighter Command with about 470 serviceable aircraft in early June and of these just 330 were Hurricanes and Spitfires. There were only 36 more aircraft in immediate reserve. The RAF lost over 1,000 aircraft over Norway and France, half of which were fighters. This was two-thirds of all aircraft delivered to the RAF since the war commenced. An even greater blow was the loss of so many aircrew. The Battle of France cost a quarter of Fighter Command's strength amounting to nearly 200 Hurricanes.

Italian leader Benito Mussolini opportunistically moved to profit from France's plight and his tanks were soon attacking his helpless and distracted neighbour. Belatedly he cynically threw thirty-two divisions at the French frontier on 11 June

1940, but they made practically no impression against just six French divisions. In retaliation the French Navy bombarded Genoa's factories, oil tanks and refineries, though the dithering French High Command forbade further offensive operations against Italy.

Although Mussolini's bombers ranged as far as the Loire Valley, on the ground the Italian Blitzkrieg failed to materialise. Only when the German panzers came sweeping down the Rhone Valley could Mussolini claim victory over the French Army. From this poor performance Hitler and his generals must have known that their ally's tanks were unlikely to make much impression against the British in Egypt.

On 13 June ten RAF Battles strafed German troops along the banks of the Seine. In addition two formations of thirty-eight aircraft bombed German positions by the Marne and lost six aircraft to 88mm flak guns. It was clear that this was the swansong of the British bomber force in France. The order was given for all remaining serviceable bombers to return to Britain 48 hours later.

British Secretary of State for War Anthony Eden visited General Thorne on 29 June, and was shocked by his complete lack of anti-tank guns. Once informed, Churchill summoned Thorne to Chequers for lunch the following day, where the General pointed out that 3rd Division was his only fully trained unit and that it was to be deployed to Northern Ireland. Britain was completely exposed to the threat of German invasion.

A solitary French or Belgian soldier watches defeated British troops as they trudge through the streets of the town of Dunkirk in the hope of being evacuated. Note the burnt out vehicle on the right, which appears to have a searchlight mounted in it. Once the Germans had broken through the Allies' defences in north-eastern France it became imperative that the BEF escape entrapment as swiftly as possible or face complete annihilation.

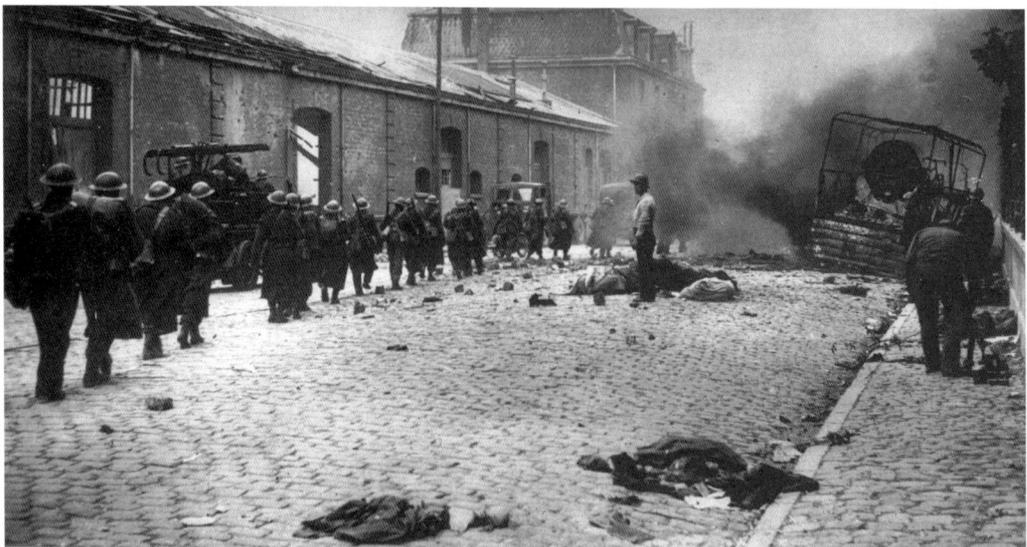

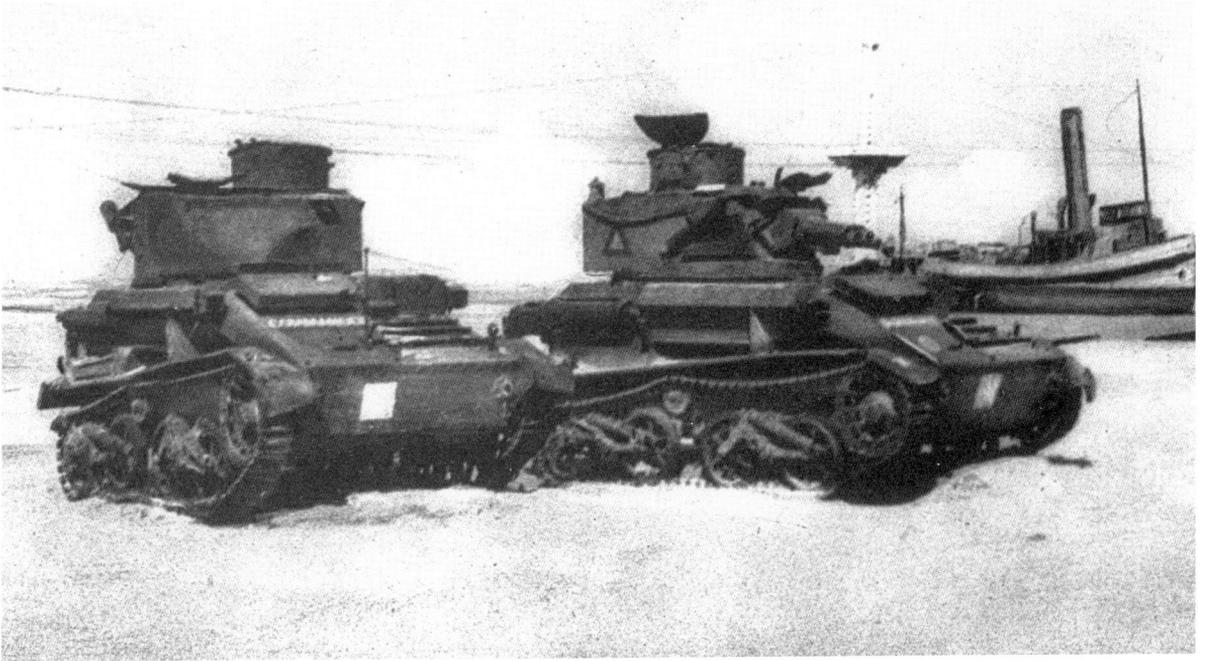

The British 1st Tank Brigade and the 1st Armoured Division lost all their tanks in France. These two shots show British Mk VIs abandoned on the beaches at Dunkirk. Following the 1940 French campaign this inadequate light tank was relegated to training duties.

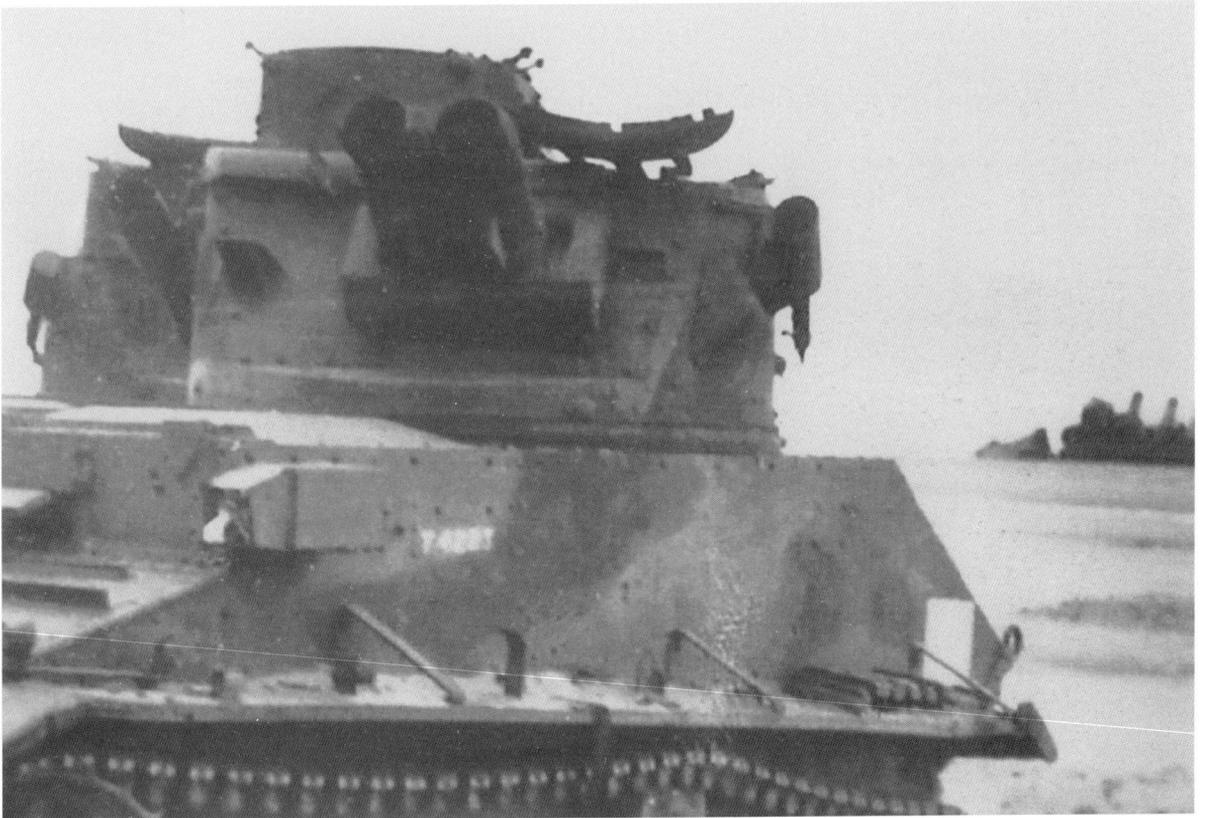

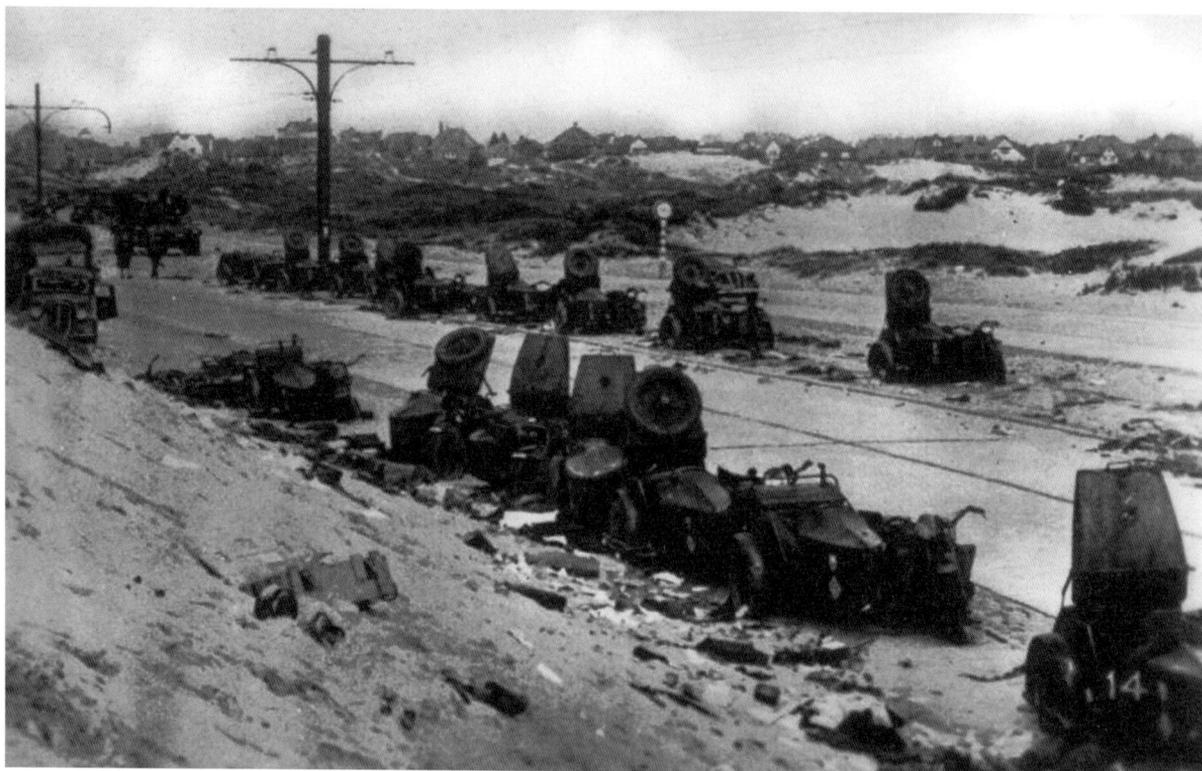

More abandoned British equipment, this time two columns of motorbikes and sidecars. It looks like their former owners set them alight to prevent them being reused by the Germans.

Yet more debris left on the beaches of Dunkirk. As well as all their tanks the British Army lost tens of thousands of motor vehicles in France.

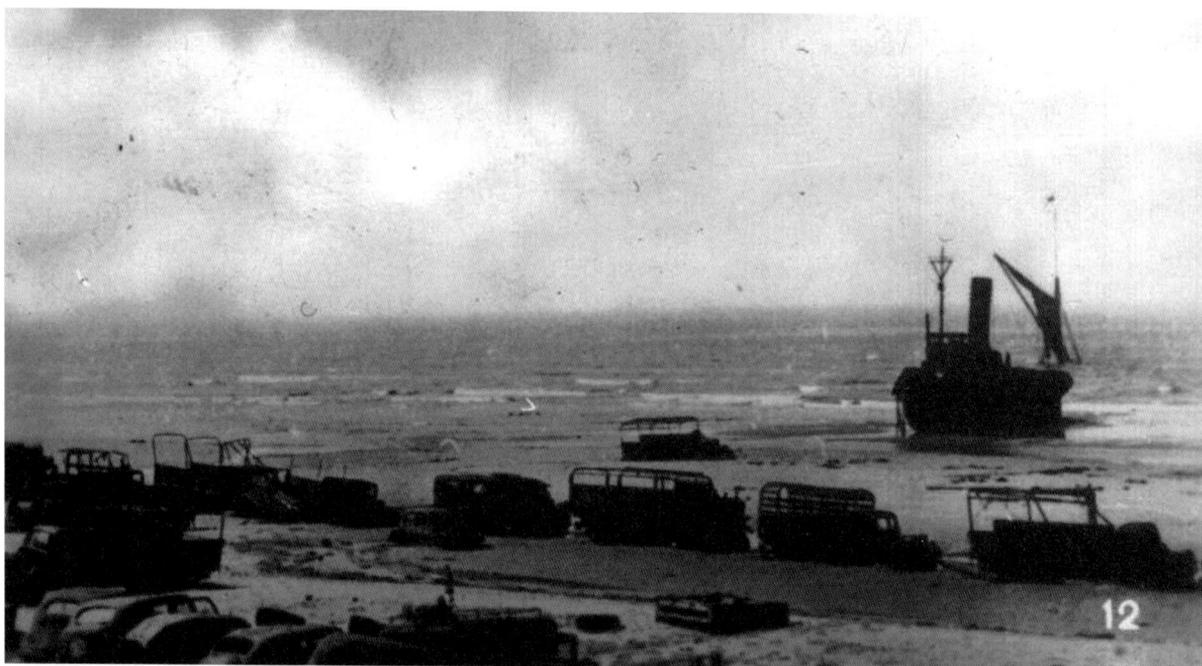

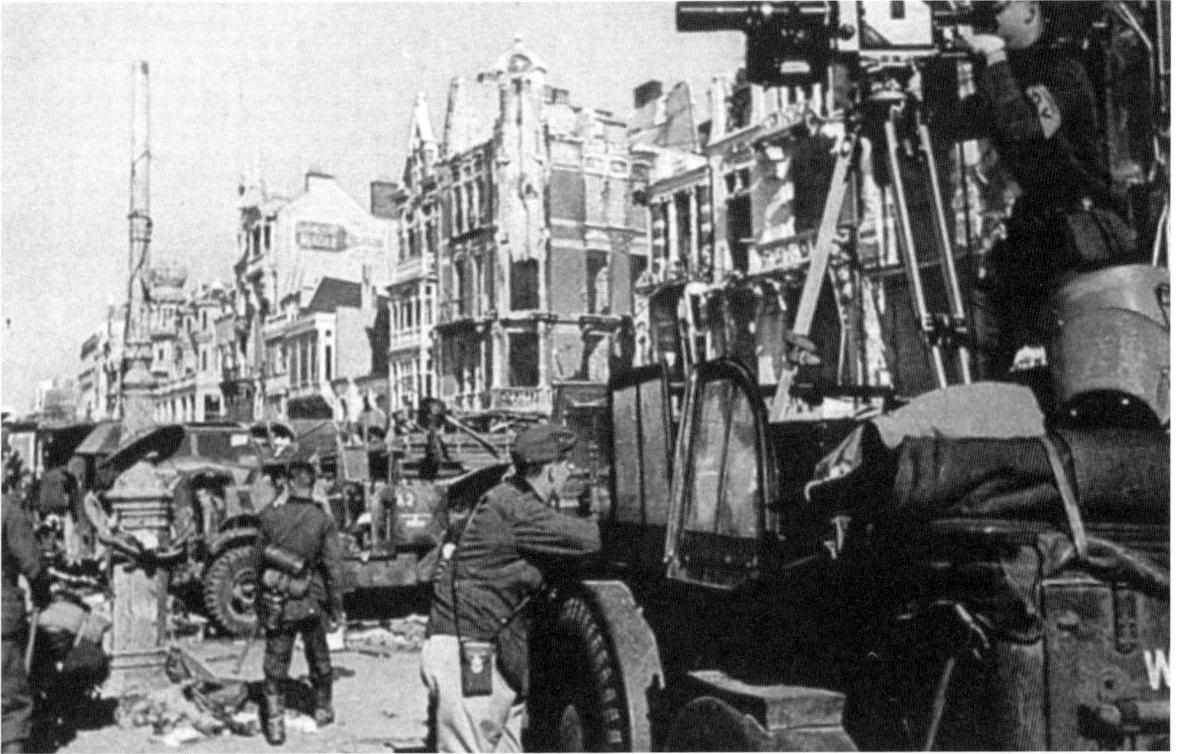

A German military film crew record the humiliation of the British, Belgian and French armies at Dunkirk.

This armoured car is a French Panhard. While elements of the French armoured and mechanised units fought bravely, they were often poorly led and motivated. France's defensive strategy was flawed from the start.

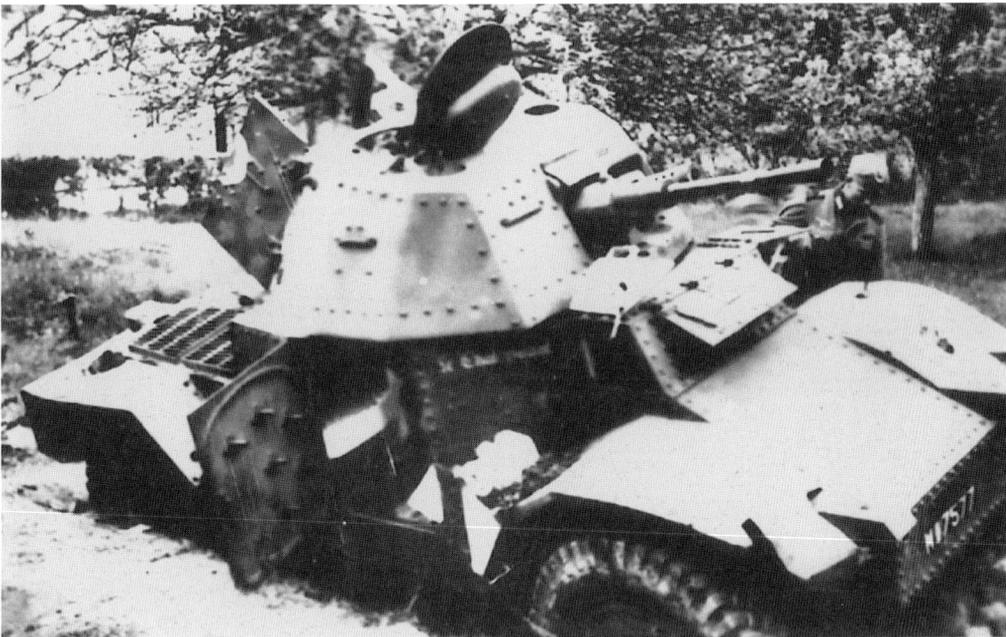

This is a very poor quality photograph, but it shows the face of defeat on these two captured British soldiers.

More Germans savour the taste of victory by sightseeing on the beaches of Dunkirk. Nonetheless almost 225,000 British troops escaped to fight another day. Well over 140,000 French soldiers were also evacuated, but most of them returned home to France almost immediately.

20

This camouflaged R-35 is engaging targets in the French Alps. On 10 June 1940 the French Army also found itself at war with the Italians when Mussolini attacked southern France.

Italian troops going off to war. A high-command communiqué issued from Rome on 14 June 1940 said that French and Italian troops had effected contact on the Alpine frontier. France had just six divisions available to resist thirty-two Italian divisions.

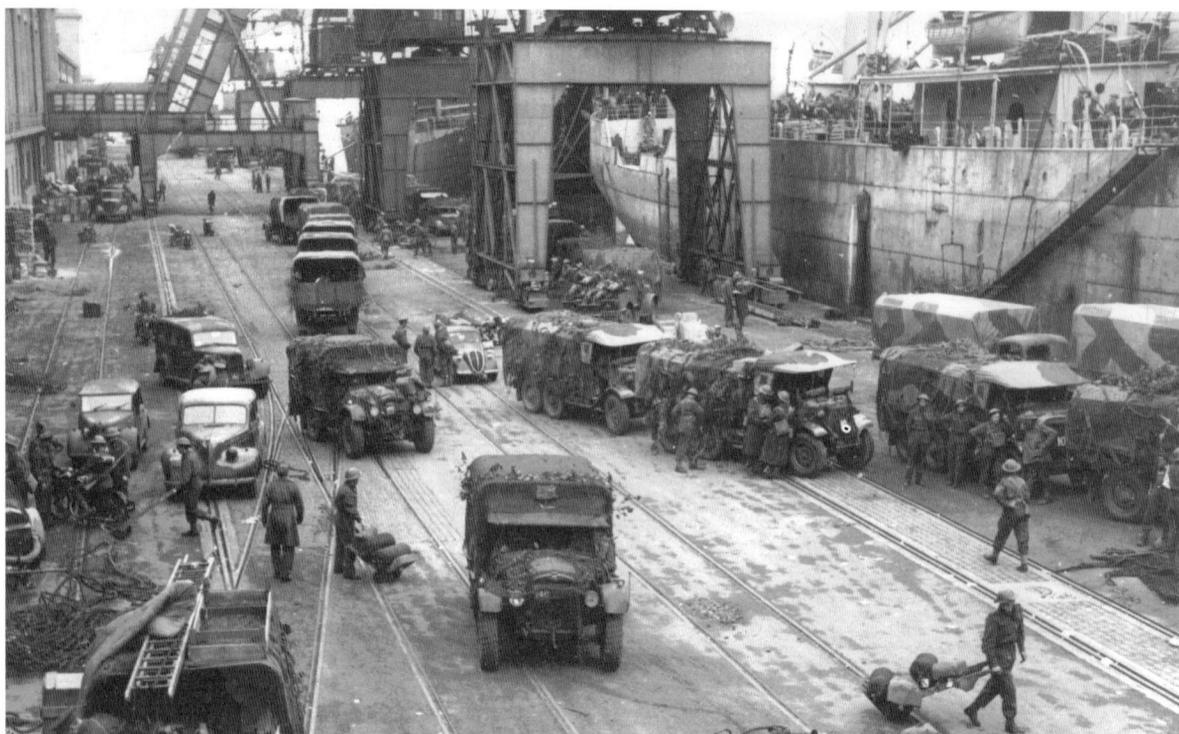

Following Dunkirk and once it became clear that the French Army had all but collapsed, the remaining BEF beat a hasty retreat to France's other Channel ports. These lorries were photographed in late June 1940 on the quayside at Cherbourg – the embarkation process looks well ordered and there is no sign of panic. The British 1st Armoured Division withdrew to the port with Rommel hot on its heels.

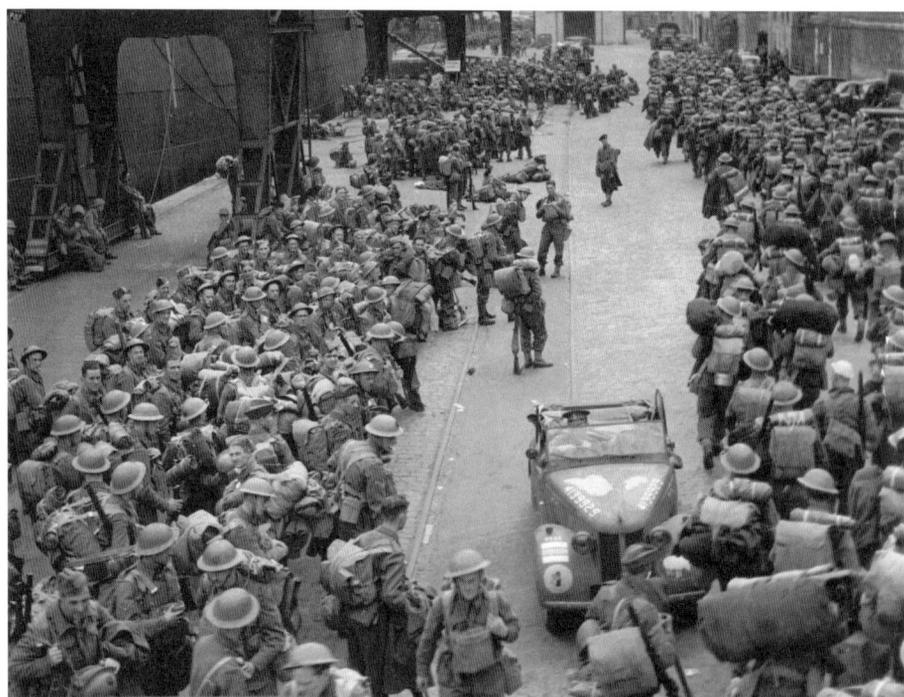

More British troops waiting patiently to be shipped back to Britain and safety. The 51st Highland Division were not so lucky and were forced to surrender to Rommel west of Dieppe.

Chapter Ten

The Fall of Paris

Concentrating on reaching the sea and cutting off the British and French forces in Belgium, the Germans did not mount a major assault on the Aisne until 9 June. General de Lattre's 14th Infantry Division held for two days throwing back three German divisions and counterattacking. With his flanks exposed, General de Lattre was forced to withdraw on the Marne. The French soon found they could not hold the Marne, Aube or Loire.

Parisians were gripped by a fear of German fifth columnists poised to instigate a sudden putsch as well as the terror of German parachutists, poisoned chocolates and many other false rumours that spread a sense of mounting panic. The Luftwaffe visited Paris on 3 June 1940 when it attacked the airfields at Orly, Villacoublay and Le Bourget. The Citroën plant was also badly damaged as well as part of the city centre. These raids made it abundantly clear just how vulnerable the French capital was to Hitler's air power. Where were the French Air Force and the RAF everyone asked?

The sense of fear resulting from the attacks was made worse when news came on 6 and 7 June that the French defences on the Somme and Aisne had collapsed. Some 46,000 women, children and pensioners were immediately evacuated on special trains. Parisians could not fail to notice that the government was fleeing too as the trains also took vital government archives and public records.

The official view was that Paris could be successfully defended against the Nazi onslaught. General Pierre Hering, military commander of Paris District, announced on 10 June that Paris would be defended street by street. In 1914 the Germans had been stopped at the Marne, but the truth was in 1940 after nine months almost nothing had been done in terms of constructing elaborate defences for Paris. What there was comprised a few trenches, machine-gun nests and roadblocks, none of which would halt the marauding panzers. Belated efforts to mobilise the Parisian workers proved a failure.

What General Hering did not know was that at the front General Maxime Weygand had already decided Paris could not be defended and should be declared an open city. This meant that the retreating French Amy would bypass Paris and hand it to the Germans without firing a shot. The French Premier Paul Reynaud received

word to this effect on 10 June just as Hering was making his rather optimistic announcement.

It was not until the 13th when Hering handed command of Paris to General Henri Dentz that he admitted that the city would not be defended against the Germans. The day before the exodus from Paris had become a flood and the railway lines and roads became jammed with refugees.

Just as France's citizens were fleeing south the country received a dagger in its back. Mussolini declared war on 10 June and added to the chaos on the roads as Italian Caproni bombers attacked anything moving. The choked roads made it impossible to rally the French Army. General Henri Honoré Giraud reported that such was the situation that military movement between the Seine and Loire was all but impossible. In the meantime General Dentz was left with the unenviable task of arranging the surrender of the French capital.

The initial cars bearing the German conquerors were sent to the north-east suburbs where they were met by machine-gun fire that killed a German officer. Incensed by this treachery, the German commander, General Georg von Küchler, was on the verge of authorising an all-out bombardment of the city. Instead at 5am on 14 June German and French officers met in Sarcelles to arrange the surrender and occupation of Paris. Shortly after a German motorised column entered from the north-east through the Porte de la Villette.

That morning General von Bock was treated to the spectacle of German troops goose-stepping under the Arc de Triomphe and down the Champs-Elysées. When the Germans arrived in Paris they found the city all but deserted, only 700,000 people remained while over 2 million had fled or were in the scattered French Army.

General Alan Brooke, commanding the remaining British troops in France, went to see General Weygand for orders. Brooke recalled Weygand saying, 'The French Army had ceased to be able to offer organised resistance and was disintegrating into disconnected groups.' At General George's headquarters Brooke saw a map showing numerous 'sausage-shaped indentations' which proved to be panzer penetrations of up to 100km in the French line. Brooke noted, 'I had asked him what reserves he had and, holding up his hands in a gesture of desperation he replied, "Absolutely none, not a man, vehicle or gun left."' France's fate was sealed.

Weygand ordered Brooke to create a 150km defensive line to hold Brittany. Brooke's first responsibility though was to his men and he wanted to get them out of France as quickly as possible. When he phoned London he found himself talking to Winston Churchill. 'You are there to make the French feel that we are supporting them', said the Prime Minister. 'You can't make a corpse feel', replied Brooke who after much discussion gained Churchill's permission to save the rest of the British Army.

The evacuation from Dunkirk was now repeated up and down the French coast. After much hard fighting on the Somme the British 1st Armoured Division headed for Cherbourg. They covered the 175 miles in 20 hours with Rommel's 7th Panzer Division hot on their heels. Rommel reached the port on 18 June but was held off until the last of the British had steamed out of the harbour and to safety. On the verge of running out of ammunition the French Admiral of the Port surrendered to a handful of panzers the day after Field Marshal Pétain asked for terms. The 51st Highland Division was not so lucky and was forced to surrender by Rommel on 12 June at St Valéry-en-Caux to the west of Dieppe. For six weeks, from the time the Highlanders went into the Saar in front of the Maginot Line, they had not had a minute's rest.

General Wilhelm Ritter von Leeb's Army Group C, which had been holding the Franco-German border since the start of the war, attacked the Maginot Line. As all of the French Army's mobile units had been redeployed the line was pierced in a matter of hours. The Germans used infantry with limited panzer support and found that it was far from invincible with many of the positions poorly sited and plainly not blast-proof.

The Franco-German armistice was signed on 22 June 1940, followed by the Franco-Italian Armistice two days later when the war in France officially came to an end. At 6am on 23 June 1940, just one day after the French capitulation, Hitler took a whirlwind 3-hour tour of Paris. His cavalcade drove beneath the Arc de Triomphe down the Place de la Concorde and then he stood as the conquering hero in front of the iconic Eiffel Tower.

The bulk of the French Army's 3,000 tanks that had not been destroyed in the fighting fell almost intact into German hands. Hitler captured 2,400 French tanks that were in a re-useable condition, of which 560 were eventually converted into self-propelled guns. Considerable numbers of Somua S-35, the best French tank in 1940 and perhaps in Europe, Renault R-35 and the Hotchkiss H-35/H-39 were taken by the Germans.

Following France's capitulation, Hitler gained an unexpected ally in the guise of the Vichy government in unoccupied southern France under Marshal Henri-Philippe Pétain. Instead of assembling the considerable resources of the French Navy and Empire to help oust Hitler, Vichy in a state of disarray spent the next year more concerned about retaining its colonial possessions. This effectively meant that French interests in North Africa and the Near East posed a threat to Britain's vulnerable position in Egypt. Vichy's policy of 'wait and see' played into Hitler's hands, for unless he could neutralise the powerful French fleet he had no real way of threatening the French Empire.

With Europe conquered Hitler's remaining problem was to persuade the recalcitrant Churchill to submit to his domination of the Continent. Hitler said of the situation, 'The British have lost the war, but they don't know it; one must give them time, and they will come round.'

It was apparent that Hitler's relations with Joseph Stalin, ruler of the Soviet Union, were in rapid decline. With his designs turning East, Hitler desperately needed peace with Britain, but the pugnacious Churchill would not negotiate. Considering Churchill's completely hopeless position, this must have infuriated Hitler, who could not understand why the British Prime Minister was being so unreasonable. Faced with Churchill's continuing obstinacy, Hitler drew the problem of invading Britain to the attention of his three service chiefs.

Hitler's biggest enemy was now time. He wanted to attack Stalin, so he had insufficient opportunity to organise and conduct a proper invasion of Britain. Also the longer Churchill was left, the stronger his defences and resolve would grow. Britain was weakest during May and June and Hitler's biggest mistake was to allow the evacuation at Dunkirk and then not follow up with an immediate invasion. After all the BEF returned home almost weaponless, but a German seaborne invasion had not been planned, nor was it practical at that stage. Britain was fortunately to be spared the fate of France. The French in contrast had to endure five years of Nazi occupation.

Despite the Allied evacuation at Dunkirk the French and British armies continued to resist the German invasion for another three weeks. By this stage both the French armoured and mechanised forces had been completely dissipated. This Char B lies derelict on a French street; German military police have marked the hull to indicate their knowledge of the tank's presence. The chains at the rear indicate that it was under tow before being abandoned.

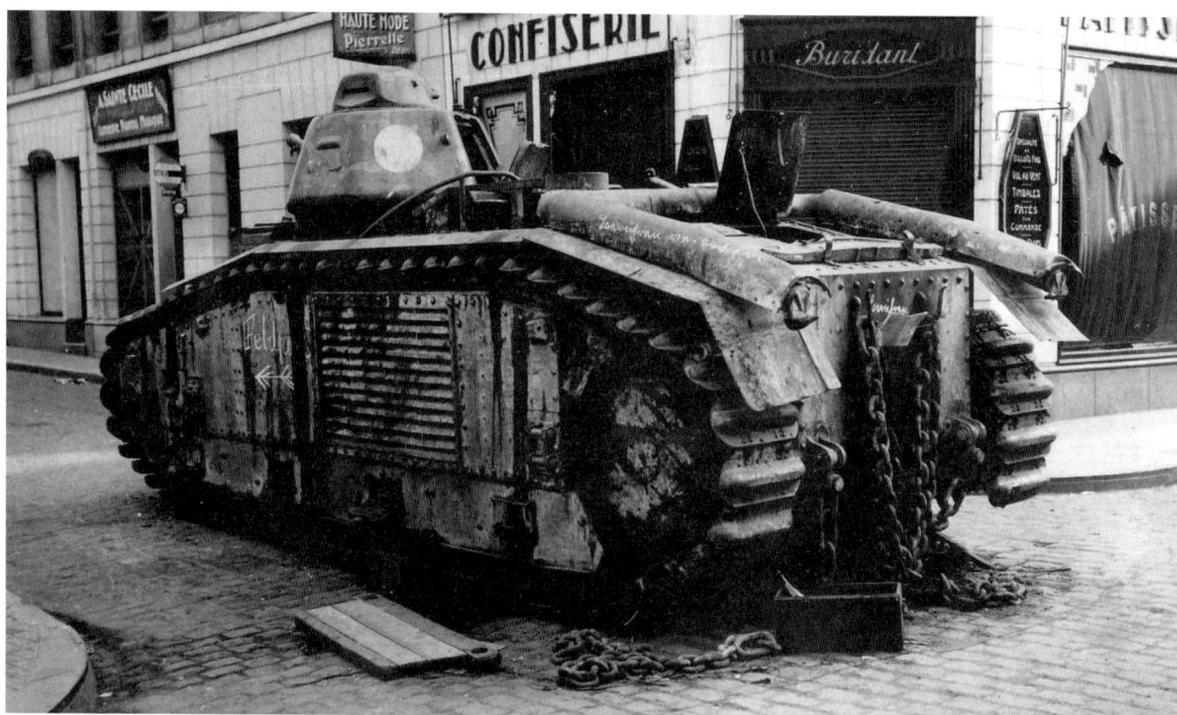

This German soldier could not resist the opportunity to have his photograph taken atop this FT-17 light tank. This particular example had clearly been painted with a camouflage scheme.

More Germans grinning for the camera – this time they are posing with a H-39.

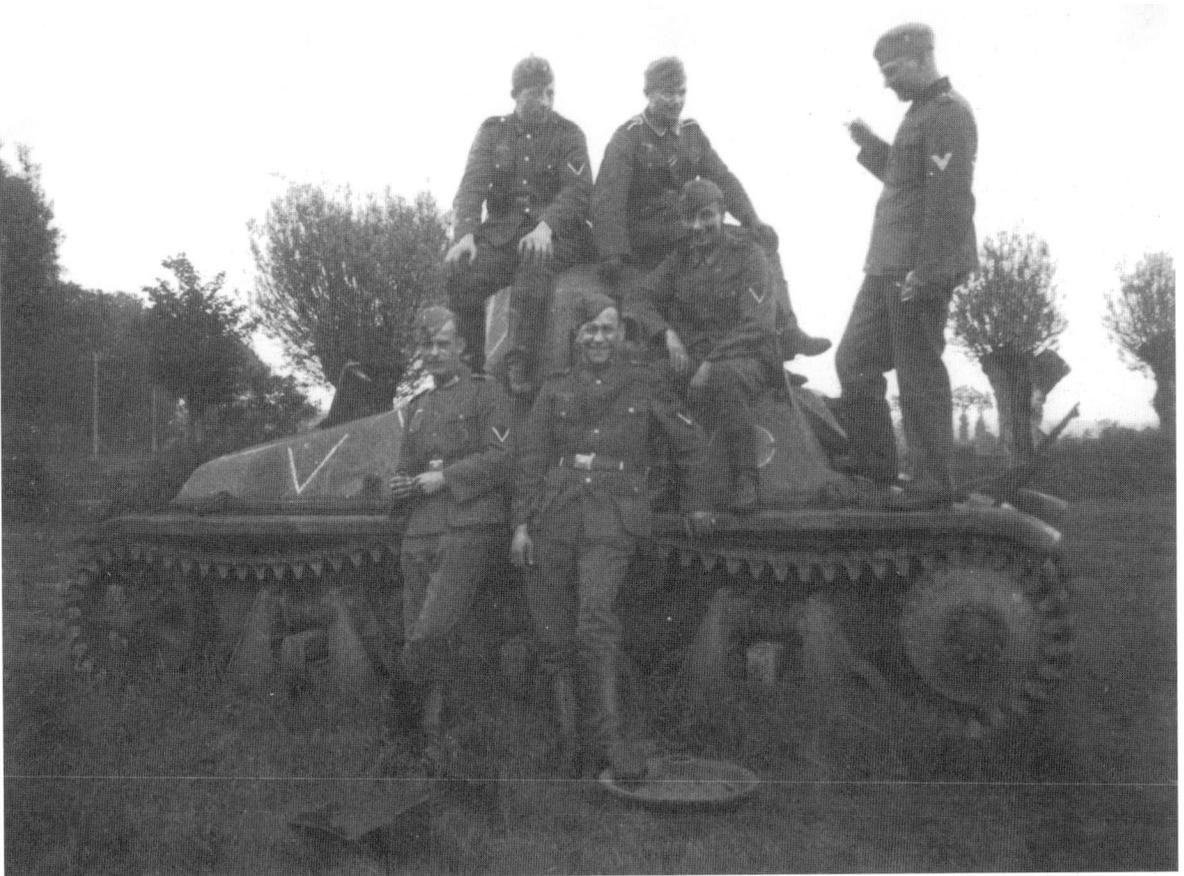

Preparations for the defence of Paris were half-hearted to say the least, comprising roadblocks, machine-gun nests and a few trenches. Such barricades as this one would have proved little impediment to Hitler's panzers.

Paris was bombed by the Luftwaffe on 3 June 1940. The French military had drastically conflicting views on whether the capital should be held against the Nazis, however on 13 June it was announced that Paris would be made an open city.

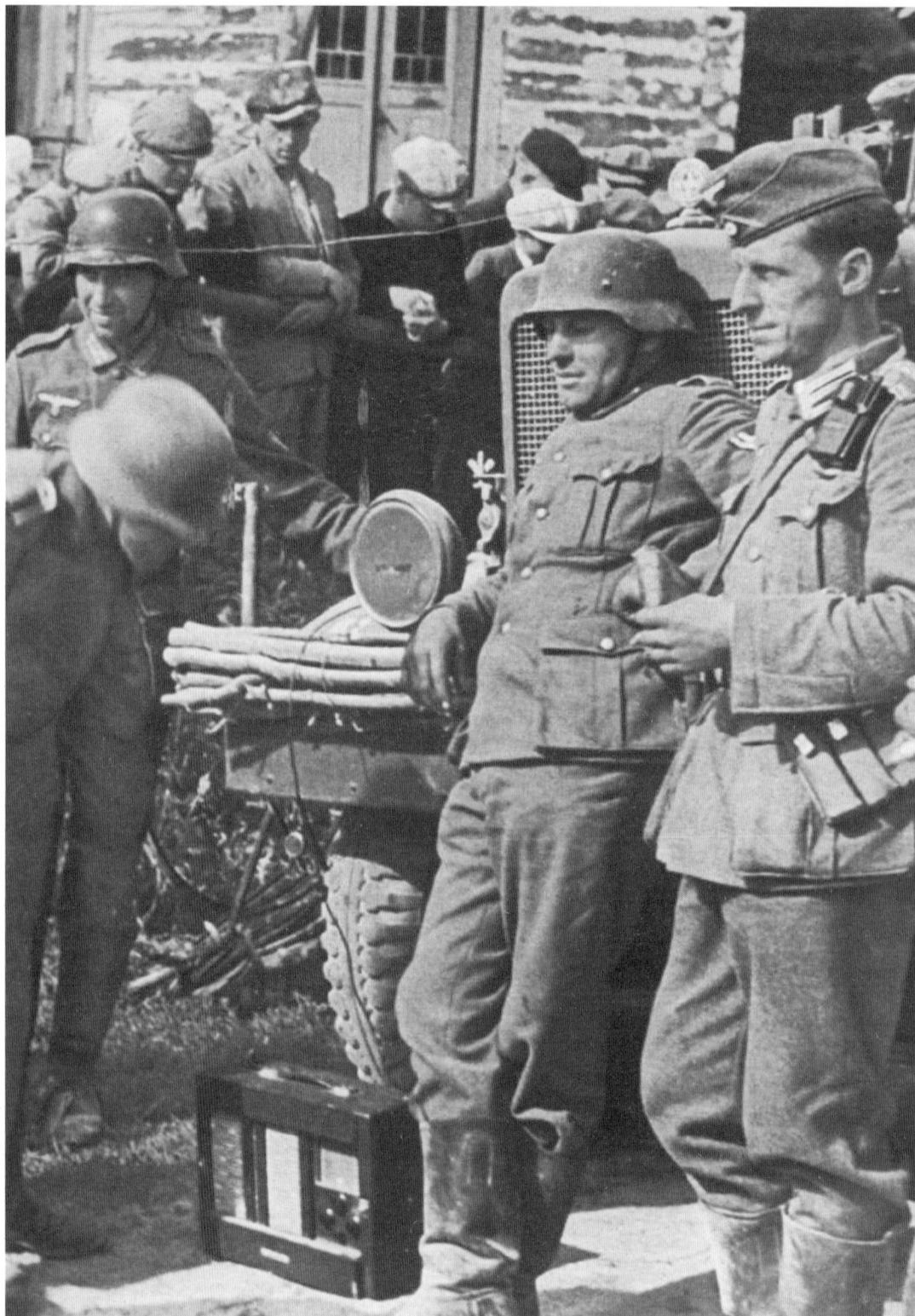

These German troops taking a break from the Blitzkrieg are listening to the radio announcement of France's surrender. The armistice was signed on 22 June 1940.

The French Army was forced to lay down its arms. The photograph above shows a French garrison marching from its fixed fortifications – the enormously costly defences of the Maginot Line proved useless in France's hour of need. The German Army Group C simply bypassed them and hemmed in the defenders. The photograph below shows a column of bedraggled POWs en route to captivity.

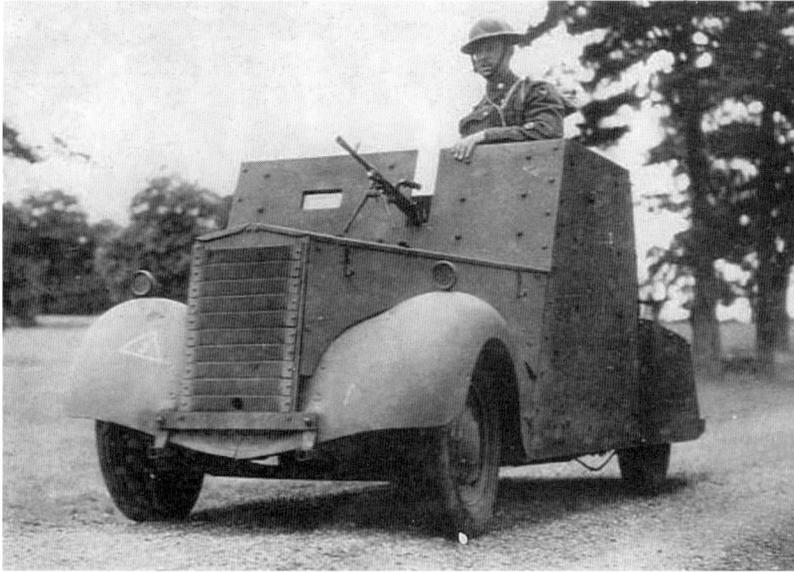

The remains of the BEF returned to Britain bereft of all its equipment. Fearing imminent Nazi invasion, stopgaps had to be produced such as this homemade-looking 'Ironside' armoured car.

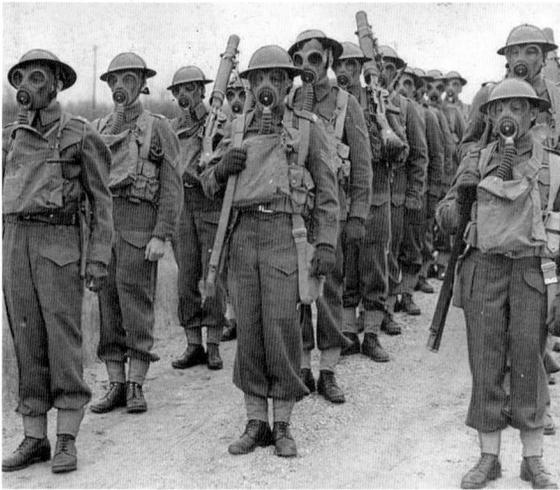

In the wake of Dunkirk the British Army had to look to its defences amidst fears that Hitler might resort to chemical weapons. Fear of invasion soon gripped the whole country.

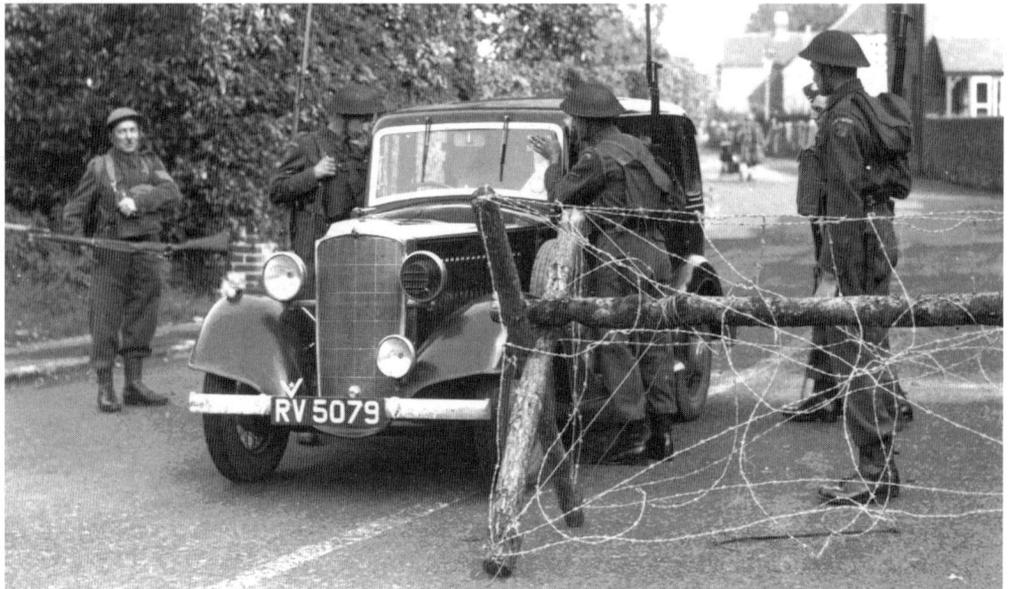

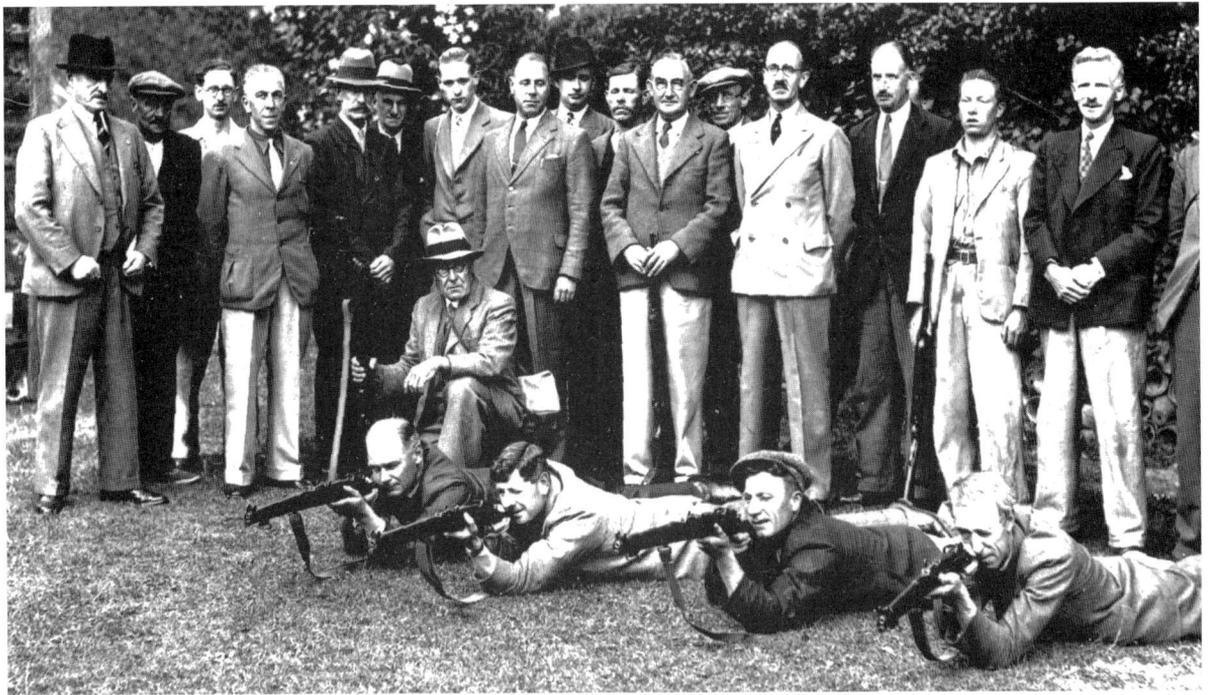

The nation also turned to 'Dad's Army' or the Home Guard to help defend the British Isles.

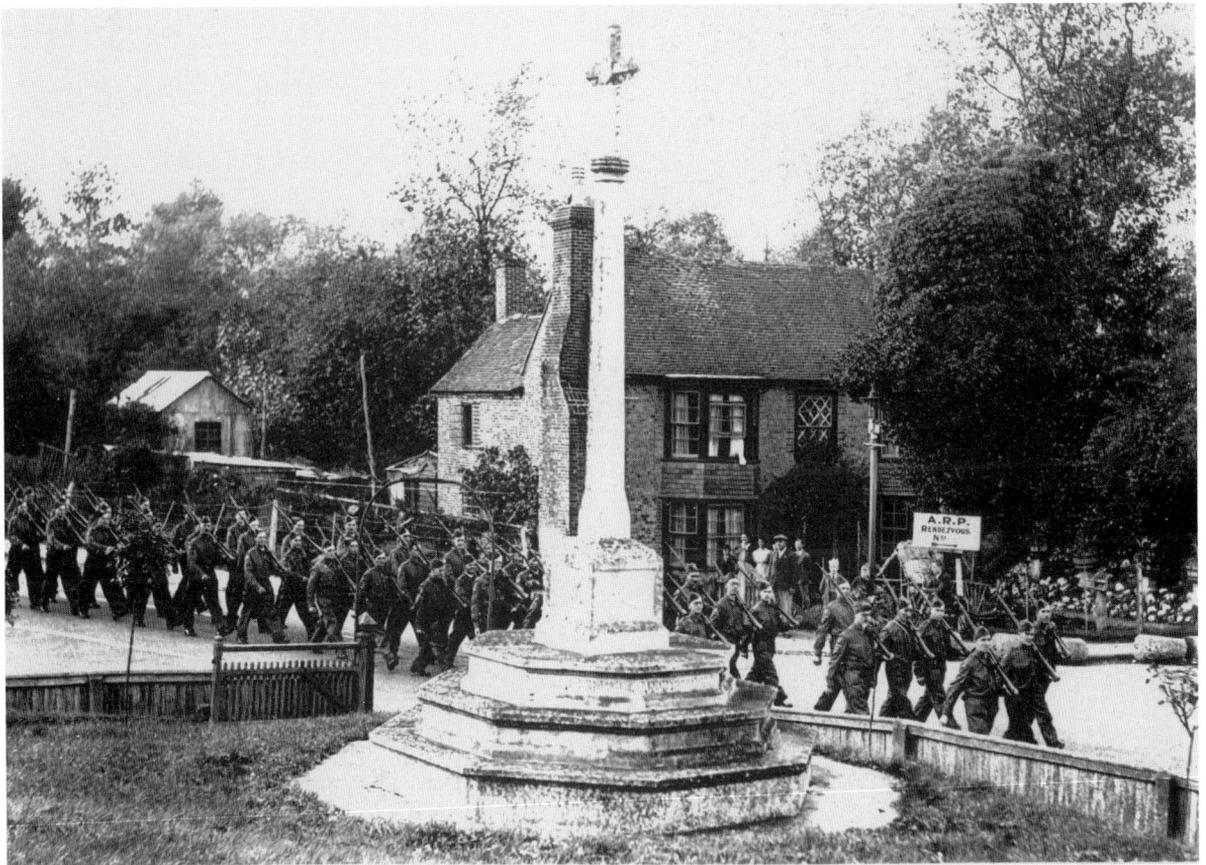

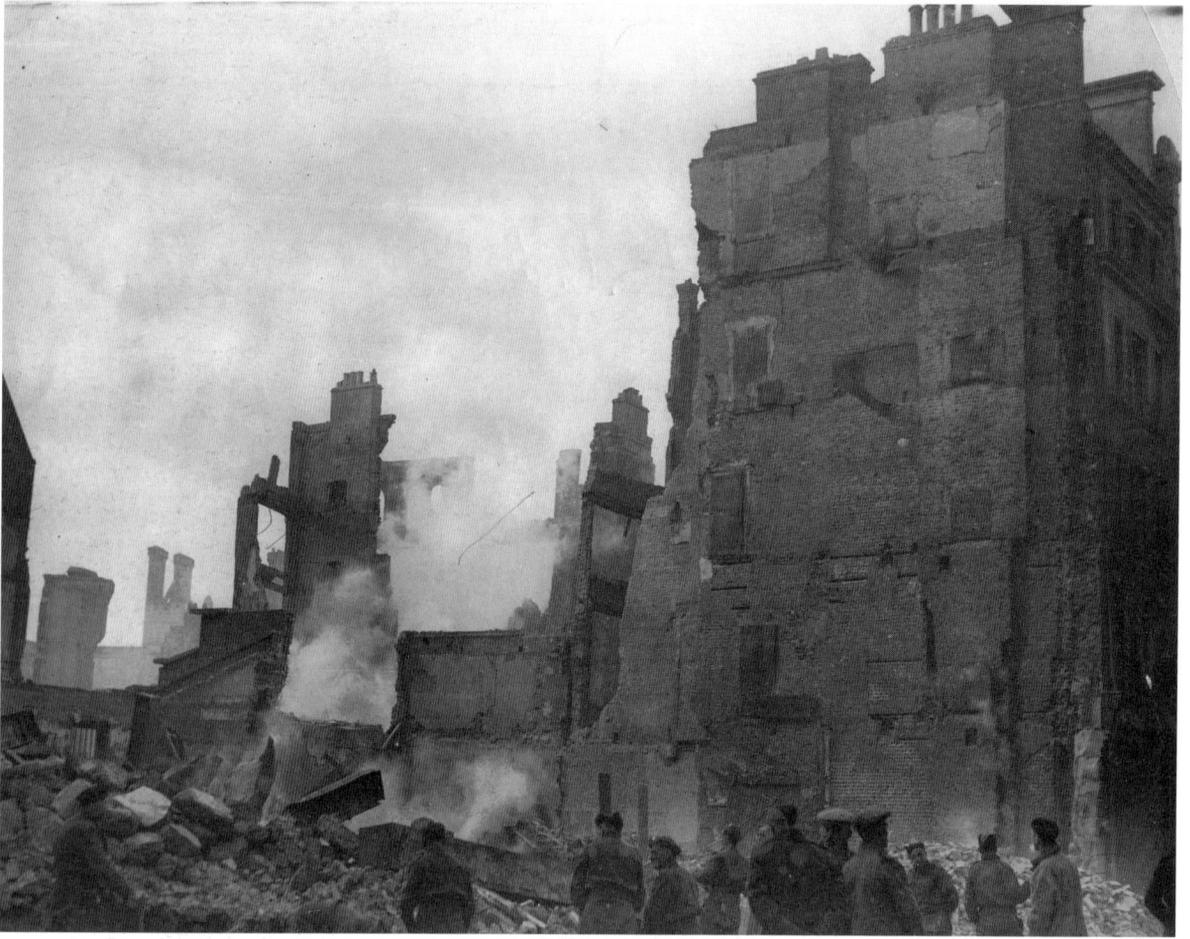

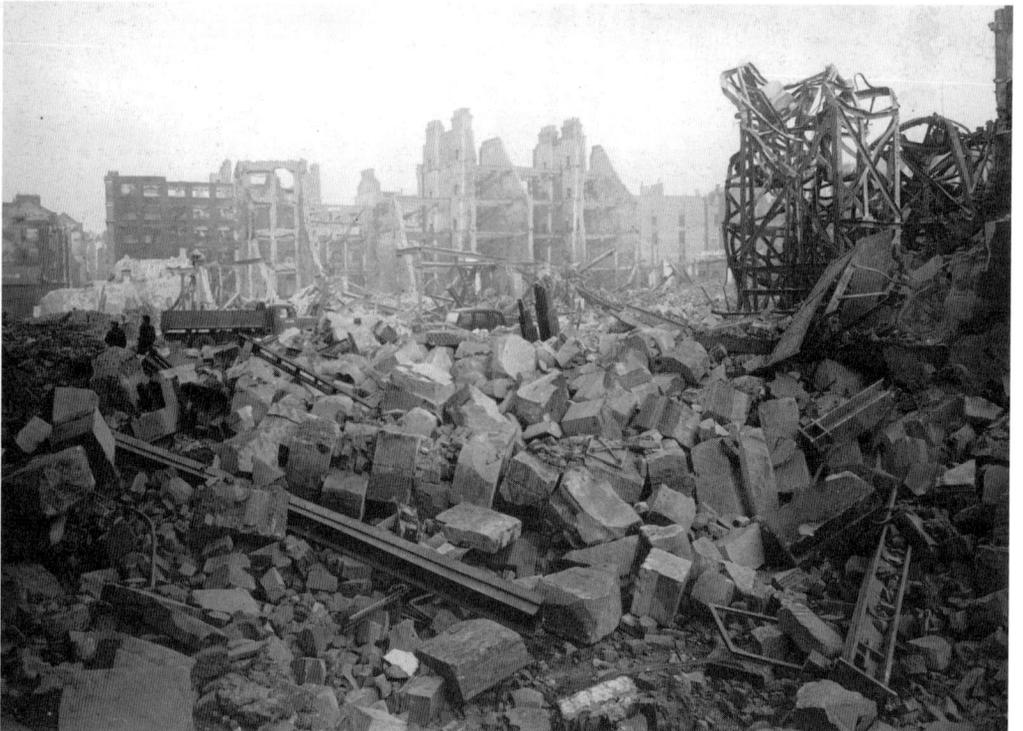

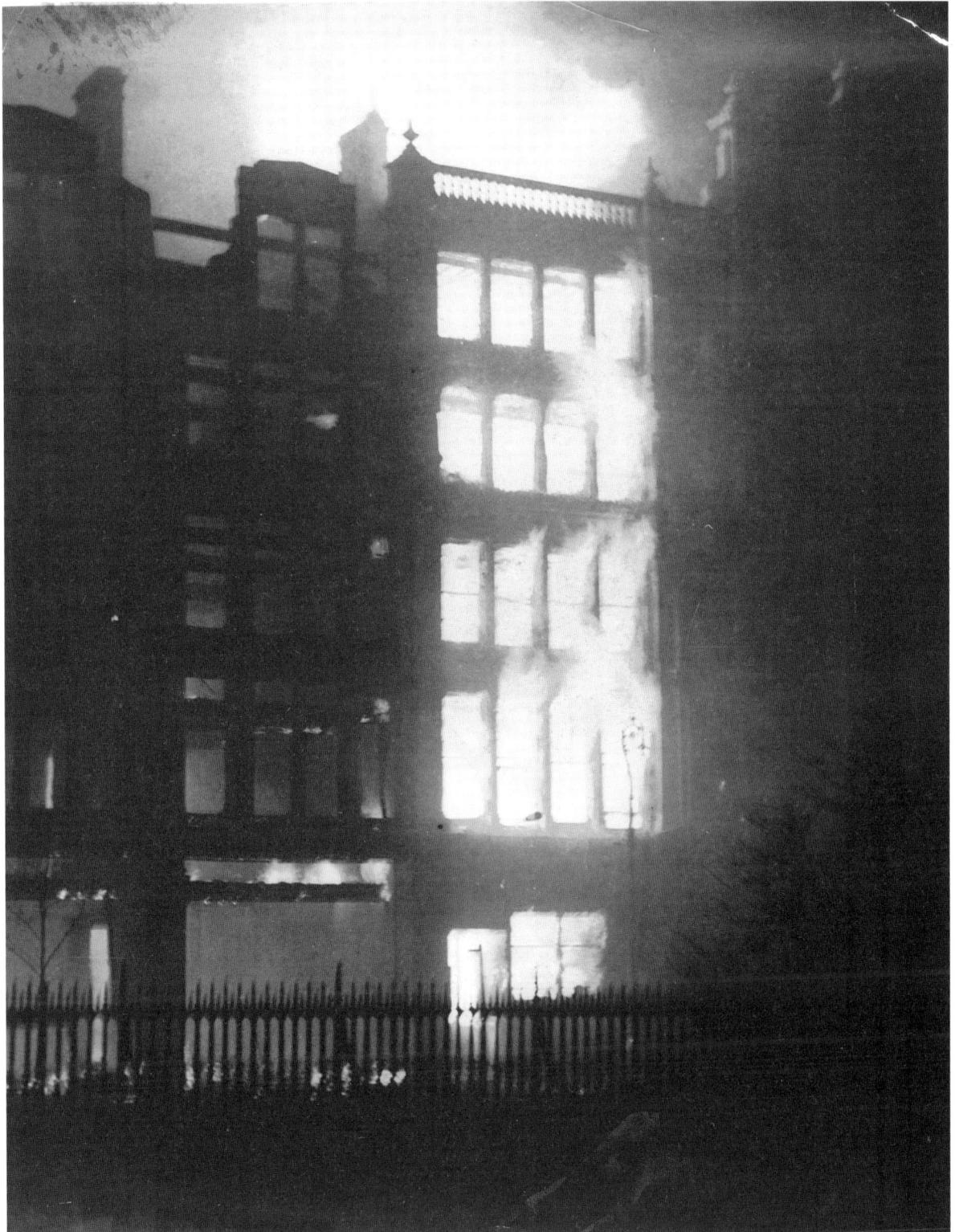

Above and opposite: It was not long before the Luftwaffe was pounding Britain's cities in a prelude to the Battle of Britain. Having taken Paris, Hitler wrongly hoped that Churchill would sue for peace.

While Britain was spared invasion France had to endure five years of Nazi occupation.